Watercolour Workbook

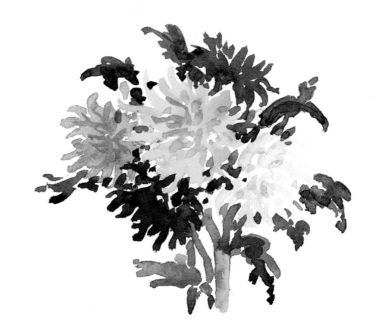

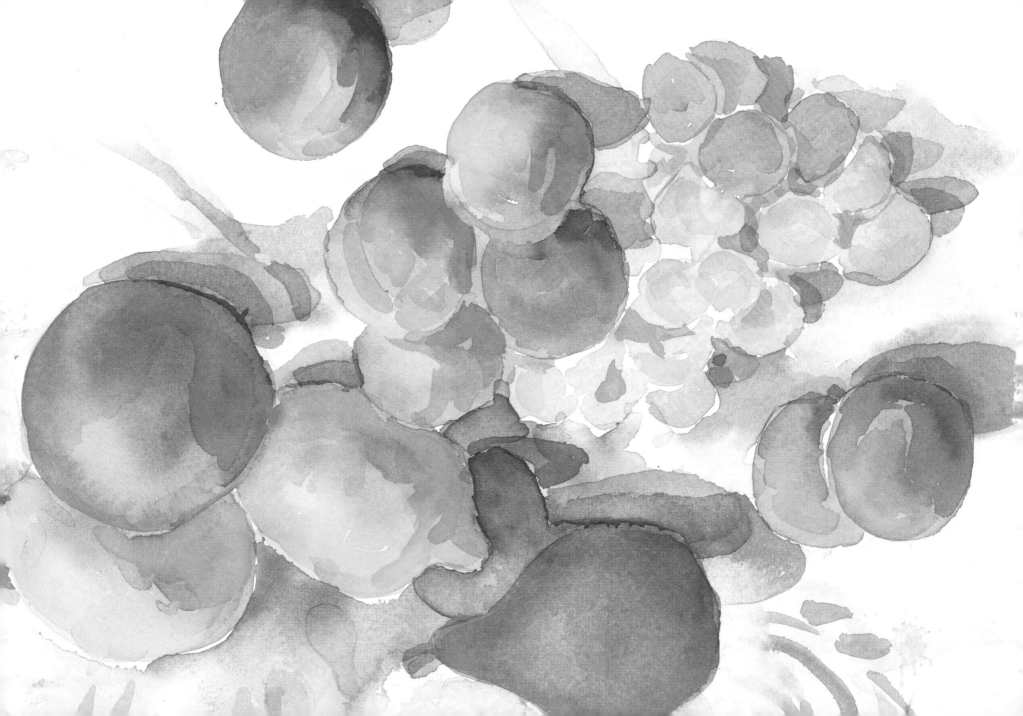

Anne Elsworth

Watercolour Workbook

A COMPLETE COURSE IN 10 LESSONS

D&C
David and Charles

DEDICATION

This book is dedicated to my students who have taught me so much.

ACKNOWLEDGEMENTS

I should like to thank my family and friends and especially my husband Brian for unfailing support and encouragement.

For the materials and equipment photographed on pages 9 and 10 by David Johnson, I am indebted to Winsor & Newton and Pro-Arte.

Thanks are also due to Emma Pearce of Winsor & Newton, and Richard Dixon-Wright of Inveresk at St Cuthbert's Paper Mill for advice and information about pigments and paper.

My thanks to Tim Tennant of the Art Shop, Ilkley, West Yorkshire, not only for over the counter and mail supplies but also for help and advice.

I am grateful to publishers David & Charles, especially Kate Yeates and Kay Ball for giving me 'lift off', Freya Dangerfield for seeing me through and Susanne Haines for her skilful and sympathetic editing.

A DAVID & CHARLES BOOK

Copyright © David & Charles Limited 1997, 2006, 2008

David & Charles is an F+W Publications Inc. company
4700 East Galbraith Road
Cincinnati, OH 45236

First published in the UK in 1997
Reprinted 1998 (three times),1999 (twice), 2001, 2003
First paperback edition 2006
New edition 2008

Text and illustrations copyright © Anne Elsworth 1997, 2006, 2008

Anne Elsworth has asserted her right to be identified as author of this work in accordance with the Copyright, Designs and Patents Act, 1988.

A catalogue record for this book is available from the British Library.

ISBN-13: 978-0-7153-3197-2
ISBN-10: 0-7153-3197-3

Printed in Singapore by KHL Printing Co Pte Ltd
for David & Charles
Brunel House Newton Abbot Devon

Visit our website at www.davidandcharles.co.uk

David & Charles books are available from all good bookshops; alternatively you can contact our Orderline on 0870 9908222 or write to us at FREEPOST EX2 110, D&C Direct, Newton Abbot, TQ12 4ZZ (no stamp required UK only); US customers call 800-289-0963 and Canadian customers call 800-840-5220.

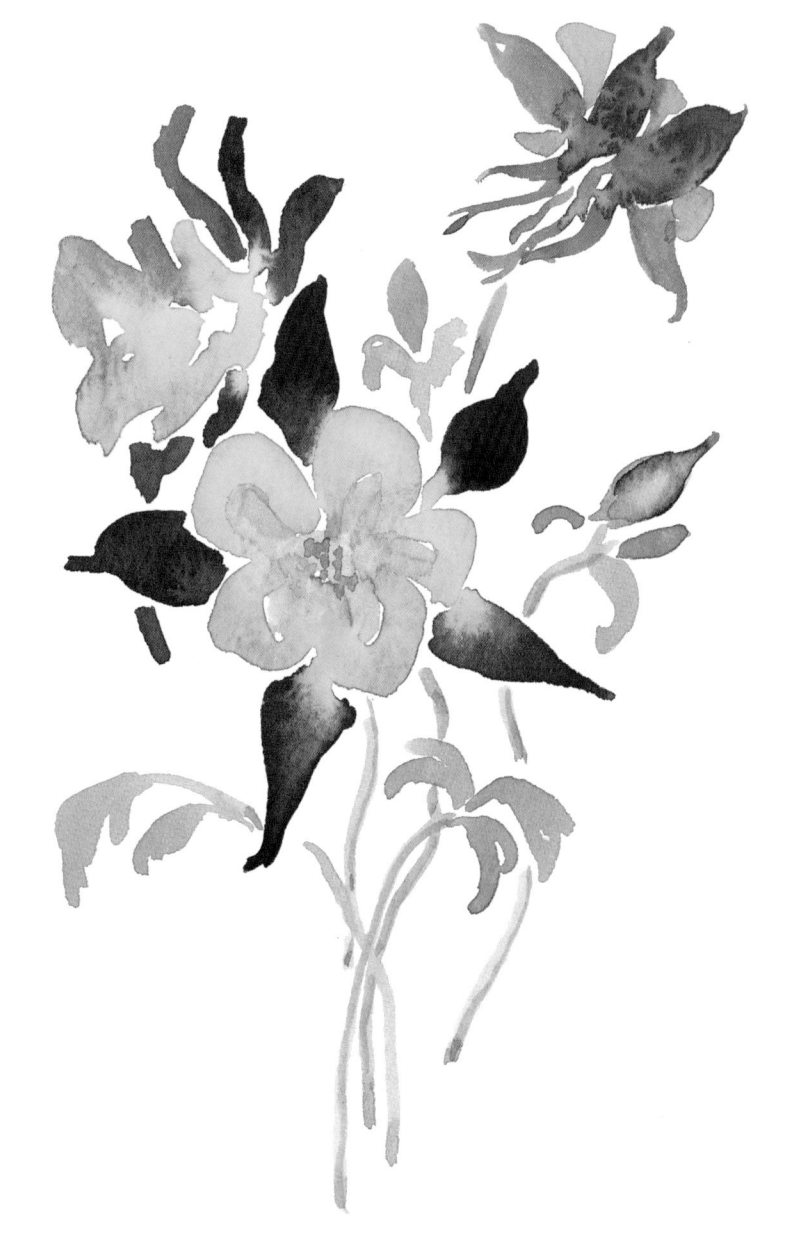

Contents

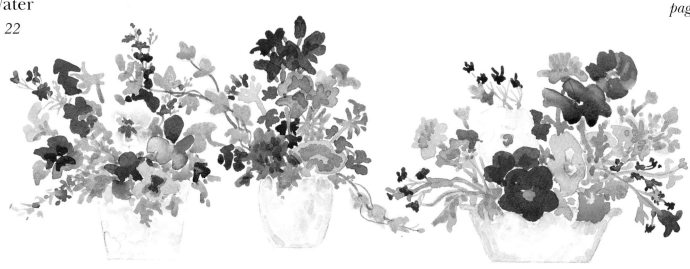

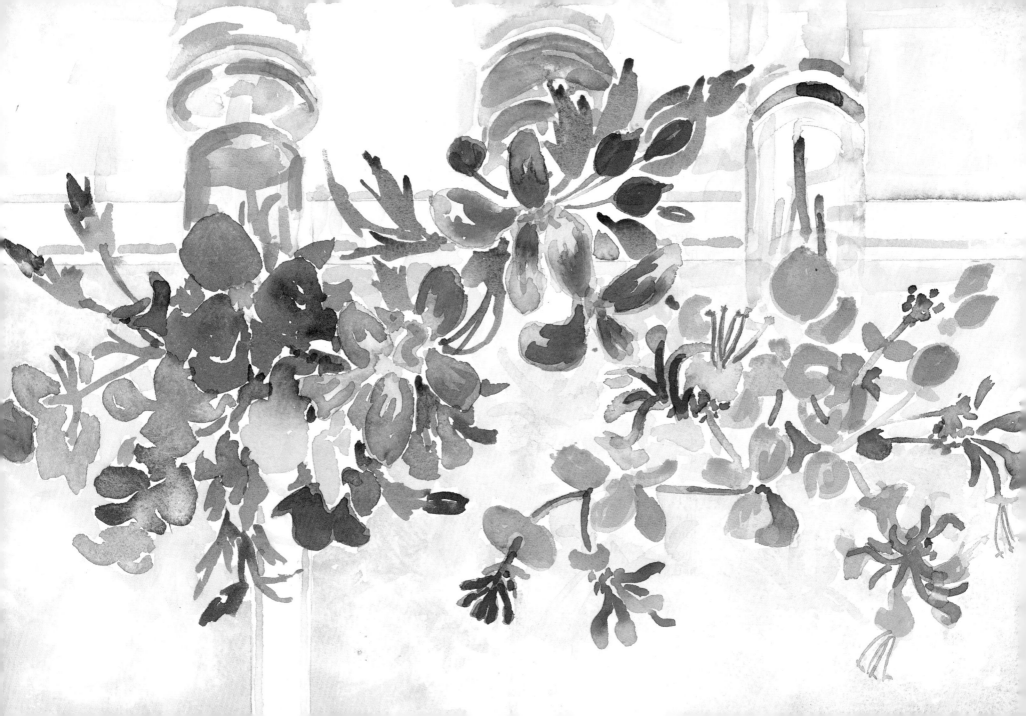

Introduction

Watercolour has a reputation both for producing work of great beauty and for being a difficult medium to master. Its reputation for beauty is easily understood. Capable of great luminosity and random, almost accidental effects – the attraction of this limpid and liquid medium – its beauty is indeed self-evident. It is ideal for almost any subject from a leaden, storm-filled sky to the pure colours and fragility of flowers – no wonder it is the first choice of many aspiring painters.

Its reputation for being difficult is harder to understand. Every schoolchild learns to dissolve pigment in water and to enjoy spreading it on paper, irrespective of the results. As adults, we become far more self-critical, only enjoying that experience if the results convey an acceptable image or at the very least a believable impression. And there's the rub, for alas what novice painters soon learn to their cost is that their efforts to achieve acceptable images and to give expression to their feelings all too often result in paint which is over-worked and has lost those very qualities for which it is most loved and admired.

Through many years of teaching I have learnt how common this disappointing experience is. Happily, I have also learnt how to avoid it. Steady progress, with the satisfaction of achievement at every stage, *is* possible if the learning is carefully sequenced. To illustrate this point to my students I usually cite the case of my son as a teenager taking up rock-climbing for the first time. An essential aid to his progress was a guide to the climbs of our native Yorkshire in which every climb was graded from 'easy' through 'moderate' to 'extreme severe'. He was thus able to choose climbs to suit his growing proficiency rather than trying to attempt too much too soon. Failure in watercolour painting may not have the dire consequence of failure on the rock-face, but the results are none the less destructive to confidence, and extremely disheartening.

This workbook is designed to lead you step-by-step through the use of watercolour in a logical sequence of learning, the first four chapters providing a foundation for the rest. There is a hierarchy of difficulty both in subject matter and in the techniques to be mastered, and a logical sequence of learning can be applied to each. Take simple flower painting as an example. It is easier to paint individual flowers on a plain white paper background than to paint a bunch of flowers in a vase, while flowers in a vase on a table against a window is more difficult still. The first demands observational skills, the creation of shapes and forms and an ability to mix colour. The last demands all this *and* the much more advanced ability to create an illusion of space, not to mention the arrangement of the separate elements of the painting into a pleasing whole (composition). At the top end of the 'subject difficulty' spectrum is landscape painting which, to employ another analogy, is the painter's equivalent of the Olympic marathon. Naturally, no runner would attempt such a feat without a planned campaign and a structured, progressive training schedule.

While some guidelines for creating the illusion of form, space and distance are included in this book, there is little in it about drawing and not a great deal about composition. Those coming to watercolour from other media will already have some experience in these essential picture-making skills, but absolute beginners should not neglect their study and practise. Drawing demands accurate observation,

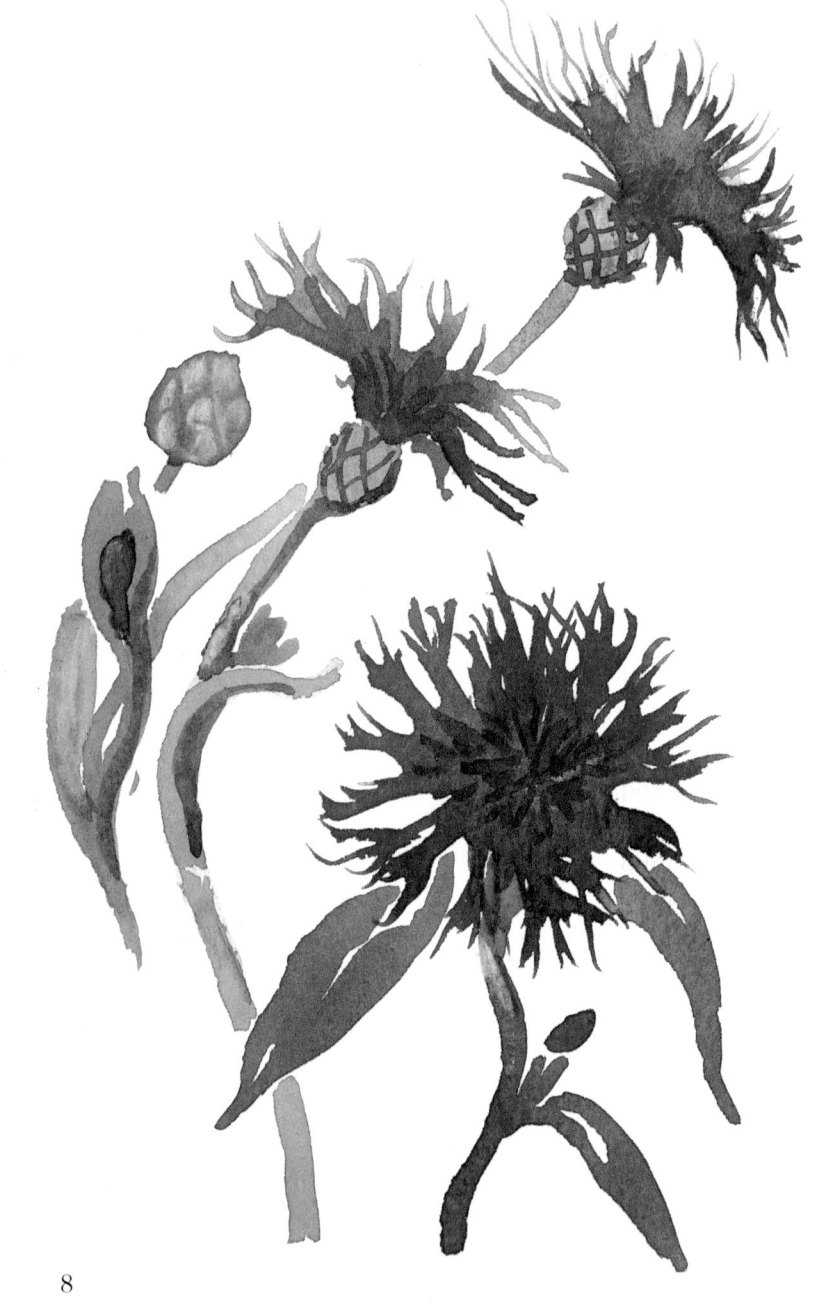

and accurate observation enables artists to translate subjects into paint, each in his or her unique, individual way and with veracity. This book, being largely about watercolour techniques and processes, makes very little use of pencils, but you would be well advised to undertake some separate pencil drawing as each new subject is introduced.

MAKING THE MOST OF THE WORKBOOK

In order to record your progress I suggest that you create your own version of this workbook, either in a ring-bound pad or on loose sheets of watercolour paper which can be punched and strung together later (see next chapter on materials). The point, however, will be lost if you simply copy my examples. By all means copy the work of anyone whose paintings you admire – it is an excellent way to learn to manipulate paint – but in order to progress and to develop your own artistic signature you

should take advantage of every opportunity to work directly from Nature.

Adults learn best when they understand exactly what it is they are trying to achieve, and for this reason a list of aims is given at the start of each lesson. You should read and re-read these aims as you work so that your experience and your understanding develop and progress together. Treat this workbook as your training manual. Many of my students before you have followed it to great effect. The trick is to practise and consolidate the learning in each lesson before moving on to the next. If you can discipline yourself to do this, success will be yours.

Although the following lessons contain much advice and many guidelines, it must be said that hard-and-fast rules are not really appropriate to any creative activity. You should feel free to experiment at all times. The advice which follows is offered to help you avoid too many disappointing failures in the early stages, after which I think it safe to say that rules are made to be broken!

Flowers painted against a white background reveal the beauty of watercolour as a painting medium. Although a simple subject, it nonetheless demands careful observation, and the interpretation of things that are seen into paint on paper. As a subject, flowers portrayed in a setting (see page 6) is far more complicated, demanding the additional skills of creating a pleasing composition and a convincing representation of space.

Materials and Equipment

One of the joys of watercolour is that it is relatively simple for the learner painter to get started. Paints, a palette, water-pot, paper, brushes and just one or two extras are all you need to begin painting.

The vast range of materials offered by suppliers can be bewildering, and your task is made no easier by the fact that every painter and teacher seems to have different advice to give. The object of this chapter is to help you make wise choices, for the time and trouble you expend at this stage will save you a great deal more later on.

To draw up the list which follows I considered what I would ideally like one of my students to bring to a class: sufficient equipment to enable us to get on with the lessons without a moment wasted, neatly organised and with no unnecessary clutter.

PALETTE

The first thing I look for is a palette with deep mixing areas. Choose one with at least three such 'wells' and a row of smaller square or oblong indentations in which to squeeze out pigment from tubes or to arrange your pans of colour. Saucers are useful for mixing large quantities of paint.

PAINTS

Watercolour paint is available in tubes, or in pans or half-pans (small blocks of colour). It is widely accepted that pans are more convenient than tubes when working outdoors on a small or moderate scale. No need to squeeze out colours: just open the box and begin. I have a box of pans myself and it is fine unless I want to work on a large scale, when I just don't have the patience to loosen a sufficient quantity of paint and get it in solution. In the main, though, I prefer tubes because, although they have to be opened, squeezed and re-capped, the moist consistency of tube paint makes it quick to dissolve. I favour them for students too because, in my experience, tubes seem to encourage the use of stronger, less wishy-washy mixes.

Paints are available in two qualities (economy or students' colours, and artists' colours). The depth of your pocket will largely govern your choice; I can only give you some of the pros and cons. Artists' quality paint, the best quality, comes in a wider range of colours and has higher pigment strength. However, the difference is more obvious in the *handling* of the paint

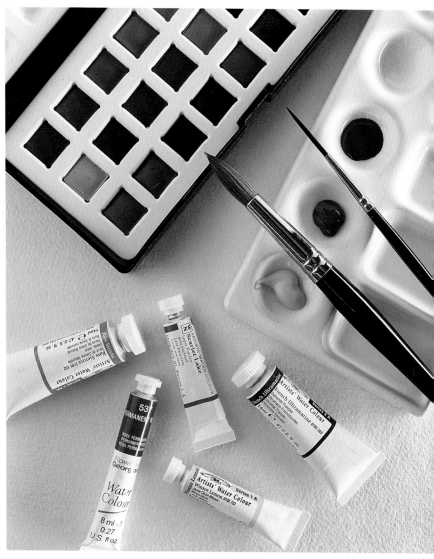

Choose a palette that incorporates deep mixing areas. Boxed sets of paints are available, though it is better to buy colours (in tubes or pans) individually and to create your own colour range, or 'palette' (see pages 20–21).

9

than in the visual effect (the cheaper paint has a more uniform consistency and is slower to dissolve). If cost is a consideration, bear in mind that you may achieve better results by being lavish with moderately priced paints than stingy with a more expensive variety.

In Lesson One I go into more detail about the properties of paints. I suggest which colours to buy and have given a selection of named pigments so that you can buy your own preferred brand. I have used Winsor & Newton artists' quality paint in tubes throughout this book, with the exception of the 'speed' sketches in Lesson Ten which were made using the economy paints in my field box (a remarkably compact kit containing 12 half-pans, mini water-bottle, water-pot, brush and sponge, which fits into my coat pocket).

BRUSHES

Good brushes are the tools of the trade and you should buy the best you can afford. All will be of the hair variety, either natural or man-made, except for one smallish hog, bristle or acrylic brush which you will find useful to lift off colour for an effect, or to make corrections. Sable brushes are the most expensive, valued for their water-holding capacity,

their fine points and their readiness to spring back into shape. However, I prefer brushes of mixed sable and synthetic hair (a relatively recent addition to the market). They combine the water-holding properties of sable with the springy and hard-wearing characteristics of synthetics, and have excellent points.

Synthetic fibre brushes with no sable content are cheaper but do require more frequent loading and are less efficient at picking off any excess liquid from the paper. However, they are preferable to the cheaper natural hair alternatives to sable (such as squirrel) because of their good points, springiness and hard-wearing qualities.

Most of your brushes will be round in shape. Brush sizes vary according to the manufacturer, but sizes approximating to Nos. 4 or 5, 7 or 8, and 10 or 12 would make a good starter set. In addition to these three, I like to have a 'rigger' (a fine-pointed brush, originally used for painting the rigging of boats) for really fine details, and I have a 13mm (½ in) flat (square-ended) brush which makes marks that cannot be imitated with a round brush. For later lessons a medium 'mop' or wash brush (preferably of squirrel hair) will be needed for laying larger areas of colour. Since sable brushes are your most expensive piece of equipment it pays to take good

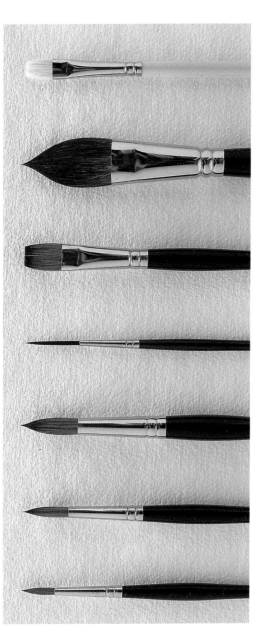

For the lessons in this book you will need the following brushes (shown left, from top to bottom):

- three round hair watercolour brushes (ideally either sable or sable and synthetic mix) size No. 4 or 5, 7 or 8, and 10 or 12
- a rigger
- 13mm (½in) flat
- a medium wash brush
- a small bristle brush

Tip

'Mop' or wash brushes do not need to be springy or pointed but must be able to hold lots of liquid. To test this, dip in water, remove, and gently squeeze the hairs with your thumb and forefinger. A good mop will take up a tablespoonful or more of water.

care of them. Do not leave them soaking in water and standing on their points. Rinse thoroughly after use and reshape them if necessary by stroking across your palm to encourage them back into their original shapes. Leave to dry pointing upwards and standing in a jar.

Brushes with bent or distorted hairs can sometimes be encouraged to regain their original shape by dipping in egg white or hair gel, reshaping and leaving to dry. Remember to rinse out the 'setting agent' before using the brush again.

WATER-POT

Never stint on water. Remember, water-colour consists of water and colour.

A collapsible water-pot with handle for outdoor working is a neat little luxury, but more important by far is an adequate supply of water in any sort of lightweight container. A one-pint plastic bottleful would be a minimum – more if you are going out for the whole day. In the studio I use a glass jar which, being transparent, does not allow me to ignore the fact that water soon becomes dirty, and painting with dirty water is not conducive to producing clean, fresh pictures. Some painters adopt the admirable practice of keeping one jar of water for rinsing the brush and

another one for diluting the pigments, but I am not one of them. Instead, I ensure that my water-pot is replenished as soon as it becomes cloudy – the more frequently the better.

PAPER

The paper you use will be a visible component of the finished work and is thus an integral element of the painting. Not only does paint behave differently on different papers, but the surface texture (or lack of it) of your chosen paper is as much a part of the painting as the colours, washes and brushmarks.

Watercolour papers are traditionally white (some very pure white and others slightly creamy), but reasonably priced tinted papers, previously only marketed in expensive hand-made versions, are now widely available.

WEIGHT/THICKNESS
Paper weight is measured in grams per square metre (g/m², or gsm), although you will also still find weights given in imperial units (lb). As you would expect, the heaviest papers are also the thickest. Papers are produced in weights ranging from 150gsm to 640gsm (72lb to 300lb) and occasionally even heavier.

A perennial problem for the water-colourist is the phenomenon known as *cockling* – a tendency of paper to form 'hills and valleys' when water is applied. The effect of cockling is to make the paint slide off the hills and collect in the valleys, making control of the work virtually impossible. The heavier the paper, the less likely is cockling to occur but, unfortunately, heavy-weight papers are too expensive for most students. The problem of cockling on thinner, cheaper paper can be overcome by 'stretching' (see page 13) – a process in which the paper is taped to a board while wet and left to dry. Thereafter the paper is not removed from the board until the picture is complete and dry, and in this stretched state it will not cockle during the painting process.

Whether your paper needs to be stretched depends on the scale of your work as much as on the amount of water you apply. As a rough guide, however, papers of 300gsm (140lb) weight or heavier will not need stretching, used up to quarter imperial (38 x 28cm/15 x 11in) size. If you use 300gsm (140lb) paper for this work-book, you are not likely to encounter cockling problems until you reach the section on wet-into-wet. At that time, because of the extra water involved in this way of working, and especially if you like to work

Care of Papers

When buying large sheets, have them cut into quarters or halves or bring them home loosely rolled. Try not to squeeze the roll as you carry it or else it may buckle or dent. Any indentations in the paper will result in pigment collecting and settling there.

Oil and water don't mix, so always take care to keep the oils from your skin off the paper by handling it as little as possible and always near its edges.

large scale, you may wish to buy a heavier paper or to stretch your thinner paper.

Many students tell me they are working on thin, unstretched paper or, worse still, on cartridge paper because they are only 'practising'. In my view this is about as useful as doing piano practice on a plank of wood – a waste of time, paper and paint!

When I was learning, the usual advice was to try all the papers available until you found the one that suited you best. What unfortunate advice. There are quite enough difficulties for the student to cope with, without the confusion of papers which all behave slightly differently. My

Recommended Papers

For the purposes of this book, I suggest that you use a paper with a 'not' surface. Bockingford is perhaps the best known and most widely available paper, but your local stockist will be able to suggest similar alternatives. It is available either in imperial-sized sheets (76 x 56cm/30 x 22in) which you can then cut into quarters, or in ring-bound pads of the nearest equivalent size.

A weight of 300gsm (140lb) should suffice for most of the lessons, without the necessity of stretching; 150/190gsm (72/90lb) if you stretch it. For Lesson Nine you might wish to have a slightly heavier paper – perhaps 425gsm (200lb).

advice is to stick to one medium-surface, medium-weight, medium-priced paper for at least a year. Familiarise yourself with the characteristics of that one paper and learn how it reacts to all the different ways of working. There will be time enough for experimentation later.

SURFACE TEXTURE

Papers with a heavy surface texture are called 'rough' and are most popular with impressionist landscape painters. A swift stroke of a brush across such a surface leaves speckles of unpainted paper showing through the paint. Such chance effects have great charm but are perhaps best left until you have a little more experience.

Papers with a very smooth surface are referred to as 'hot pressed' papers. (Think of removing creases with a hot iron and you will remember it.) They are ideal for pen and ink work and paintings requiring fine detail, perhaps botanical studies or architectural subjects where clean edges or precise lines are necessary. There is less feeling of control when using such papers, there being no tooth or texture to hold the flowing liquid.

Between these two extremes comes cold pressed paper, better known as 'not' paper. ('Not' refers to the fact that the paper is not hot pressed.) The medium texture of

HP OR HOT PRESSED PAPER

A smooth surface suitable for detailed work because it enables clean, sharp edges. Often used for pen and ink work, architectural or botanical subjects.

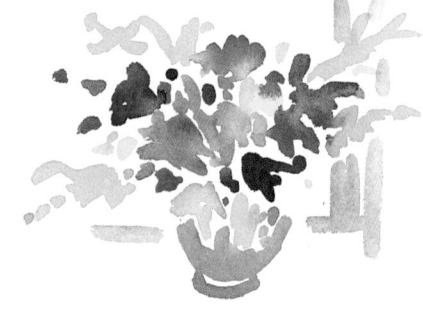

'NOT' OR COLD PRESSED PAPER

A medium surface, all-purpose paper and the one used for most of the paintings in this book.

ROUGH PAPER

As the name suggests, a highly textured paper most commonly used by those who have a broad impressionistic approach. Enables creation of the sparkling effects of light on water when used with a swift dry-brush technique.

'not' or cold pressed papers makes them ideal for the beginner.

The very best papers are hand-made. They are a joy and a delight to work with, but they are also very expensive. I suggest you save them for your 'mature period'!

STRETCHING PAPER

You only need to stretch paper if there is a risk of it cockling while you work.
You will need:

- Gummed brown paper strip approximately 3.5cm (1½in) wide.
- Drawing board. The surface should be only slightly porous – if it is too porous it will absorb all the gum, and the paper will spring loose. On the other hand, a completely imporous surface will prevent the glue from functioning. I use the smooth side of offcuts of hardboard. I sometimes find it necessary to give them a coat of decorator's size to render them less porous. With even relatively small pieces of hardboard, paper is strong enough to bend the board as it dries, so for larger sheets it is better to use a thicker board. The board must be larger than the paper by about 2.5cm (1in) all round to allow for fixing the tape.
- Paper, cut to appropriate size.
- A sponge and bucket of water.

Tip

You may wish to invest in a patent paper-stretching device – a useful luxury which secures the paper and prevents cockling.

METHOD

Generously sponge water over the paper, first on one side and then on the other. (Alternatively, run a shallow bath of cold water, submerge the paper by sliding it in, and leave to soak for a few minutes before removing it.) Allow excess water to drip from the paper and then lay it gently on the board and leave it to 'grow'. Since the purpose of the exercise is to fix the paper firmly to the board at a time when it has expanded to the full, it is not wise to rush this job. How quickly the paper expands depends on how large and how thick it is, but if you do leave it too long and it starts to dry out, nothing is lost: simply re-wet and try again.

Tear off four appropriate lengths of tape and dampen one of them with a sponge. (I do this by holding one end of the strip in my teeth and the other in one hand leaving my other hand free for the sponge – the best way I know to prevent the gummed strip from sticking to itself.) The sponge should be damp rather than sodden since too much water will wash off the glue.

Starting with one long edge, fix the paper to the board with the dampened gummed strip – half on the paper and half on the board. Use the damp sponge to press the tape very firmly in place taking care not to rub the paper itself.

Take hold of the paper by the two remaining free corners and gently pull out and away from the stuck-down edge to ensure that the paper is completely flat before you stick down the second side. Complete the operation by sticking down the remaining two edges.

Always allow boards of stretched paper to dry flat. Leave the paper to dry away from direct heat as rapid drying sometimes pulls the tape and paper away from the board.

Once the paper is dry it should remain attached to the board until the painting is completed, when it can be removed with a craft knife.

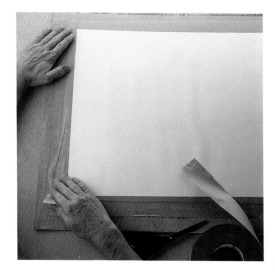

Tape the paper along both long edges before fixing the shorter edges.

Problem Solving

If your stretching attempts leave wrinkles which do not disappear during the drying process, or if the tape fails to adhere properly to the board, cut the paper from the board with a craft knife along its extreme edges. The remaining half of the tape will float away when the paper is soaked in water once more. You can then repeat the sticking-down process without any detriment to the paper.

DRAWING BOARDS

Unless you are going to work solely in a ring-bound pad, which will have a rigid card backing, you will need something to fasten your papers to. This should be light-weight and preferably a little larger than the paper itself. A board 40 x 30cm (16 x 12in) will take a quarter-imperial sheet, and one 40 x 60cm (16 x 24in) a half-imperial sheet. I recommend a piece of hardboard, which can also be used for stretching paper. You will need some masking tape or board clips with which to secure paper to board.

OTHER ESSENTIALS

I am never without a piece of kitchen paper in my hand when painting. I use it mostly for keeping control of the amount of wet-ness in the brush after rinsing, but also for blotting off unwanted runs and accidents. Some artists prefer toilet tissue because it is untextured, but it is liable to disintegrate, with the risk of bits of tissue and fluff getting into the brush and on the paper. Cotton rag was used long before kitchen paper was invented, and serves perfectly well.

A selection of pencils will be needed: an HB or B for preliminary outline drawing and a 2B, 4B or 6B for studies.

An artist's sponge can be used for paint-ing textured areas as described in Lesson Four, and also for lifting out colour and making corrections.

You will need some cartridge paper, a chunky stick of charcoal (not compressed charcoal or charcoal pencil) and a putty rubber for the compositional studies suggested in Lesson Five.

Lesson Nine offers opportunities for experiments in creating texture, and mask-ing fluid, an old toothbrush, a wax candle or crayon, some salt, an old domestic spray to atomise water and some blotting paper will be useful additions to your equipment at that stage.

EASELS

Although working at an easel is by no means essential for watercolourists, my own prefer-ence is to paint from a standing position, and I feel that standing at a field easel makes it easier to assess the progress of a painting by taking a few steps backwards to view it from a short distance. However, you can do this just as well when sitting to work out-doors, with the board or pad balanced on your lap, provided you remember to stand up and stretch your legs now and then.

I find wooden field easels are invariably more difficult to erect and to adjust than metal ones. I use a folding metal field easel which, although heavier than some others on the market, is very stable and easy to erect. I give it added stability on windy days by suspending a piece of stone in a bag from the centre.

It is easy to vary the angle of the board on my metal field easel while I work, without having to loosen and tighten wing-nuts. This is something that someone seated on the ground or on a stool would do without even having to think about it, of course, so I must repeat that an easel is in no way essential. However, if you do decide to invest in one, remember that heavier easels are both more stable and less easy to carry over long distances. A compromise between stability and portability may be called for.

A field easel can be used indoors as well as outdoors, but most people find it more comfortable to sit at a table (see page 22).

WORKING OUTDOORS

Even an experienced painter may feel some anxiety at the prospect of working out-doors. It is difficult enough to know what to take and how to pack and carry it, let alone having to work in the public gaze. Of course, you can start in your own garden if you are lucky enough to have one or go with a friend on the 'safety in numbers'

Tip

When packing for a long outdoor session, I put boards of stretched paper face to face so that nothing can accidently fall on them. Remember that when paper is wet it will be even more susceptible to damage by abrasion.

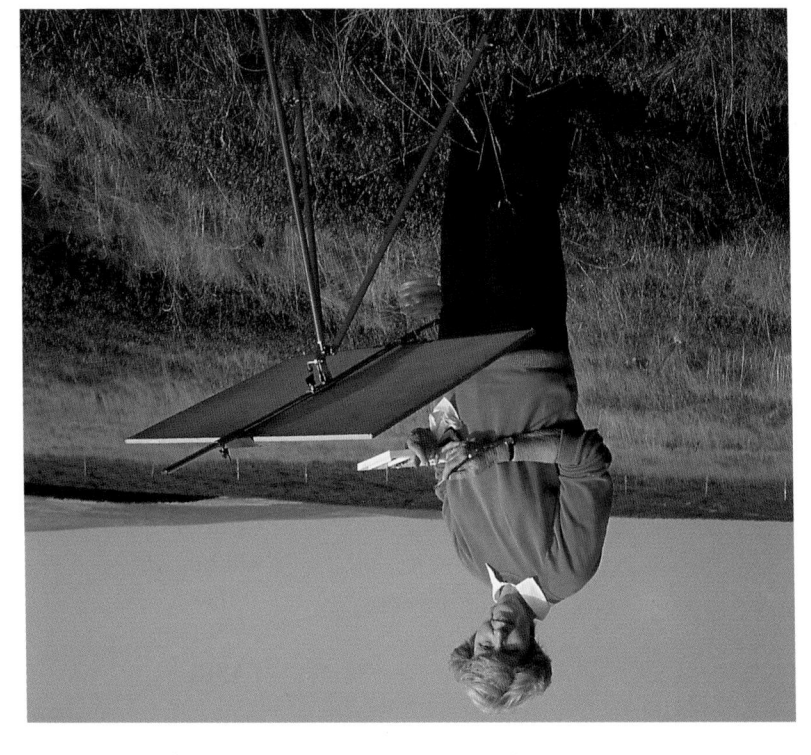

I like to use a metal field easel when I am working outdoors.

principle, but sooner or later you will have to meet your public.

Try to choose a spot where it is not easy for people to approach you from behind. If you find a place where you can sit with your back to a wall or thick clump of bushes, any interested parties will at least have to approach you head on, whereupon you can become deeply engrossed in your work. If this fails, and you are asked 'Do you mind if I look?', you can always say that you prefer to finish before showing the work to anyone. You could perhaps start in a quiet corner of a country churchyard, the grounds of a stately home or a public park. Before long you will overcome your embarrassment, although unwanted visitors are always a distraction no matter how experienced you are.

I like to carry a flask of coffee to help me over those times when I lose concentration and have to stop and think. Indeed, stopping work to pour a cup often encourages passers-by to move on when they see no immediate prospect of watching me at work.

PACKING YOUR BAG

You will need paints, palette, paper, water-carrier, water-pot, brushes, sponge, kitchen roll or rag, and pencil case. A field box (see page 10) is a handy luxury. Fasten several pieces of paper (quarter-imperial for early efforts) to a piece of stout card or hard-board, using either clips or masking tape to avoid their flapping about in the breeze. Carry brushes strapped to a piece of card or in a brush carrier, making sure they cannot come to rest on their points.

In addition, you should have a small sketchbook for making notes and trying out rough sketches and compositional studies. To this end your pencil case should include HB, 2B and perhaps 6B pencils, also a putty rubber and an old film container or pill bottle for chunky pieces of charcoal. Coloured pencils or crayons are useful for making colour notes.

I add midge-repellent, camera and a viewfinder (see page 64). All this will fit into a back-pack or satchel with shoulder strap and should weigh no more than a small bag of shopping. You then only have your easel to carry and could take a stool if you want one. I prefer an inflatable cushion in case I can't find anywhere dry enough to perch when I am working on a small scale.

When working on a larger scale I take my easel, my satchel, and a large poly-thene bag with handles in which I carry a lightweight drawing board up to half- or sometimes even full-imperial size.

WHAT TO WEAR

Dress appropriately for the weather conditions you are likely to encounter. Layer dressing and stout waterproof footwear, body-warmers and fingerless mitts are all good for wintry weather. Painting is a sedentary pastime, so you will feel the cold much more acutely than if you were out for a walk. On bright, sunny days, a hat with a wide brim is preferable to tinted glasses. If visiting a remote spot, ensure that someone is aware of your route and your expected time of return.

Colour

Mastery of colour is vital if you are to succeed as an artist. The importance of beautiful colour cannot be overestimated. Ability to mix colour confidently will come with a combination of theory, understanding and practical experience. You will require a surprisingly small number of pigments in your 'palette' (your selection of colours) to yield a vast range of colour. In this lesson you are asked to make a simple colour chart, and this will enable you to discover the variety that can be obtained by mixing pairs of colours.

Do not be tempted to skip this exercise, even if you have reasonable control over colour mixing in another medium. This lesson is an introduction to handling the paint in a way that does not involve having to make acceptable images and as such is the foundation for all that follows.

Much confusing and apparently conflicting advice has been given on which colours to buy and use. The fact is that individual painters have their own favourites. As you gain experience, you will develop your own preferences, but for the time being I suggest you use pigments similar to those on the colour mixing chart opposite (also see page 20).

This lesson also aims to give you the opportunity to experience dissolving and diluting pigment, and to practise really basic brush skills. Although the colour-mix chart on page 19 will provide useful reference material in the lessons that follow, just looking at it is no substitute for the experience of mixing the colours for yourself. However, before we begin, we need a common language.

Aims

- To learn some useful colour terms
- To create a reference chart of two-colour mixes
- To experience dissolving and diluting pigment to control colour strength
- Using a medium-size round brush (No. 4 or 5), to control the load of the brush
- To gain information about a range of colours appropriate to both landscape and flower painting, including such characteristics as transparency, purity, granulation and staining

The Language of Colour

Primary colours Yellow, red and blue.

Secondary colours Orange, violet and green. In theory, mixing two primaries will produce a secondary; yellow and red make orange, red and blue make violet, and blue and yellow make green. In practice (as Lesson 3 reveals), this is an oversimplification.

Colour temperature Yellows, oranges and reds are broadly seen as warm colours, while greens, blues and violets are cool colours. Again, this is an oversimplification as colour temperature involves relative or comparative judgements (for example, although yellows are warm, an acidic lemon yellow is cooler than a golden buttery yellow). Another aspect of temperature is that in general warm colours appear to advance while cool colours appear to recede.

True colours These are colours that have little or no temperature bias.

Pure/impure In nature pure colours (primaries and secondaries) are found most commonly in flowers, while impure colours are the mustards, olives, browns and greys of landscape. Only two manufactured impure pigments are used in the chart on the next page. Mixing your own impures normally involves combining three primary colours.

Tints Colours can be tinted (ie, made paler) by the addition of white pigment, sometimes called 'body colour'. In watercolour, however, this would result in loss of transparency, so colours are tinted by adding extra water, thus allowing more white paper to show through the mixes.

Tone Undiluted pigments from the pan or tube each have their own tonality (light/darkness). Yellows are the lightest-toned pigments; cool reds and blues are much darker in comparison. The tone of any pigment is made lighter by tinting, and darker (to make a shade) by the addition of a complementary colour (see Lesson Three), or of black. My own preference is for a palette with neither black nor white; nor do I recommend them for beginners.

PAINT TO PAPER

Before starting your chart, paint some squares of colour on a spare piece of watercolour paper. Squeeze paint from the tube onto the palette, or loosen paint in the pan with water and a No. 4 or 5 brush. Transfer to a well on the palette and dilute with only a tiny amount of water to make a strong mix.

Apply a brush stroke of this full-strength mixture at the top of the square, then dip the brush in water and dilute the paint on the paper with a brush stroke below the first to show the colour in its paler or tinted form. (By full strength I mean using the smallest amount of water possible, *not* a smear of neat pigment.) Rinse the brush well before using another colour, and control the amount of water in the brush by wiping it, if necessary, with kitchen paper.

MAKING A CHART OF TWO-COLOUR MIXES

Using an HB pencil and ruler, draw a chart of squares on watercolour paper. Write the names of your pigments on your chart (yellows and reds along the top, blues and greens down the left-hand side) and paint each square of colour full strength at the top, with a pale tint at the bottom.

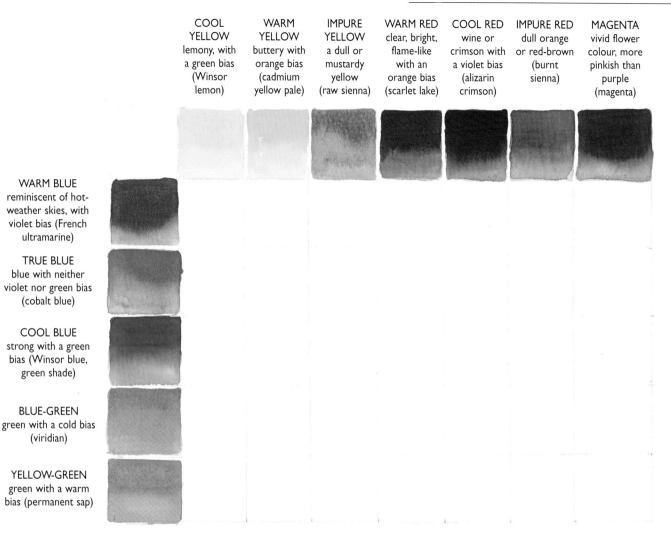

CHART OF TWO-COLOUR MIXES

The colour chart is shown significantly reduced in size. Draw up your own chart at about 180 x 245mm (7 x 9½in) in pencil, and write down the names of the pigments you are using for reference. Here I have given the names of the pigments I used together with a general description of the colour.

Change the water in your pot frequently so that the mixes will be as clean as you can make them, or use two water-pots – one for rinsing and another for diluting the pigment. Next, start filling in a blank square with the colours made by mixing one colour from the top of the chart and one from the left-hand side mixed in varying proportions. To begin, take the top left-hand square which combines warm blue with cool lemon yellow (see right). The square has been sub-divided into six (use pencil lines as a guide, if you wish). The three left-hand sub-divisions use the colours at full strength while the three right-hand sub-divisions use the colours

in their paler, tinted form (diluted with water). In the top pair, yellow predominates, making yellow-green, while in the bottom pair, the blue predominates, making blue-green. Paint these two colours and their tints before the centre colour and its tint. For the centre colour, you should aim to produce a mix that is balanced between the two colours, one that you perceive as *true* green (ie, without a yellow or blue bias). It is helpful to have a piece of scrap paper for testing your mixes.

The illustrations below show how two different blues produce quite different colours. A completed version of the whole chart is shown opposite.

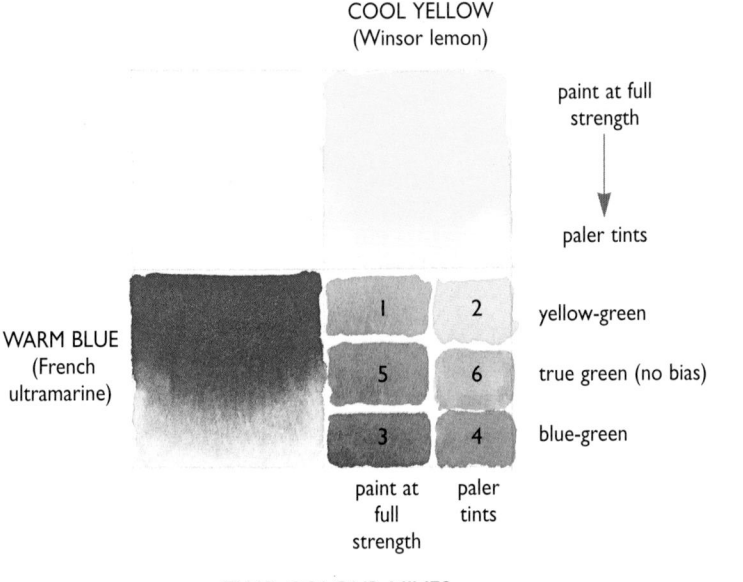

COOL YELLOW
(Winsor lemon)

paint at full strength

↓

paler tints

WARM BLUE
(French ultramarine)

1	2	yellow-green
5	6	true green (no bias)
3	4	blue-green

paint at full strength paler tints

TWO-COLOUR MIXES

In one well of your palette dissolve a cool yellow, in another a warm blue (both at full strength). Transfer some yellow to a third well and add a touch of the blue. Paint this yellow-green in box 1; dilute to a tint and paint box 2. Transfer more blue to the mix and paint the full strength blue-green in box 3; dilute to a tint and paint box 4. Now add more yellow to the mix to achieve a true green (with no blue or yellow bias) and paint box 5; dilute for its tint in box 6. It should become easier to judge the correct amount of pigment to water, and whether you need to offload a little colour by dragging the brush gently across the edge of the palette before painting the squares.

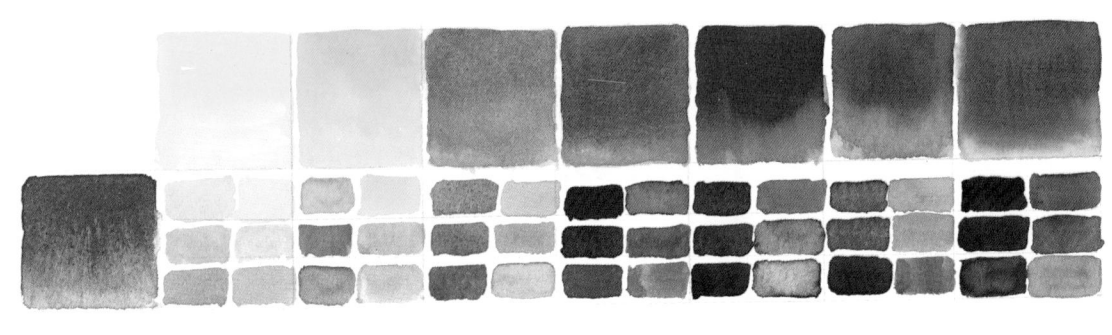

Mixes made with warm blue

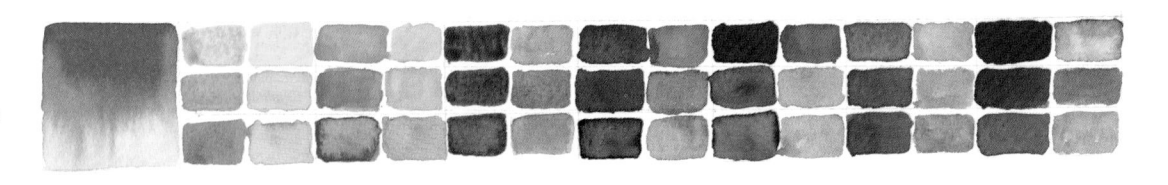

Mixes made with cold blue

TWO-COLOUR MIXES CHART

This colour chart will introduce you to the wide range of colours that can be made by mixing different reds and yellows with a variety of blues and greens and will provide useful reference for your painting. It will also sharpen your judgement of how much water to add to get the tint you want. Do not expect perfection. Even experienced painters may find it difficult to keep all the full-strength mixes uniformly strong and the tints all tinted to an equal degree. To avoid a 'wishy-washy' look, make all the full-strength mixes (in the left-hand side of each colour-mix column) really strong, so that the columns of tints on the right-hand side are strikingly pale by comparison.

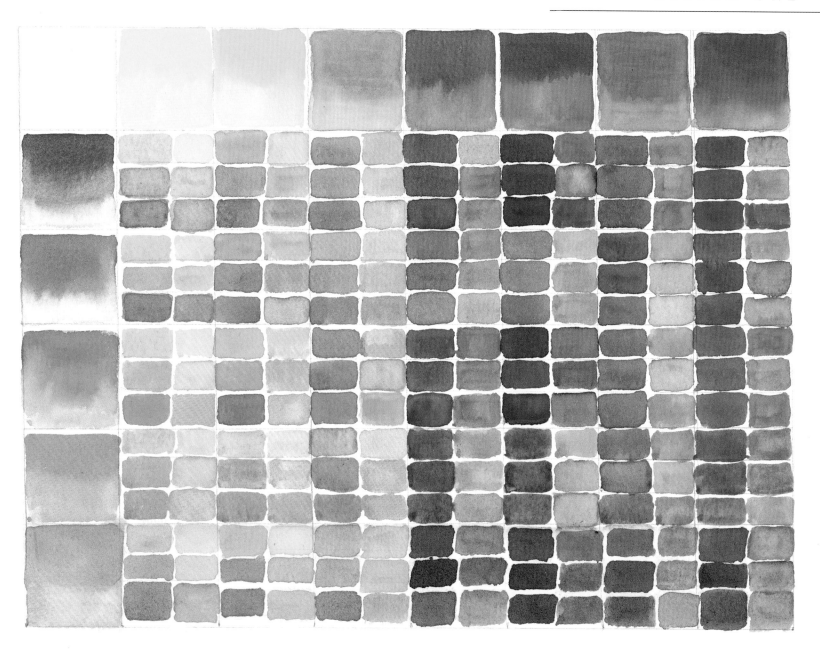

BUYING PIGMENTS

Colours which are marketed by different manufacturers under the same name will not necessarily appear exactly the same.

An added confusion for the new painter is the fact that manufacturers' colour charts contain many colours which look almost identical. Different pigments each have their own characteristics, which you will learn through experience. In the beginning, limit yourself to as few as possible, at most ten or twelve pigments, and become familiar with them before moving on.

The palettes accompanying the step-by-step illustrations indicate my preferences, but equally good alternatives are listed in the chart of colour characteristics opposite. It is not comprehensive, but includes the most widely used pigments.

Recommended Workbook Palette

I suggest that you start with the pigments in the two-colour mix chart on page 17 (or their equivalents, see chart opposite); two pure yellows (a cool and a warm yellow), two pure reds (cool and warm), two pure blues (cool and warm), a magenta, an impure yellow and an impure red. (The true blue and the two greens are optional extras).

LANDSCAPE PAINTER'S PALETTE

Winsor yellow
or aureolin
(true pure yellow)

raw sienna
(impure yellow)

alizarin crimson
(cool pure red)

burnt sienna
(impure red,
or, in layman's
terms, brown)

French ultramarine
(warm pure blue)

monestial or
Winsor blue,
green shade
(cold pure blue)

optional extra

viridian
(blue green)

FLOWER PAINTER'S PALETTE

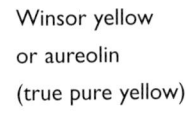
cadmium yellow
pale
or cadmium yellow

Winsor yellow deep
or cadmium orange

scarlet lake

permanent rose

quinacridone or
permanent magenta

permanent mauve
or purple

cobalt

cerulean blue or
manganese blue

Far left This palette is the one I most frequently use for landscape painting. Other teachers will offer different, though not necessarily conflicting, advice. Remember that choices are governed by the colours of the landscape where you paint, the medium used (oil, watercolour, and so on) and the painter's personal preferences. Most landscape palettes contain two pure blues (one warm and one cool), one pure yellow and one pure red, and some impures, such as siennas and umbers.

Most advice conforms to this general principle, although the actual colours included in the palette may vary. The pure blue-green viridian is very much an optional extra since it can be closely imitated by mixing aureolin or a similar yellow with a cold blue. I use it only when mixed either with red or with an earth colour to take away the garishness of the pure colour.

Left For flower painting, I would wish to add lots of pure colours to the palette. It is possible to mix appropriate equivalents to magentas and violets by combining crimson with ultramarine, but the results will be dull in comparison with the brilliance of those shown here.

CATEGORY	PIGMENT	S	T	O	G	A	E
Cool yellow	lemon yellow			•		•	
	Winsor lemon	•	•			•	
	lemon yellow hue						•
True yellow	Winsor yellow	•	•			•	
	aureolin	•	•			•	
	transparent yellow	•	•			•	
	cadmium yellow hue						•
Warm yellow	cadmium yellow	•		•		•	
	cadmium yellow pale	•		•	•	•	
Impure yellow	raw sienna			•	•	•	
	yellow ochre			•	•		
Warm red	cadmium red	•		•	•	•	•
	cadmium scarlet	•		•		•	
	Rowney vermilion			•		•	
	vermilion hue	•		•	•	•	
	Winsor & Newton scarlet lake	•	•			•	
	cadmium red pale						•
True red	cadmium red deep			•	•	•	
Cool red	alizarin crimson	•	•			•	•
	permanent rose	•	•			•	•
	permanent alizarin crimson	•	•			•	

CATEGORY	PIGMENT	S	T	O	G	A	E
Impure red	burnt sienna			•		•	•
	light red			•		•	•
Magenta	permanent magenta	•	•			•	
	quinacridone magenta	•				•	
Violet	purple						•
	mauve						•
	permanent mauve			•		•	•
Warm blue	French ultramarine			•		•	•
	ultramarine						•
True blue	cobalt blue			•		•	•
	cobalt blue hue						•
Cool blue	monestial blue (phthalo blue)	•	•			•	
	Winsor blue (green shade)	•	•			•	
	Prussian blue	•	•			•	•
	intense blue						•
Blue green	Viridian			•		•	•
	monestial green (phthalo)	•	•			•	
	Winsor green (blue shade)	•	•			•	
	viridian hue						•
Yellow green	permanent sap green	•	•			•	
	sap green			•		•	•

CHART OF COLOUR CHARACTERISTICS

Key

S STAINING
Colours resist lifting and washing off.

T TRANSPARENT
Most have this property.

O OPAQUE
Some have a small degree of opacity.

G GRANULATING
Pigment settles in the hollows of the paper, creating texture. Use distilled water to reduce the effect in hard-water areas.

A ARTISTS' QUALITY

E ECONOMY
(some colours are available in both qualities; technical details are given only for artists' quality).

PERMANENCY TO LIGHT (See manufacturer's ratings.) Avoid fugitive colours.

Brush Strokes, Colour and Water

The best way to become familiar with the wide range of effects that can be created with watercolour is to take a few sheets of paper and just have fun experimenting.

At this early stage it is easier to paint small subjects. It is also easier to paint imaginary shapes so that you do not have to worry about choosing, studying and reproducing a subject *and* controlling the paint.

The following pages show how easy it is to create imaginary birds and flowers with just a few strokes of your brush. The importance of this lesson, however, lies *not*

in the creation of recognisable images but in the discovery that watercolour paint as a medium possesses an inherent beauty which is to be valued for its own sake.

SETTING UP

Position your board or watercolour paper pad at an angle of about 45 degrees, either using an easel or by supporting it with a couple of books, or resting it between your lap and the edge of a table (see illustration below right). When you paint, any excess liquid will then collect at the bottom of each shape and can be lifted off by touching with a slightly damp brush. This bead of excess liquid, or 'reservoir', is essential to the learning process, since there is no other way of discovering how much water is too much.

In my experience, students who learn to work in this way soon become able to control the flow of the paint. You will quickly find yourself working with less liquid and with the board at any angle you choose. The option of working with only a little water from the outset may appear to be a

good way to keep things under control, but if you adopt this method you are unlikely to become a true watercolourist.

If you are right-handed, place all equipment to the right of your work (on the left if you are left-handed). You should have: at least one jar of clean water; a selection of brushes (see page 10); some kitchen roll or rag; pans of pigment, or pigment squeezed from tubes along the edge of your palette; 2 or 3 saucers for dissolving, diluting and mixing colour (unless your palette has appropriate pre-formed wells). Secure a sheet of watercolour paper to your drawing board with masking tape or clips.

HANDLING THE BRUSH

Hold the brush lightly, quite high up the handle, balanced rather than gripped like a pen, because you need to be able to move and twist it about by flexing fingers or wrist. Practise these movements with a dry brush first, then load it generously with a solution of pigment in water and paint some freehand shapes, working from the top of the paper to the bottom.

Opposite Some of my own freehand brush strokes and experiments with handling the brush. All the brush strokes are shown at actual size. You may find it helpful to refer to this when selecting brushes for the step-by-step paintings in the workbook.

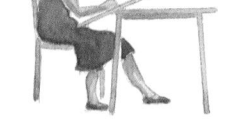

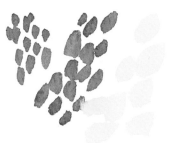

Strokes pulled upwards with Nos. 4, 8, 10, 12 rounds.

Blob of colour applied, and then pulled outwards with a rigger.

Various small marks made with Nos. 4, 8, 12 rounds.

The same brushes used to pull paint downwards.

As above using a No. 4 round.

Chunky marks made with a 13mm (½in) flat.

Nos. 5 and 10 dragged upwards with a twisting motion.

No. 10 round pressed down and lifted sharply to create pointed marks radiating out from a central point.

As above using a No. 4 round, the hairs fanned out by squeezing near the ferrule.

Long and short marks made with a No. 5 round.

No. 10 and a 13mm (½in) flat used almost dry with a light, swift upward movement.

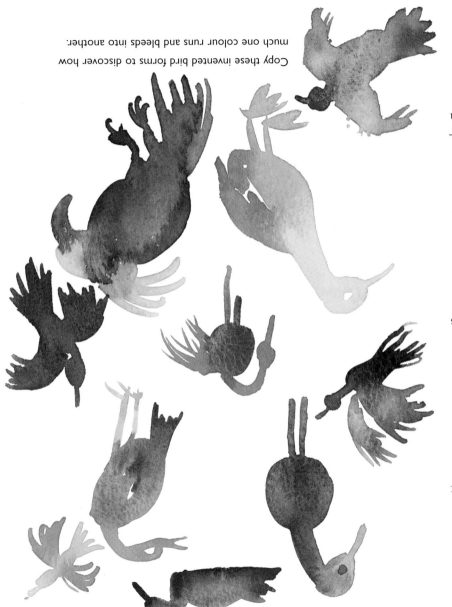

Copy these invented bird forms to discover how much one colour runs and bleeds into another.

DISCOVERING TECHNIQUES

Imaginary exotic birds are an ideal subject for trying out different colours together and, depending on the brush strokes you make, all sorts of weird and wonderful bird shapes can be created. Avoid using pencilled guidelines at this stage. Working without pencil drawing encourages expressive manipulation of the brush. Start by painting some bird shapes of your own, then try copying some of the examples to see if you can imitate the techniques used. Practise until you are familiar with them all, and experiment with techniques of your own.

Do not be tempted to paint an outline shape first and then fill it in – instead, aim to use an appropriately sized brush to pull the paint into whatever shape you choose.

WET-INTO-WET

A number of the birds shown here use the technique of painting wet-into-wet. To do this, paint a shape, such as the bird's body. Wash the brush in clean water and load a second colour. While the first application of paint is still wet, add the second colour adjacent to and touching the first colour, perhaps where the neck extends from the body. Alternatively, feed the second into the first while it is still wet.

PAPER DAMS

Of course, you may prefer the colours not to run together. To prevent bleeding, paint the second colour carefully close to the first, leaving a tiny gap, or paper dam, between the two colours.

BLEEDING, FEEDING AND LIFTING

Flowers, like birds, allow you to combine any colours and shapes and still come up with a pleasing impression. We will use flowers to explore some further techniques with colour and water.

An interesting effect is achieved by painting a shape on the paper using just clean water, then picking up almost neat pigment on the end of the brush and lightly touching the wet area of paper. The pigment immediately bleeds into the wet area, diffusing into the shape.

Another technique is to feed extra water into colour just painted. This forces the pigment to the edge of the wet area, creating a dark edge to the shape. The angle of the board will cause the excess water to collect at the bottom of the shape. This should be lifted off by touching with a damp brush.

1 Do not be tempted simply to paint an outline and then fill it in.

2 Always build up the shape stroke by stroke. Here the petals are painted first, in four strokes. Then the petals are drawn together in the middle to make the base of the flower.

3 These flowers are painted with two colours each. The second colour is applied while the first is still wet, therefore allowing the colours to blend or 'bleed' together.

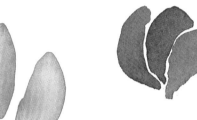

4 These two flowers were created by first painting the shape of the flower with clear water. Then nearly neat pigment was touched onto the shapes, with startling results.

5 Here, additional clean water has been dropped or fed into wet, coloured shapes. This creates a hard edge around the subject.

6 To prevent two colours from running togther, leave tiny gaps or 'paper dams' between them.

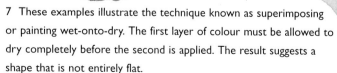
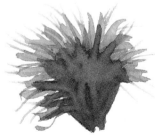

7 These examples illustrate the technique known as superimposing or painting wet-onto-dry. The first layer of colour must be allowed to dry completely before the second is applied. The result suggests a shape that is not entirely flat.

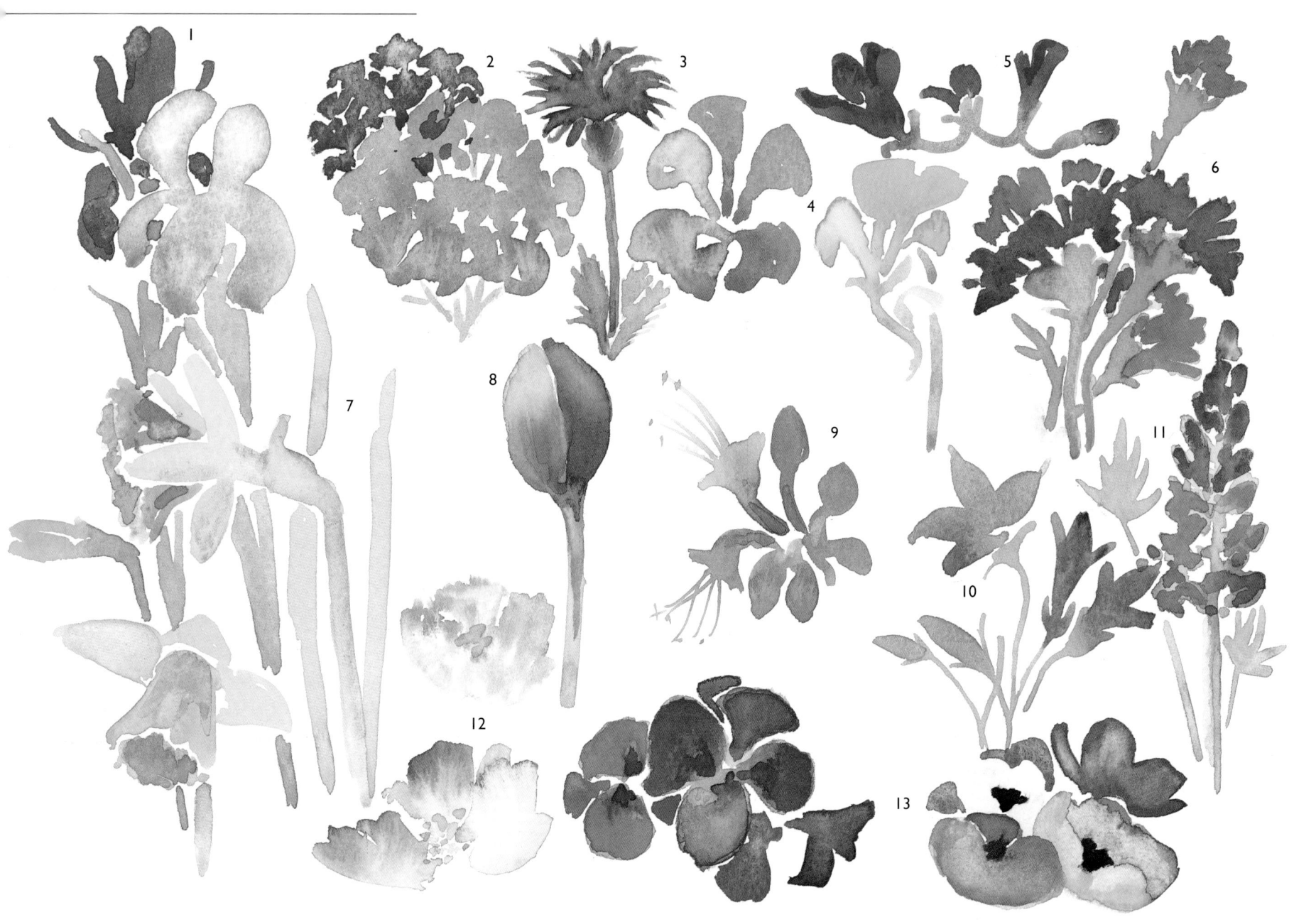

Opposite FLOWER STUDIES

The brush-stroke techniques that you have learnt on the previous pages can now be put into practice to create a range of more life-like flowers. Copy from these illustrations, referring to the notes in the caption if necessary. When you feel ready to work from observation remember to make separate pencil studies first, but continue to paint freehand without resorting to pencil or painted outlines.

1 IRIS Pale blue shape fed with extra water while still wet, forcing pigment to the edge of the petals. Collect excess water as it runs to the bottom of the shape.

2 HYDRANGEA Mixes of pink and blue allowed to blend at random. Paint the whole head with holes and ragged edge, rather than as individual petals.

3 SAWWORT Two colours dropped into a wet circle, then the paint pulled outwards using a No. 4 round brush. The wet shape is then fed with extra water to create a dark outline.

4 NASTURTIUM Painted with orange and red. Some petals fed with extra water to push pigment to the edge. Take up excess liquid as it runs to the bottom of the shape.

5 FREESIA Stems painted with a No. 5 brush in quick rhythmic movements.

6 PINKS Fringed edges created with rapid back-and-forth movement of brush.

7 DAFFODILS The two yellows of the petals kept separate by use of paper dams. Note natural effect of allowing petal and stem colours to run and blend.

8 TULIP Paper dam keeping pale and dark petals apart. When the petals were completely dry the white dam was stroked with a barely damp brush, allowing both colours to run slightly and so concealing the gap.

9 HONEYSUCKLE Stamens pulled out from still-wet flower shape using a rigger or very fine brush.

10 HAREBELL Blue petal shapes created by pressing down on the brush, then lifting off sharply.

11 LUPIN Original orange shape allowed to dry, then other colours superimposed.

12 POPPIES Shapes painted first with clear water, then strong colour touched in with a lightly loaded brush and allowed to run freely.

13 GROUPS OR BUNCHES Nearest flowers painted first, farthest flowers 'tucked' behind. Wait for each to dry or use paper dams.

Right FOLIAGE

The size of the brush you use is governed by the size at which you like to work, and the nature of the subject. Remember to try different brush sizes. These studies were made with a No. 4, a No. 10 and a rigger.

1 No. 4 pulled upwards.

2 No. 10; some colour was lifted off with a damp brush while the shape was still wet.

3 No. 4 and a rigger.

4 No. 4.

5 Nos. 10 and 4.

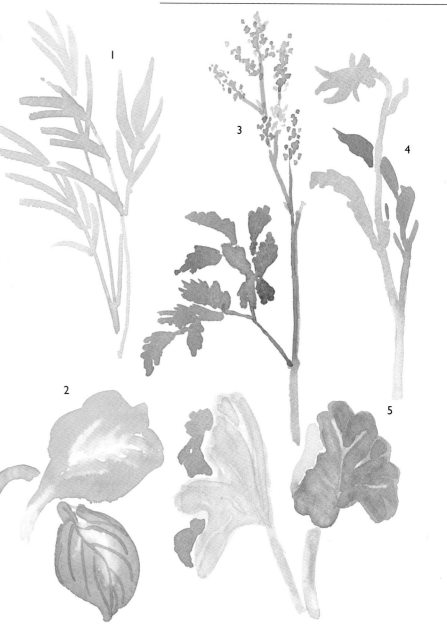

A SIMPLE FLOWER PAINTING

Now that you are familiar with using your paint and brushes and creating flowers, it is time to paint your first composition. Copy the step-by-step example here first, before painting your own vase of flowers. Note that no work has been done in pencil – the subject is painted freehand straight onto the paper.

Set up your work space (for suggestions on how best to arrange this see page 22). The size of the paper should be between 25 x 20cm (10 x 8in) and quarter-imperial, 37.5 x 27.5cm (15 x 11in), used in a vertical or portrait format (the composition is taller than it is wide). You will need two brushes (Nos. 4 or 5, and 7 or 8). The palette illustrated here (and for all step-by-step paintings) shows the pigments that I used (I limited it to five colours: a warm and a cool red, a magenta, a true blue and a cool yellow). Use these or their equivalents, and refer to your two-colour mix chart (see page 19) for the colour mixes available to you.

The composition follows flower arranging principles and was contrived on the paper, using one flower as a model, rather than painted from observation of an actual vase of flowers. It is easier to see individual shapes in this way.

Palette

SCARLET LAKE

ALIZARIN CRIMSON

QUINACRIDONE MAGENTA

COBALT BLUE

WINSOR LEMON

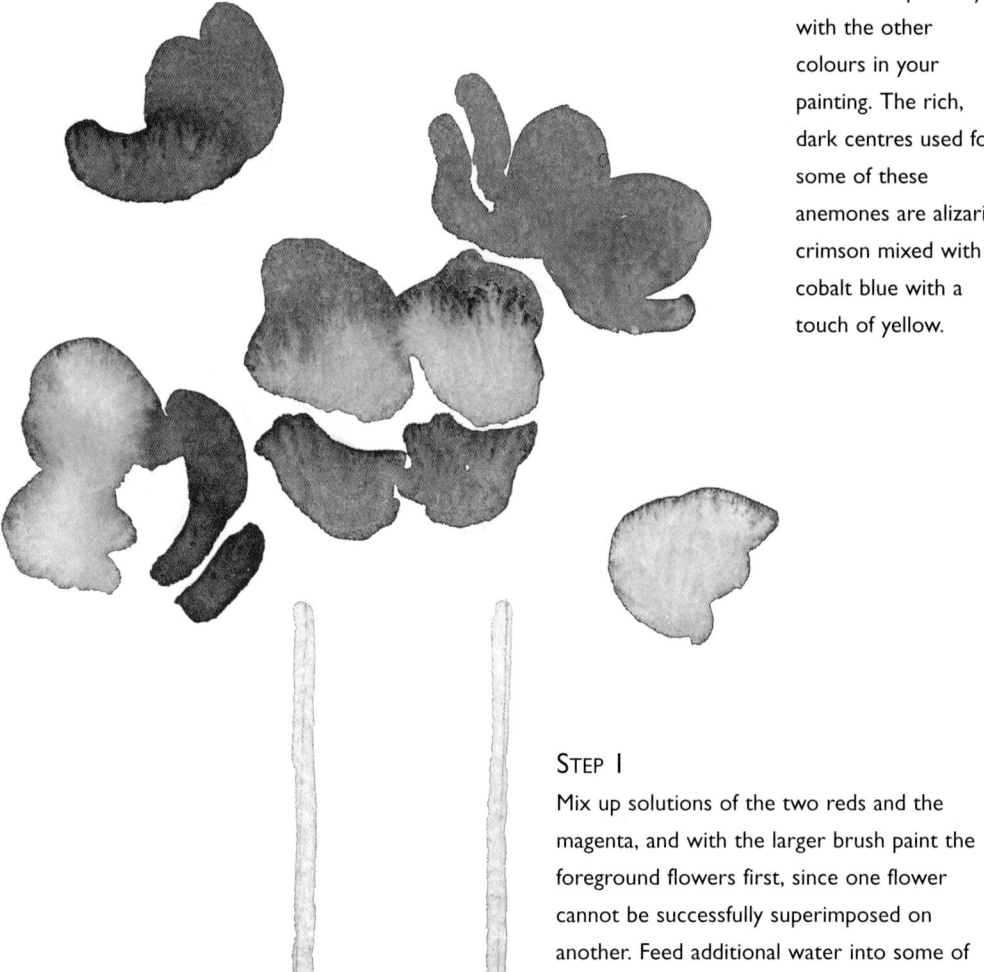

Tip

If you mix your own blacks, you can ensure compatibility with the other colours in your painting. The rich, dark centres used for some of these anemones are alizarin crimson mixed with cobalt blue with a touch of yellow.

STEP 1

Mix up solutions of the two reds and the magenta, and with the larger brush paint the foreground flowers first, since one flower cannot be successfully superimposed on another. Feed additional water into some of the shapes to soften the effect. Use the smaller brush to indicate the vase in a weak wash of cobalt blue.

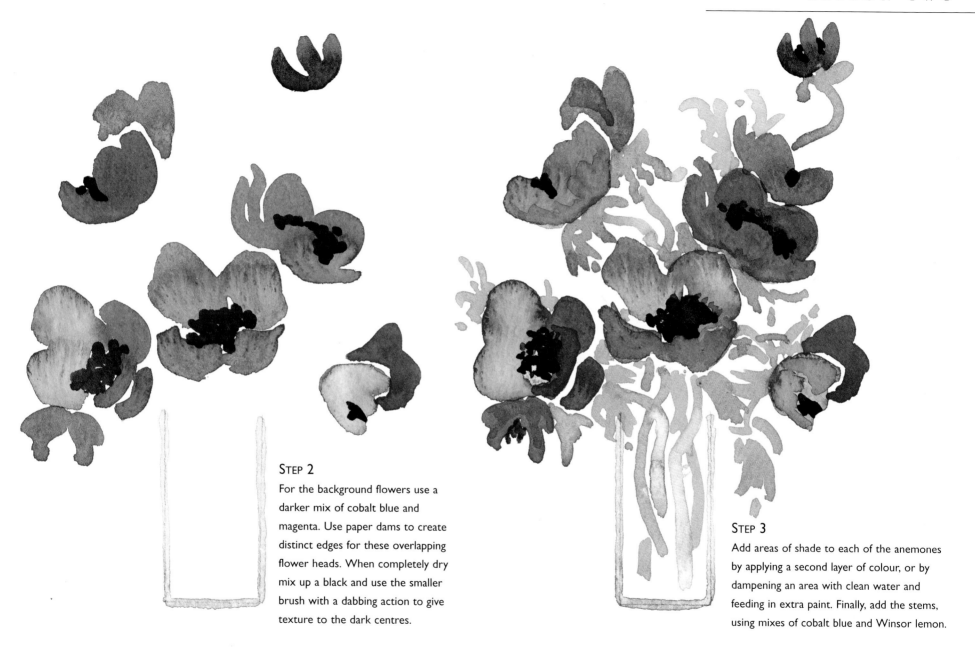

STEP 2

For the background flowers use a darker mix of cobalt blue and magenta. Use paper dams to create distinct edges for these overlapping flower heads. When completely dry mix up a black and use the smaller brush with a dabbing action to give texture to the dark centres.

STEP 3

Add areas of shade to each of the anemones by applying a second layer of colour, or by dampening an area with clean water and feeding in extra paint. Finally, add the stems, using mixes of cobalt blue and Winsor lemon.

CONTAINER COMPOSITION

This painting gives you the opportunity to develop your flower painting skills using a slightly more complex composition, in a horizontal, or 'landscape', format. It also incorporates preliminary drawing in your painting, which should be kept minimal at this stage.

The composition was brought together on the paper, working from individual containers of summer flowers to create a pleasingly asymmetrical arrangement, linked by the trailing ivy.

When painting, aim to work intuitively, at first placing colours at random but gradually building patterns and rhythms of colour to lead the eye around and across the composition – rather like threads of colour in a tapestry which repeatedly surface and disappear and reappear else-where. It does not matter which colours are painted first, but it does make sense to paint the larger and nearer flowers first.

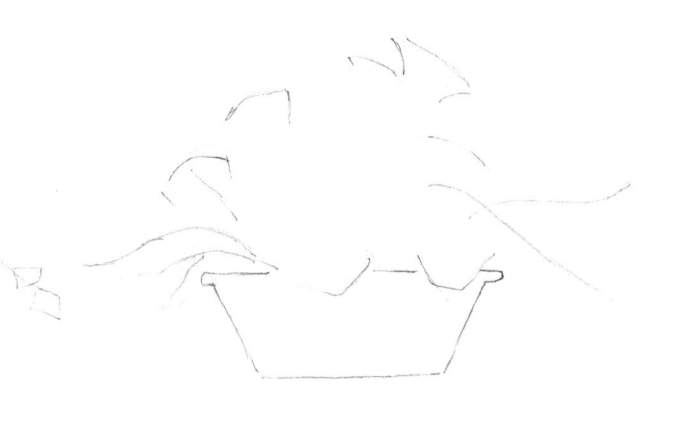

STEP 1

Using an HB pencil, draw lightly onto the watercolour paper, indicating the overall structure and outline of the composition – just a few lines for the containers, one or two of the larger shapes and the foliage direction.

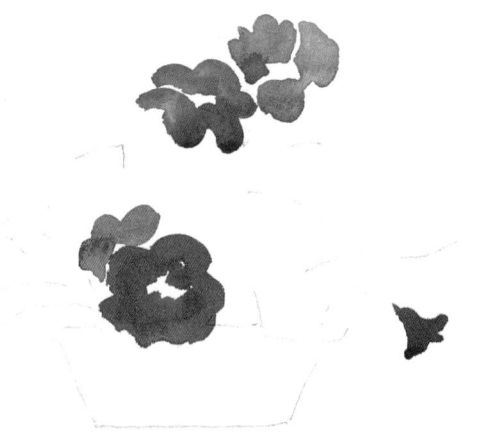

STEP 2

Paint the largest and nearest flowers first, composing the colour scheme as you go and working across the composition, rather than attempting to complete any one area before starting another.

Palette

RAW SIENNA

AUREOLIN

SCARLET LAKE

PERMANENT ROSE

PERMANENT MAGENTA

COBALT BLUE

VIRIDIAN

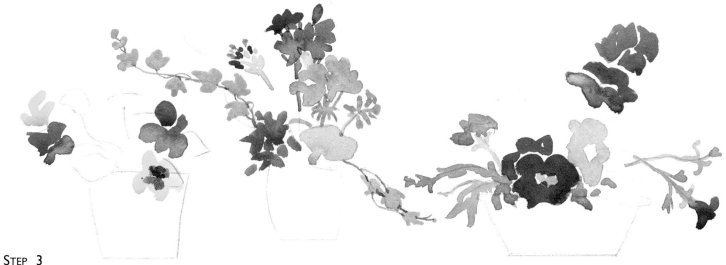

STEP 3

Refer to your colour chart to help you mix a variety of greens for the foliage. The tendrils of foliage help to link together the three containers, leading the eye across the work and around the elongated picture format.

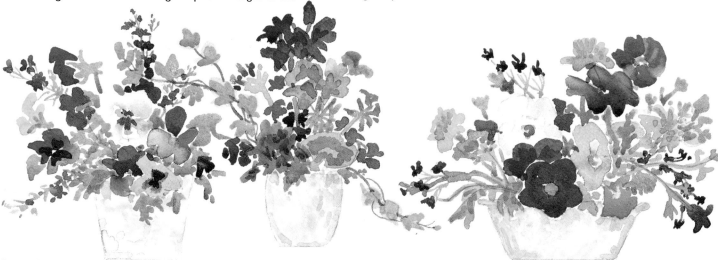

STEP 4

Once you have completed the larger flowers and their foliage, use a smaller brush, or even a rigger, for the fine details. Keep the containers deliberately pale so as not to detract from the vivid colours of the flowers. Paint the container shapes first with water and then touch in tints of violet, pink and green.

OBSERVATION AND INTERPRETATION

Most beginners find it easier to paint from their imagination, building up the composition on the paper as they go, rather than to arrange flowers in a vase and then paint what they see. Observation from life, however, is paramount, and, as you become more familiar with your subject, you will begin to develop your own individual approach.

The final two flower studies in this chapter – the amaryllis on this page and the pelargoniums opposite – illustrate two different methods of working. The picture of the amaryllis is an attempt to portray the subject *expressively*, to capture the plant's strong and flamboyant spirit rather than conveying a general impression. The tone of the picture is both sturdy and spirited. It is my honest attempt to capture the quintessential personality of the subject. I have tried to paint the pelargoniums *impressionistically*, first examining them with care and making several preliminary studies in both pencil and watercolour to ensure a faithful, albeit free, rendition of the subject.

When working in either of these ways, it pays to make preliminary 'detail' studies of small sections of your subject. This encourages you to consider every part of the subject individually rather than simply taking an overview. A maxim popular among artists is 'What I have not drawn, I have not truly seen', and only by studying your subject closely in this way can you hope to see it truly and reproduce it with veracity. Neither impressionism nor expressionism should be taken as similes for carelessness. To be successful, both depend on accurate observation.

AMARYLLIS

These flowers were painted from life, but not as a pre-arranged group. First, the nearest flower was lightly sketched with an HB pencil onto a large sheet of paper, then painted with a large brush using strong and dilute mixes of permanent rose and magenta. Yellows and greens were added wet-into-wet. Paper dams were used to give definition to the paler central petals. Slightly paler, less vivid mixes were used for the background flowers. The dark accents (burnt sienna and a touch of blue) give definition and the sturdy stems enhance the feeling of robust growth. Standing to paint this subject at an easel encouraged a boldness of approach.

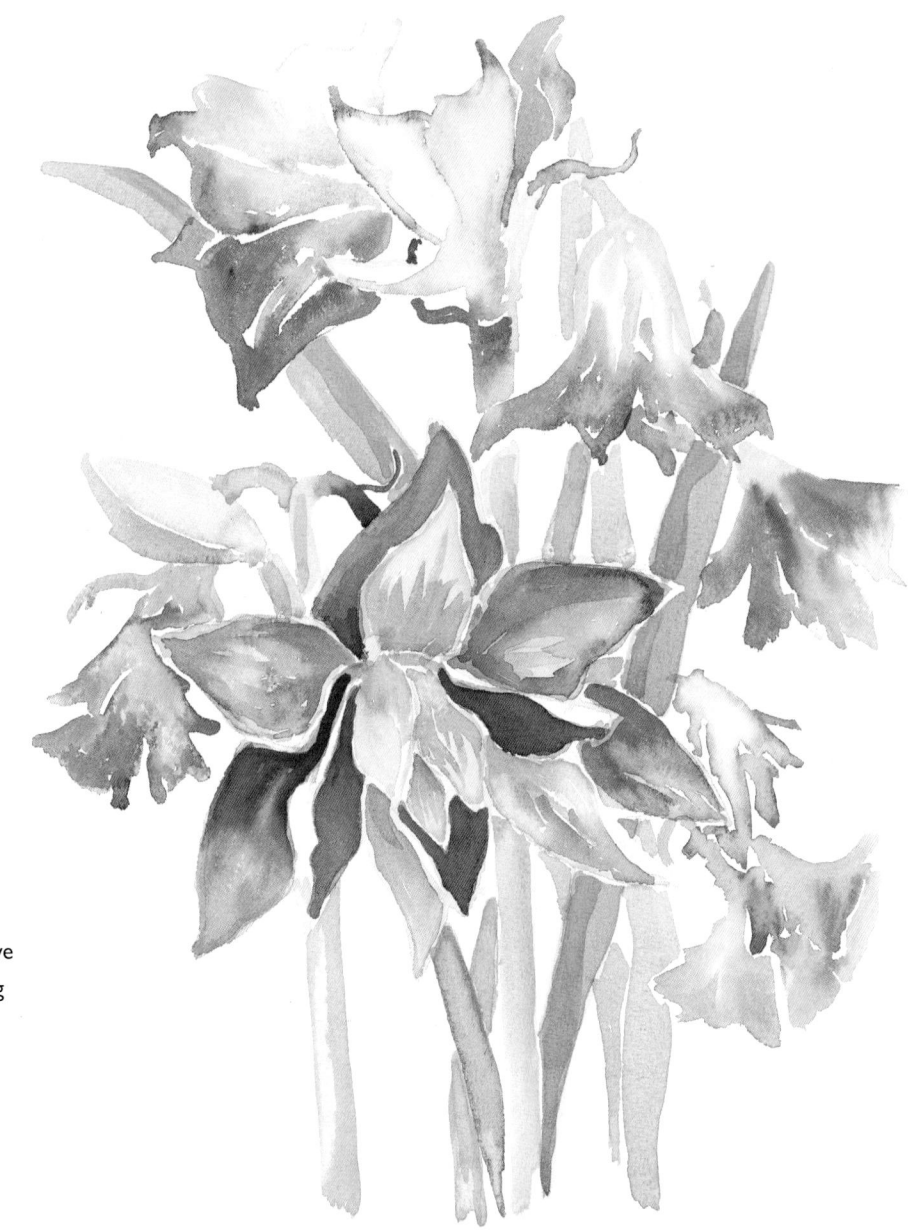

PELARGONIUMS

Preliminary studies enabled me to paint confidently and with veracity. In places the numerous petals appear to merge into a solid mass with ragged edges and occasional small gaps. This observable fact gives the key to painting pelargoniums (and similar multi-petalled flower heads such as hydrangeas). In the same way, colour variation and dead or curled edges help to add veracity to foliage. It may be tempting to use a single red for flower heads like these. However, by using a range of similar colours (orange, red, pink, crimson) I have been able to convey colour intensity while at the same time recording areas of light and shade.

Tip

Gracefully curving stems cannot be rendered with a slow, hesitant hand, but demand a swift, bold stroke with an appropriately sized brush – a gestural brush mark, which requires a certain amount of practice.

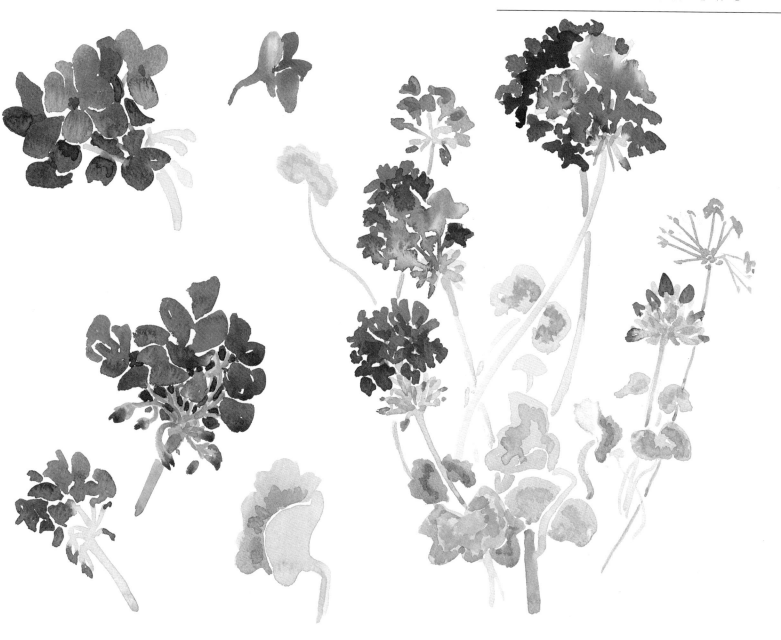

Creating Form

If you have been following the advice given in the Introduction, taking things slowly and repeating the exercises over and over before moving on, you should by now have amassed a large portfolio of flowers, foliage and other subjects. Some will no doubt please you, while others you will consider rather disappointing efforts. If I were able to look at them with you, we might well differ on which are good and which are not. I would remind you to judge them first and foremost in terms of the beauty of the paint. It is important to be clear in your mind that the beauty of the paint is the first priority at this stage.

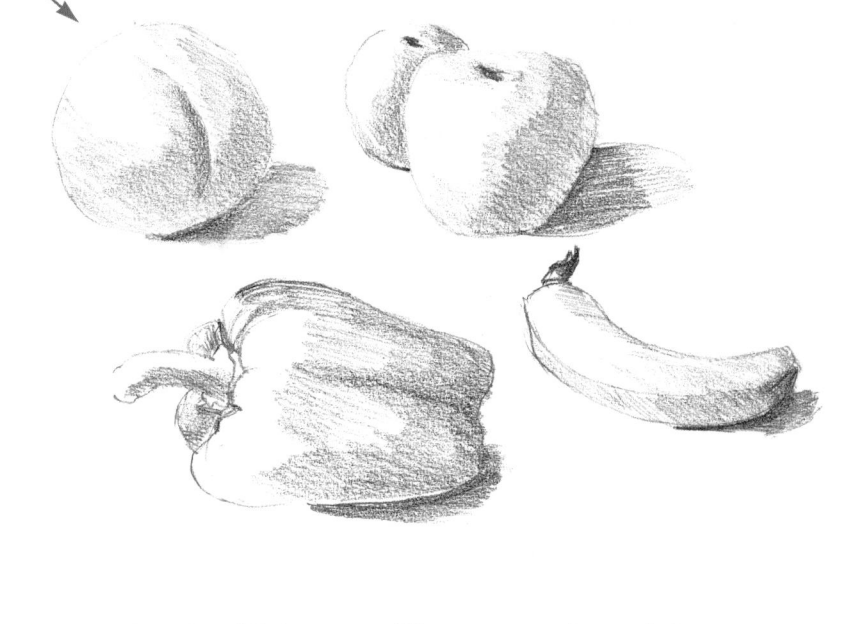

direction of light

Aims

■ To experiment with two ways of creating form in paint:
1 by using the colour wheel method
2 by lifting off highlights, and superimposing shadows as a second layer of paint on top of a dry colour
■ To gain more experience of painting wet-into-wet shapes
■ To practise the use of paper dams

A convincing representation must, for the moment, take second place. This may seem strange advice, but I can promise you that both beauty and accuracy will be achieved in time via observational drawing and constant practice.

The teaching so far has been concerned with helping you to create beauty in paint for its own sake – the mastery of brushes, pigment and water – and your work should reflect this above all else. If you have also managed to paint something recognisable, then well done. If you haven't, don't worry.

However, acceptable representation must, of course, be learned if you are to become a successful watercolourist. In this lesson you will take the first step along that path by learning how to create the illusion of a three-dimensional image on a flat sheet of paper – the creation of form.

TONAL DRAWING STUDIES

Before beginning the painting exercises in this lesson, I would like you to make some observational drawings of a very specific nature. Arrange some fruit near a window or other directional light source. Then, working with cartridge paper and pencil, draw their outline shapes and make diagonal hatching lines to show the light and shade. Give no thought to producing beautiful drawings but concentrate on seeing and recording the tonal values of your subject – the varying shades of light and dark – created both by the way in which light falls on the fruit and by the form of the fruit itself. It is easier to see tones if you look at the objects through half-closed eyes. This exercise will help you to become familiar with tone and form without the worry of controlling colour and paint.

Arrange fruit near a window or other strong directional light. Draw outlines with an HB pencil. Add diagonal hatching using a softer pencil (4B or 6B) to differentiate between areas catching the light and those in shadow. Record the shadows cast onto the table as well as on the fruit itself, since this will add to the illusion of solidity.

CREATING LIGHT AND SHADE

We are now going to explore the creating of form with watercolour in two very different ways.

The first method employs colour wheel theory and makes use of the wet-into-wet technique practised earlier.

The second employs two different techniques – lifting and superimposing. Here we will practise lightening the tone of an area by lifting off colour while the paint is still wet, and darkening an area by the superimposition of a second colour over the first after it is dry.

As you will note from the illustrations on the next pages, the colour wheel method of creating light and shade produces the more vivid results.

Both methods have equal merit, but you may feel that the first is more appropriate for subjects where colour brilliance and colour purity are important, for example in painting fruit and flowers. Painters who have a passion for vivid colour might use the colour wheel method exclusively.

Whatever your personal preference for creating light and shade, though, you must at this early stage practise both methods with equal diligence in order to gain mastery of the all the different techniques which are involved.

AVOIDING BLACK AND WHITE

Watercolour purists make colours lighter by adding more water, without resorting to white pigment. Some artists use white with watercolours to lovely effect, and white can be used for highlights. However, these effects have been omitted here for the sake of simplicity. It might be supposed that colours are darkened by adding black pigment, but this can have an unpleasant, dirtying effect, especially inappropriate for flowers and other brightly coloured objects. Although black can provide a short-cut to colour mixing, students should not use it as the sole means of darkening colours.

COLOUR WHEEL METHOD

The colour wheel is a convenient way to arrange the colours of the spectrum. The wheel illustrated here is positioned in such a way that the lightest-toned pigments and mixes are near the top, with the colours becoming progressively darker in tone near the bottom. Following the simple maxim, 'up the wheel to lighten, down the wheel to darken', we can select colours from the wheel in order to create objects in light and shade without any loss of colour purity. Before putting this into practice, however, you must first make your own colour wheel in order to get to know it.

THE COLOUR WHEEL
Using full-strength mixtures of the cool and warm pure colours (the primaries) from your palette, paint circles or patches of colour as arranged here, with cool yellow at the 12 o'clock position. With the basic 6 colours in place it can be seen that the warm yellow and the warm red have an affinity to orange and when mixed together will make a range of bright pure oranges. Paint one with yellow predominating at 2 o'clock, and the other with red predominating at 3 o'clock. Follow the same principle for the violets and greens (ie, cool red and warm blue for both violets, cool blue and cool yellow for both greens). If you inadvertently mix bright red and cool blue for a violet, you will achieve only a range of greys (albeit very attractive ones) and will have discovered why we need two of each primary colour to produce bright, pure secondaries.

The colour wheel method was used to paint the orange at the top of the next page. Refer to the pencil studies you made earlier to see where the tones should be lightest and darkest. This simple example uses just three shades: the natural colour of the fruit; a lighter, more yellow tone; and a darker tone with a red bias. These are mixed with two pigments (a warm red and a warm yellow) by varying the mix and the dilution. You will find it easier to make up all three mixes before you begin rather than trying to darken your lightest mix by stages. Begin with the lightest area, since it is easiest to work from top to bottom of the subject, using a warm yellow mix.

Then, using a separate orange mix containing a little less water, paint the central area in the same way, working wet-into-wet where the two colours meet to create a gradual change of tone.

Finally, using a third mix with even less water, this time with a red bias, complete the lower section of the fruit.

It takes time to learn to control the paint so that the colours can be made to blend together wet-into-wet while maintaining their separate identities. Work freehand and fairly large and load the brush more lightly than for some of your flower experiments. This will make it easier to control the extent to which colours run together. There will be less 'reservoir' to lift off when the shape is complete, and one touch of a barely damp brush should be sufficient to absorb it.

LIFTING AND SUPERIMPOSING

The second method achieves a similar end by a very different route: try painting the orange as shown in the lower half of the illustration on page 37.

First, paint the whole shape a flat, uniform orange and, while it is still wet, use an almost-dry brush to lift off some of the paint to create a highlight near the top of the fruit. Paint from the surrounding area may run back into the lifted-off area. The less water that is used in the paint, the less paint will run back. Also, the drier the brush is, and the more firmly you press, the less paint will run back. The final stage is to superimpose an area of shadow using a darker colour. Wait until the orange area is completely dry, then superimpose the shadow with a stroke of blue. To avoid an unnatural hard edge to the shaded area, stroke the paint gently along its upper edge with a clean, damp brush (practise first).

The final stage can be done by a different method: after the paint has dried, re-wet the whole area and feed in one stroke of the blue. This must be done with a lightly loaded brush if the blue is not to bleed and run over the entire shape.

It is quite safe to give a painted area a second, third or even fourth coat of paint provided the underlayer is completely dry.

PRACTISING TECHNIQUES

Now try painting other fruit using the techniques you have learnt, for instance a green apple with mixes of yellow-green, true-green, and blue-green. Use any blue with any yellow and make your three mixtures by simply varying the proportion of blue to yellow (refer to your colour chart). Tomatoes look especially realistic in mixes of orange, red and crimson or, for a very dark shadow, red-violet. Many fruits and vegetables make excellent subjects for this type of study (see pages 38–9).

You may find it beneficial to apply these new techniques to the bird and flower images you made earlier. Keep practising with simple shapes until you are confident of your ability and ready to tackle something a little more testing, such as the still-life arrangement on pages 40–1.

Tip

To test for dryness, touch the painted area with the back of your index finger. Then apply the same test to a piece of unpainted paper. The back of your finger is highly sensitive to temperature and you will be able to make a comparison. If the painted area is not completely dry, it will feel cooler than the unpainted paper. It is possible to use a hairdryer to hasten drying times, but bear in mind that this makes the paper artificially warm and it must be allowed to cool before testing.

COLOUR WHEEL METHOD
Step 1
With the brush lightly loaded, apply a warm yellow, well-diluted mix to the top of the shape.

Step 2
Without rinsing the brush, pick up some slightly less dilute orange mix and continue to bring the shape down the paper, wet-into-wet.

Step 3
Complete the fruit with a stroke of stronger mixture with a red bias. Take up any excess paint, or 'reservoir', with a barely damp brush.

LIFTING AND SUPERIMPOSING
Step 1
Use a warm yellow and a warm red to make an orange mix and paint a circular shape of uniform colour.

Step 2
While it is still wet, use a barely damp brush to lift off some of the paint where the most light is falling. This can be controlled by the pressure on the brush, and by the dryness of the brush. The drier the brush, the more moisture it will soak up from the paper.

Step 3
When the shape is completely dry, add a stroke of warm blue for the shadow area. Avoid a hard edge to the shadow by stroking the upper edge with a clean, damp brush. Alternatively, re-wet the whole shape and feed in a lightly loaded brush stroke of warm blue.

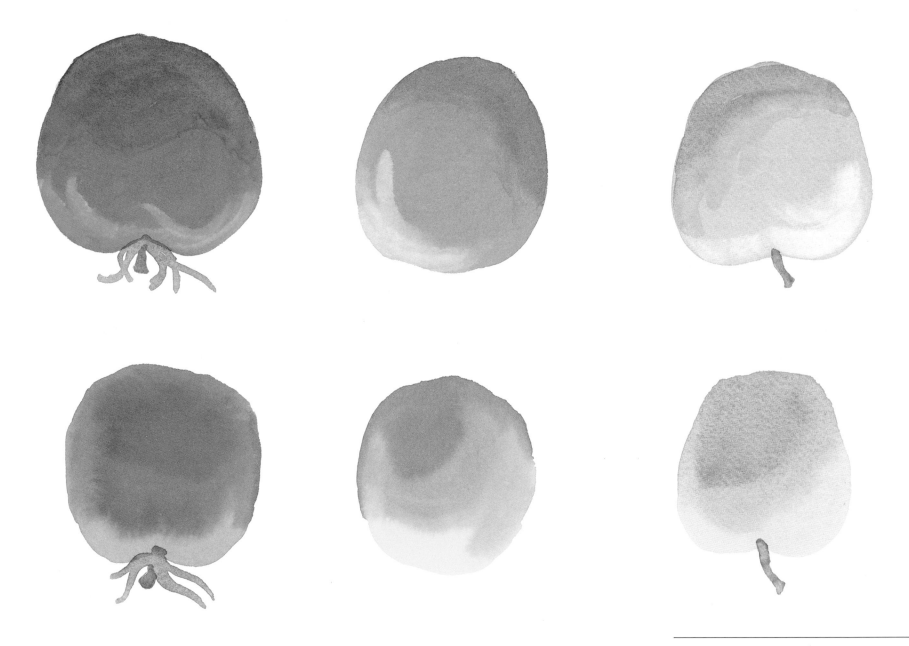

COMBINING THE TWO METHODS

The techniques learned in this lesson can be combined. First, create the shapes using the colour wheel method. Then, when the paint is quite dry, superimpose a little blue in the shadow areas by one of the methods described in Step 3 on page 37. As before, help the top edge of the blue strokes to bleed softly away by coaxing with a damp brush. In practice, experienced painters will often feed a touch of blue into a shadow area before the first colour dries, but this technique is difficult to control and should perhaps be left until you feel more confidence in your ability. Although I have set out two distinct ways of creating form using watercolour techniques, as your experience grows you will use either or both methods and your own variations. Painting is creative and not a matter of strict adherence to formulae.

A useful exercise now is to analyse the examples on this page, to identify the methods used, and then to copy them.

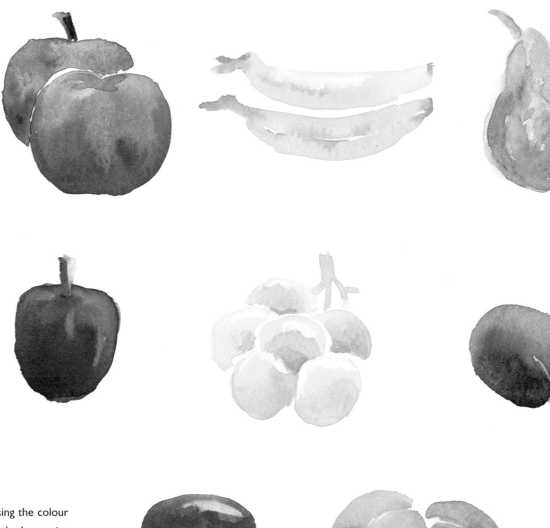

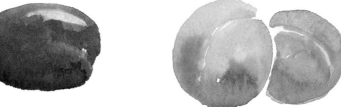

Opposite top row Fruit painted in three colour mixes using the colour wheel method. For the apple, Winsor yellow and French ultramarine were used in mixes of yellow, yellow-green and blue-green. For the orange, Winsor yellow and scarlet lake were used. Winsor yellow with scarlet lake and alizarin crimson were used for the tomato. *Bottom row* The same fruit painted by lifting and superimposing.

A selection of assorted fruits, the illusion of form being created by a variety of methods.

DRAWING FOR PAINTING

So far, with one exception, I have avoided the use of pencil line drawing as a basis for watercolour painting, preferring to concentrate on brushwork, controlling the load and flow of mixes, and pulling the paint into shapes rather than filling in outlines.

However, pencil lines and marks can be a beautiful component of watercolours, as well as an aid to composition, and will be of benefit in this exercise.

For now I would suggest that you use an HB pencil, but if, as you progress, you find that you like the effect of pencil lines in the finished work, you might prefer to use a slightly softer B, or even a very soft 2B pencil.

Over time you will come to depend less on my directions and suggestions, and will use more of your own initiative, but I would offer two warnings about pencil work which are worth bearing in mind.

First, an excess of graphite on the paper can be loosened by the subsequent washes of colour, which will then appear less pure and bright.

Second, you should try to erase as little as possible and use a really soft putty rubber, because rubbing can roughen the surface of the paper and result in an uneven application of paint.

A SIMPLE STILL LIFE

First, copy this still life of vegetables, and then compose your own to paint from. Arrange some fruit or vegetables on a plain white cloth with a few folds in it, on a surface with good directional light. (If you do not have a suitably positioned window, a table lamp will serve just as well.) Have some shapes overlapping and some separate, some near to you and others further back. Begin with a light pencil drawing using an HB pencil. Remember to keep correction to a minimum and to use only a soft putty rubber. Draw the shapes at least life-size to allow room for wet-into-wet working and gradated shadows.

Apply paint to one fruit at a time, working wet-into-wet where necessary. Wait for some fruits to dry before painting the adjacent ones, while with others you can practise leaving tiny paper dams between the painted areas. As in the earlier lessons, you will find that even the narrowest of

SCARLET LAKE

ALIZARIN CRIMSON

AUREOLIN

COBALT

STEP 1
Start by arranging some fruit or vegetables on a loosely folded cloth and make a light HB pencil drawing of the outline shapes, working at least life-size.

40

white gaps is sufficient to prevent one colour bleeding into another. This device has the bonus of adding sparkle and light to the work, but take care not to overdo it for it can be intrusive in excess. (When the paint on either side of them is completely dry, paper dams can be rendered less obtrusive with repeated strokes of a slightly damp brush.) At all costs, avoid allowing painted areas to overlap, since this will result in unnatural dark outlines.

It will not be easy to identify any particular colour in the folds and creases of the white cloth, but patient study may reward you with hints of blues and violets, and maybe some colours reflected onto the cloth from the fruit. You will find some appropriate tints in the right-hand side of the columns in your colour chart.

Until all the main elements of the painting have been committed to paper, the relative strengths of the different mixes can be difficult to judge. However do not allow your concentration on painting a single object make you overlook the need for the whole work to look cohesive. Mixes that are too dark will create a 'black hole' effect, while those that are too pale will merge and disappear into the background. Remember, it is easy to give weak areas a second coat once the first has dried.

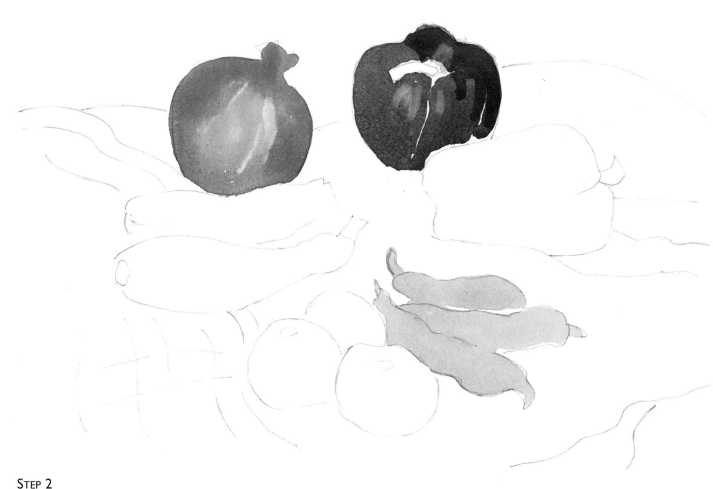

Step 2

Use a large round brush (No. 8 if you are working at life-size; No. 10 if working larger than life-size). Paint one vegetable at a time, giving each the opportunity to dry before painting adjacent vegetables (alternatively, leave tiny paper dams). Paint the onion using wet-into-wet techniques, and use the lifting and superimposing approach to create tone on the red pepper.

Step 3

With the main shapes
in place and dry,
develop the form of the
objects, superimposing
extra layers where this
may be necessary.
Without the shadows
cast onto the cloth, the
vegetables would
appear to float in space.
Pay careful attention to
their colour, shape and
tonal intensity.

A good long stare
should reward you with
some hints of blues and
violets in the shadow
areas and colours
reflected onto the cloth
from the fruit.

The hot orange-reds
in the tomatoes help
the shapes to 'advance'
towards the viewer,
while the cooler
red of the pepper
allows it to drop back
in the picture.

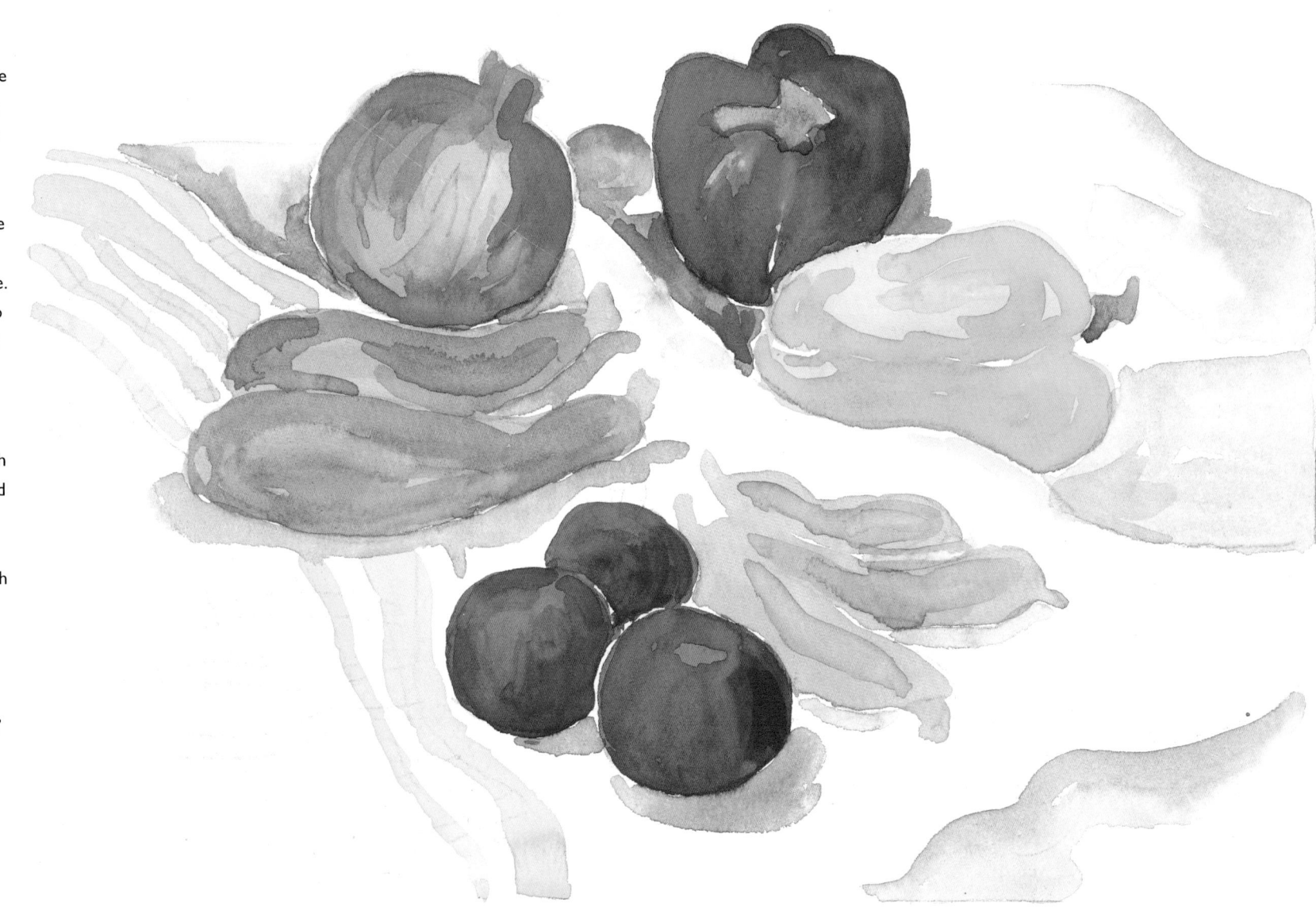

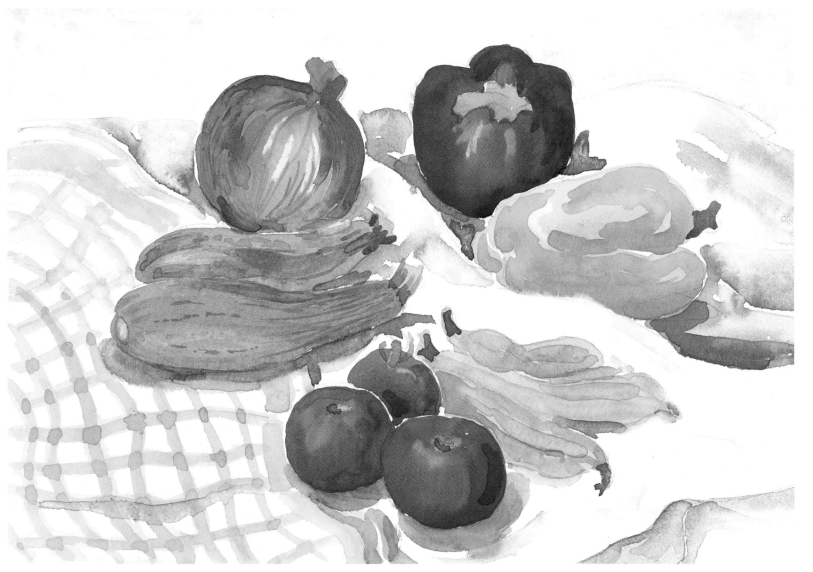

STEP 4

In the early stages of painting the still life you will make constant reference to the actual objects and be concerned with how to record it; what colour, shapes, brush marks? As the work takes shape, however, a new imperative takes over; how does the picture look, is it pleasing, in what ways does it fail, what does it need? The answers to these questions are often found by returning to close observation of the subject. The addition of well-observed details, texture, the dark accents of stalks and deep shadows are final touches that will lend conviction to the painting.

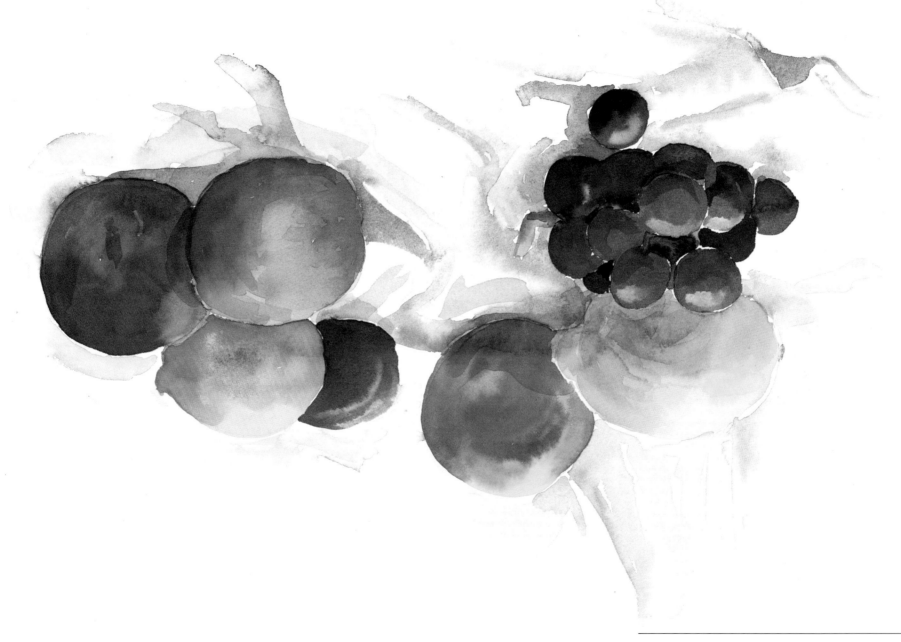

FRUIT, POPPIES AND PAINTED PLATES

The forms in this painting are created using both the colour wheel method and the lifting and superimposing method. The fruit painted on the plates is deliberately rendered in a rather flat, stylised way. The tones of the flowers suggest a cup-like form, but also in a stylised, rather than a naturalistic way. In contrast, the fruit has bold convincing form, rendered by the use of strong colour, light and shade, and cast shadows.

I started at the top of the painting with objects furthest away, gradually working down to the bottom of the paper. In this way I was able to increase the strength of the mixes and the brilliance of the colour, gradually creating a sense of space (compare the foreground cherries to those on the smaller painted plate).

Opposite FRUIT SALAD

The colour wheel method has been used in this still life to create the illusion of form without any loss of colour brilliance (which would have occurred if black had been introduced). This degree of colour brilliance, or saturation, demonstrates that watercolour, while often appreciated for its soft and delicate effects, can produce powerful images without in any way compromising the beauty and transparency of the medium.

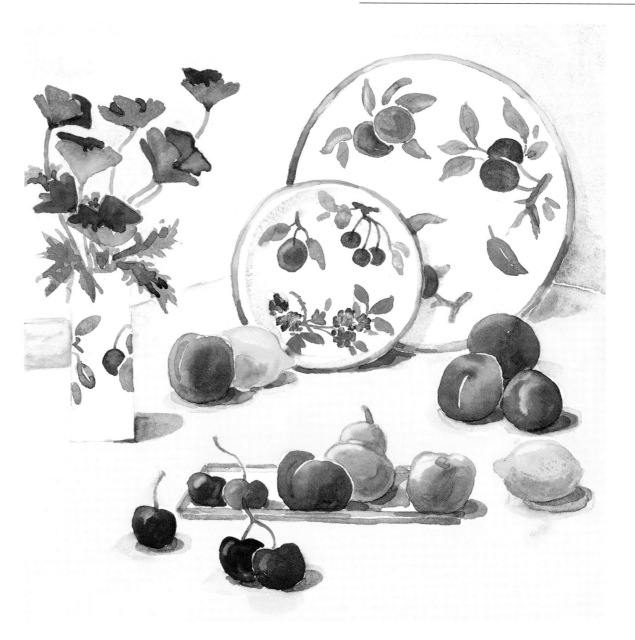

45

LESSON FOUR
Trees and Texture

There are a number of formal elements intrinsic in all artistic work – the 'nuts and bolts' – which have to be learned thoroughly if you are to succeed. Once mastered, these elements can be manipulated to create your own unique way of working.

The illustrative subjects I have chosen for this chapter are all trees, but this is not simply a lesson on tree painting. I have chosen to show trees because, as subjects, they incorporate all the formal elements contained in the previous lessons: variety of colour in their foliage; line in their branches; shape in their silhouettes; and tone where light falls on their forms. Add to this the varying textures of different species and we have the perfect subject with which to consolidate our learning.

Aims

- To consolidate everything learnt so far
- To find ways to create foliage texture; dry-brush and sponge
- To learn to create 'negative shapes'
- To work on dampened paper
- To paint shapes with ragged edges

PAINTING TREES

Before you consider the techniques of rendering texture, you will find it easier to begin by painting some imagined or remembered tree shapes, as with the flowers and birds of Lesson Two, and then move on to copying my (or any other) watercolour examples. You should then feel able to work from photographs. Black and white photographs are to be preferred. Not only are you then free to use whichever colours you choose, but colour photographs are usually much stronger in both colour and tone than would look right in a watercolour painting. When working from colour photographs, it is all too easy to fall into the trap of using too much pigment and not enough water, with heavy, unpleasing results.

The next step is to paint some real trees, working initially from your own observational drawings and then out of doors in a garden or park.

The predominant colour used in tree painting is, generally, green, but within that greenness lies a panoply of subtle changes

Mixing Greens

The two-colour mixes shown below will yield a wide range of greens depending on the proportion of yellow to blue used in the mix and the amount of water added. Any green can be made less vivid by adding a touch of red to the mix. On the colour wheel on page 35 you will see that red and green are opposite each other. Two colours that oppose each other in this manner are known as a *complementary pair*. It is possible to tone down any vivid colour in this way by the addition of its complementary (eg, a touch of blue in an orange mix will make a caramel orange, while still more blue will turn it brown, and so on).

Vivid greens
cool yellow and cool blue
eg Winsor lemon and Winsor blue

Less vivid greens
true yellow and warm blue
eg aureolin yellow and French ultramarine

Earthy greens
warm yellow and warm blue
eg Winsor yellow deep and French ultramarine

Rich, slightly less earthy greens
warm yellow and cool blue
eg Winsor yellow deep and Winsor blue

To tone down green
To make any green less vivid, add a touch of red (its complementary colour)

in tone, temperature and purity sufficient to tax the abilities of any watercolourist. The chart opposite shows a variety of colour mixes which will form the basis of your tree-painting, ranging from the vivid tones of springtime foliage to the more earthy colours which are seen in late summer.

SIMPLIFYING THE SUBJECT

It is a constant temptation to aspiring artists to paint what we know rather than what we can actually see. Thus the leaves that we know clothe summer trees tempt us to an overstated, fussy and somewhat naive interpretation. A combination of more careful observation and a range of effective techniques is called for.

The methods used for painting the fruit forms on page 37 need only little adaptation to serve for trees. Indeed, the ragged outline shapes of trees are actually easier to achieve than the more regular spherical and ovoid forms of fruit and vegetables. Very little in the way of small brush marks need be added to the tree to indicate the leaf-covered surface.

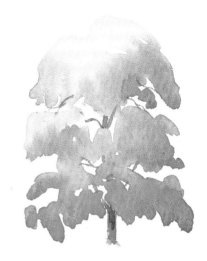

Above Tree painted using the colour wheel method with yellow-green and blue-green, allowing the two mixes to run and blend together. There is no need to rinse the brush when changing to the second mix. The trunk and branches were superimposed when the shape was dry.

Right Tree painted by the lifting and superimposing method. At each stage the work must be allowed to dry completely before superimposing first the shadow (*centre*) and then the texture (*right*).

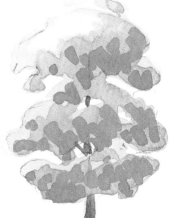

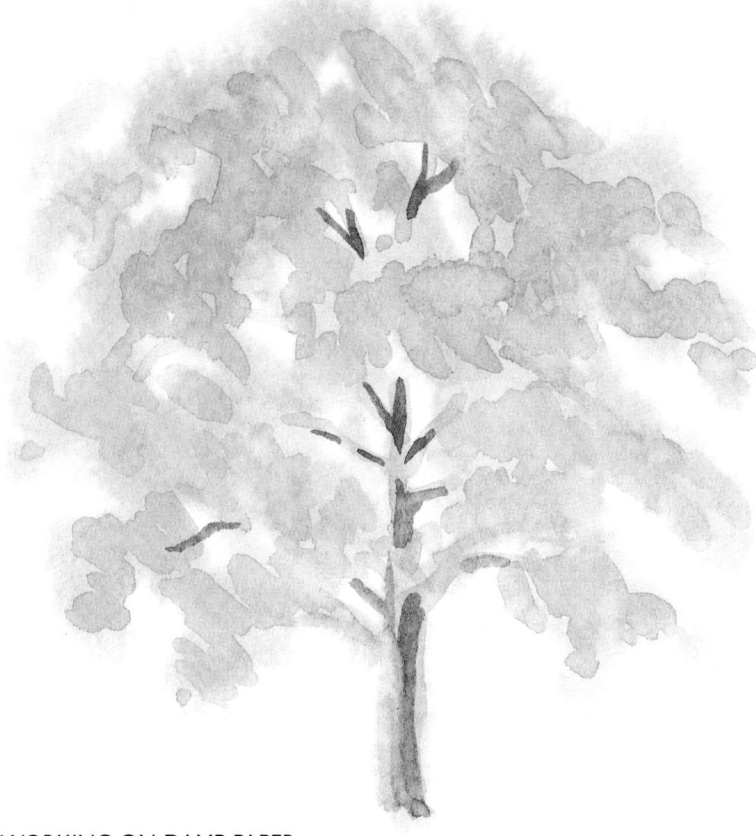

WORKING ON DAMP PAPER

The methods used to create the trees on the previous page can be applied to painting on damp paper. This will have the effect of softening the outlines of your subject and evoking misty conditions. Using a sponge, dampen the paper lightly with water, then paint the shape with a brush using a stronger mix than usual and a very lightly loaded brush. When dry, tone and texture can be superimposed in the usual way, but mixes must be kept very pale so as not to stand out starkly from the soft-edged shape. Again, the trunk and branches should not be added until the foliage is dry.

CREATING TEXTURE

The superimposition of small brushmarks is just one of many techniques available to us in the creation of texture. Sponging and dry brush techniques also lend themselves to the interpretation of the texture of twigs and foliage. In Lesson Nine other ways of creating texture are introduced.

The size of brush you use will also affect the texture of the subject. In the pictures on page 49, the small No. 4 brush creates a much lighter foliage effect (1) than the 13mm (½in) flat (2) or the thicker No. 8 round (3).

DRY-BRUSH
Make up a stronger mix of colour than usual, and load a flat brush. Immediately off-load it by wiping it on the edge of the palette. To ensure that the brush is not holding too much mixture, off-load a little more by dragging the brush across a piece of scrap paper. With the brush now very lightly loaded, make deft, swift strokes, fanning outwards and upwards to create a twiggy effect (see opposite).

A round brush can be used to similar effect if you squeeze the hairs close to the ferrule between your finger and thumb to spread out the hairs after off-loading it as described above.

With paler mixes this technique can be used to suggest the haze of fine twigs around the top and outer edges of winter trees.

SPONGING
For this you will need a piece of sponge, preferably natural, which is used instead of a brush. Use it dry or damp to pick up small amounts of strong mixture, and apply it to the paper with a gently dabbing motion. The examples at the bottom of the opposite page show the effect of sponging with two colours and with three colours.

Experiment with sponging techniques, making use of yellow-green, true-green and blue-green within the one image as a way of creating form. Trunks are best painted from the bottom up lifting the brush as you work to create a line which is broad at the base and thinner at the top. Careful observation is needed to get the width of a trunk in correct proportion to the foliage.

1 With a No. 4 brush, two greens are applied in dots and dashes to create spaces between the clumps of foliage.

2 A 13mm (½ in) flat brush is used to apply a background colour and then a dry-brush technique is used to suggest the texture of a mass of foliage and twigs.

3 A No. 8 brush applies the paint in sweeping curves to produce a much denser foliage. A darker blue-green is fed in while the original yellow-green is still wet.

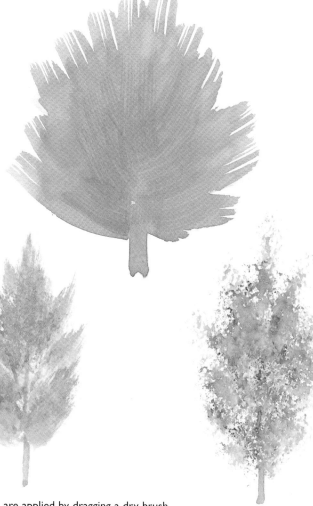

4 Almost neat pigments of pink, yellow and green were applied onto a wet surface by random sponging to create this mottled pattern.

5 Two colours are applied by dragging a dry brush, then a final, darker green is sponged on top, also slightly dragging the paint across the paper.

6 Two tones of brown paint were dappled on with a sponge, wet on dry.

7 Here, yellow and green are sponged onto a dry surface.

DISTANCE AND TEXTURE

The closer you are to any subject, the more detail you will be able to discern, and trees are no exception. Surface texture should therefore be more noticeable on the foreground trees than on those in the middle distance, while a dab or two of colour may suffice for trees viewed from afar. At long distance the colour difference between trunk and foliage becomes barely discernible and painting distant trees tends to become a simple case of creating shapes in a range of similar tones and colours.

NEGATIVE SHAPES

Thus far we have concentrated on painting everything we see, but it is possible to create the illusion of solidity by painting only what surrounds your subject and leaving the area of paper occupied by the subject blank.

Try creating a network of pale trunks and branches by painting only the spaces between as shown on page 51. This 'negative shape' painting is an important part of all art, and is especially significant in watercolour work because, without white pigment, white or very pale objects can only be created by preserving areas of white paper in quite specific shapes.

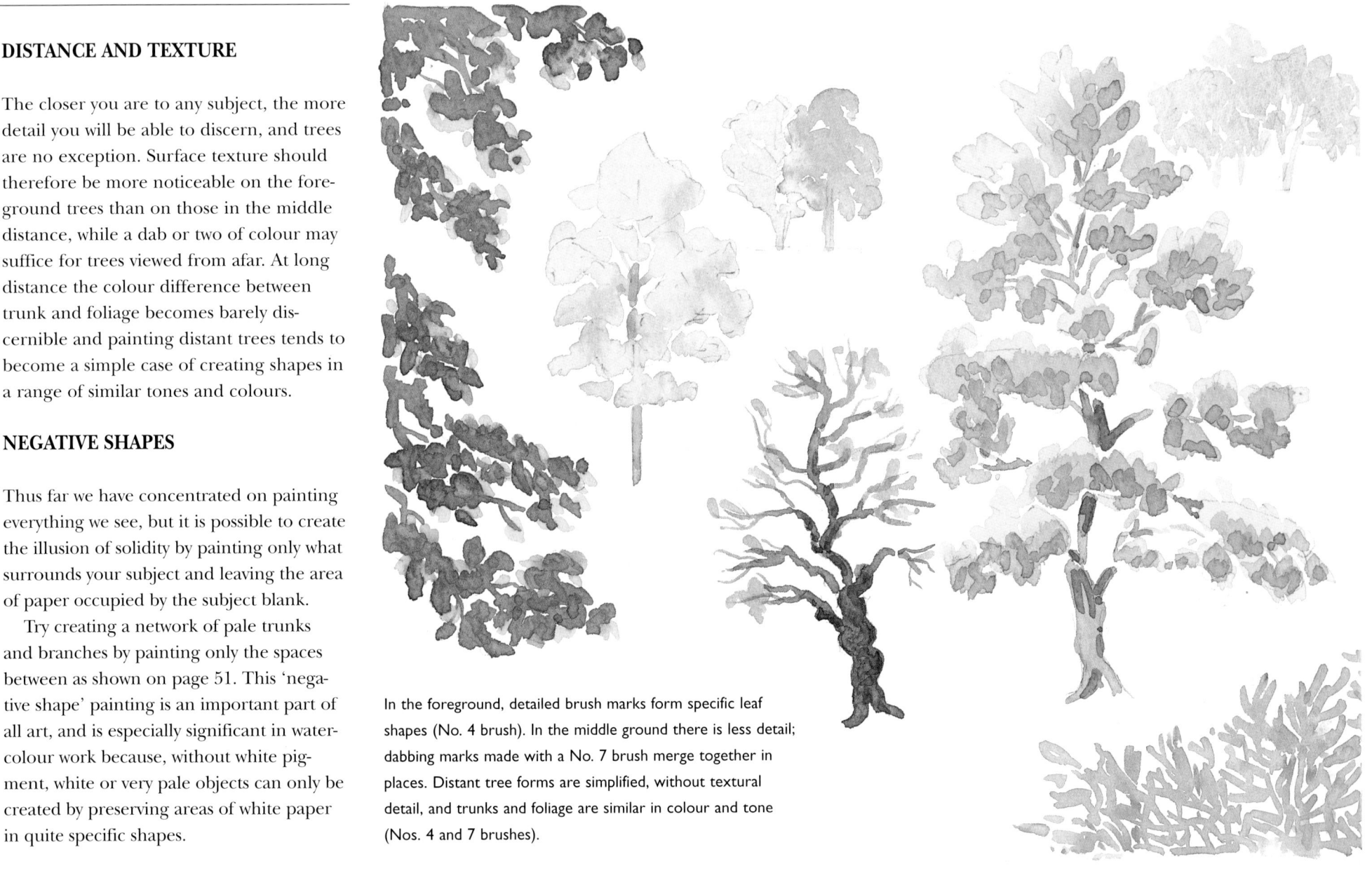

In the foreground, detailed brush marks form specific leaf shapes (No. 4 brush). In the middle ground there is less detail; dabbing marks made with a No. 7 brush merge together in places. Distant tree forms are simplified, without textural detail, and trunks and foliage are similar in colour and tone (Nos. 4 and 7 brushes).

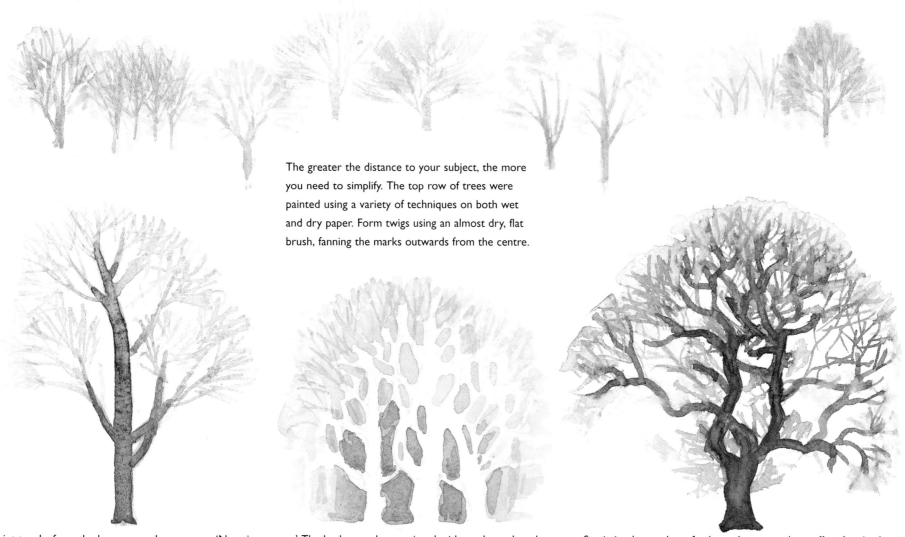

The greater the distance to your subject, the more you need to simplify. The top row of trees were painted using a variety of techniques on both wet and dry paper. Form twigs using an almost dry, flat brush, fanning the marks outwards from the centre.

Paint trunks from the base upwards, lifting the brush away from the paper to make the trunks thinner at the top than at the bottom.

'Negative spaces.' The background was painted with a pale wash and allowed to dry. Some of the main trunks have been drawn in pencil, but only the spaces between have been painted. Stronger mixes were used closer to the centre.

Semi-circular strokes of pale wash create a haze effect for the fine twigs. Upper branches and twigs were added while damp for a soft-focus effect. The trunk and lower branches were added when everything else was dry.

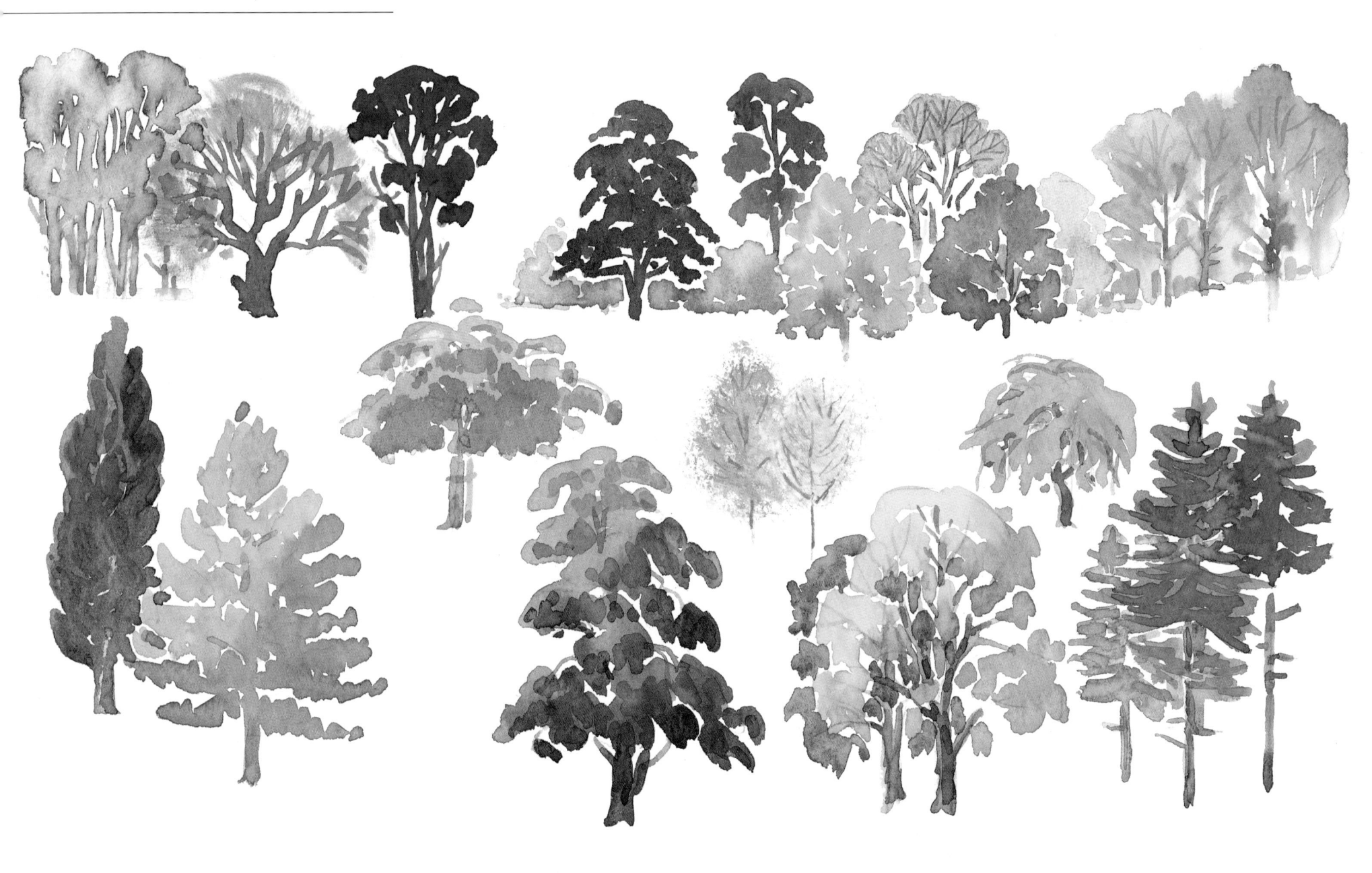

GROUPS OF TREES

Try painting groups of trees as well as single specimens, concentrating on differentiating individual trees via subtle changes of tone and colour. Paper dams can be effectively employed here, though they should be used sparingly for maximum impact. To see what your trees might look like in a landscape painting, paint a pale green background and when dry superimpose a stand of trees.

Opposite Try to capture the character of the tree species in a simplified translation into paint. Dabbing strokes were used in the darker, tall trees in the top row, merging in places of heaviest foliage. A fine brush was used to create a network of fine branches for the tree further to the right. Upward-twisting strokes create a coniferous column (*bottom left*), while in the neighbouring tree, sweeping outward movements of the brush increase in width for the lower branches. Similar rhythmic swings of the brush were used for the pines (*bottom right*), crossing and re-crossing the tall, straight trunks. Note how some branches rise almost vertically, while others appear to radiate outwards like a fan. A few trees, such as willows (*centre right*), have graceful, downward-curving branches.

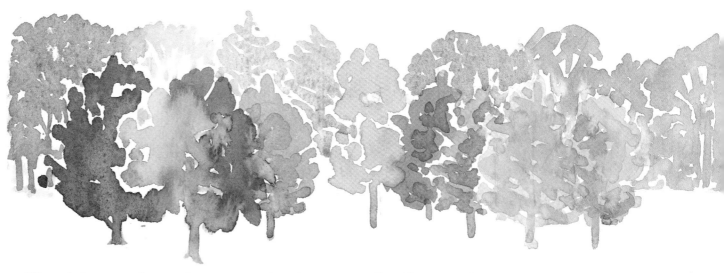

When painting groups of trees, paint one tree at a time, the nearest ones first. Allow some colours to run together, and keep others separate by use of paper dams. Employ some superimposition for shadows and texture, wet-onto-dry (see Lesson Three).

Wet-onto-dry in two steps. This stand of trees is painted on a patch of pale green; when the green ground was completely dry, the trees were superimposed, working as described above.

Wet-into-wet. When adding the trees to the wet ground, stronger mixes and a very lightly loaded brush will ensure that tree colours do not bleed away and lose their shape. The area may be re-wetted and more colour added as often as necessary.

Composing a Landscape

Watercolour is much less forgiving than other painting mediums, affording only limited amounts of correction before the paint begins to lose its intrinsic beauty. It is for this reason that we have spent the previous lessons gradually building your knowledge and understanding of the way in which watercolour paint behaves. It is now time to build on the foundations laid so far by setting out on that Olympic marathon I referred to in the Introduction – the composition of your first landscape.

The journey is full of challenges: there will be problems of drawing, composition, colour-mixing, and the challenge of creating an illusion of land and sky, space, light and air. One challenge we have not

Aims

- To paint a landscape in the direct method (that is, painting one area at a time, working from the top downwards)
- To make a compositional study for a landscape painting in terms of tonal masses
- To use aerial perspective to create an illusion of space and distance

encountered before is the changing light and the vagaries of weather. We must pack and transport the necessary materials, choose a suitable viewpoint, and contrive to translate what we see onto paper. It may sound daunting, but have no fear; as always we shall take it one step at a time.

CREATING AN ILLUSION

It is important to recognise that most painting involves creating an illusion. Compare any watercolour landscape with a photograph of the actual scene. The painting you are viewing might well be instantly recognisable as a *representation* of its real-life equivalent, but that is all it is – only a representation. Watercolour as a medium lends itself to all kinds of interpretation. Rather than merely copying from Nature, a painter creates an illusion; a visual equivalent.

Once we appreciate this concept our task becomes much less daunting, for we are free to manipulate, select, simplify or exaggerate; indeed, to do anything that serves to create the illusion we are seeking. Was it Matisse who reproved a critic for suggesting

that an arm in one of his portraits was unnaturally long with the words, 'Madam, you are mistaken! It is not a person, it is a painting'. As artists, we are free to take whatever liberties we choose in the creation of beautiful paintings. I cannot stress this too strongly; by far the most important element of watercolour painting is to create an image that is beautiful in itself. Your subject is simply a hook on which to hang it.

AERIAL PERSPECTIVE

If you take the time to look carefully at a natural landscape or at a colour photograph of a landscape, four aspects of the scene will become apparent.

Firstly, objects in the distance appear to be *smaller*. This may seem a point too obvious to be worth making, and indeed with large, distant objects such as buildings, trees or geographical features you should be able to create the illusion of distance through size quite easily. However, it is difficult to apply this principle consistently (for example, the comparative size of near and distant fields, of clouds near the horizon

Right: Four images showing the illusion of distance.

Distant objects, including clouds and field patterns, appear smaller.

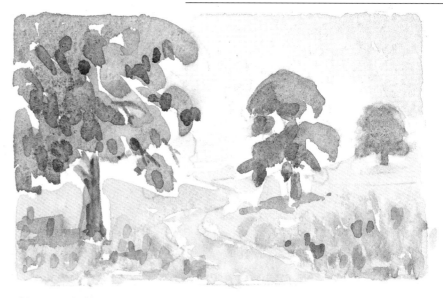

Objects in the distance are less detailed and less clearly defined, even a little blurred.

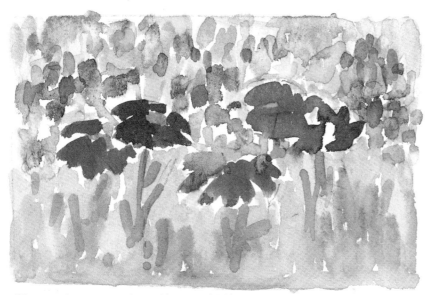

Distant colours are cooler and less pure/vivid.

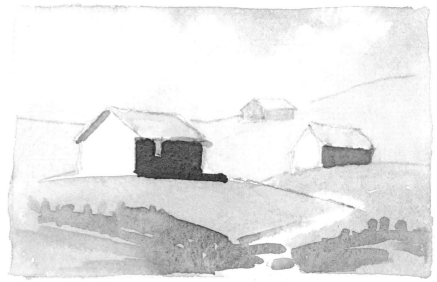

Tones are lighter/paler and exhibit less contrast in the distance.

and high in the sky, the diminishing width of rivers and roads).

Secondly, objects in the distance are *less detailed*. Not only do the details of the object – the door and windows of a house, for example – become less easy to pick out, but the outline of the object itself may become less clearly defined, even a little blurred. This effect is often found in summer when the warm air can be less clear than on bright winter days.

Thirdly, *colours* become both *cooler* and *less pure* (less vivid) the further away they are. Thus the vivid green which you might use to paint a tree in the foreground of your picture will need to become a little more blue, or a grey-green, to paint the same tree at a distance.

Finally, as objects recede, their *tones* appear *paler* and *less contrasted*. Thus, not only will you need to lighten tones when painting distant objects, you will also require fewer of them.

It is important to remember that all these four characteristics of distant objects are *comparative*. Distant objects are smaller, less detailed, cooler in colour, paler and less contrasted in tone *in comparison with those closer to you*. Thus you can never evaluate any part of your work in isolation, but only in relation to the whole painting.

As I have already said, rules are made to be broken, and these guidelines are no exception. Once you are aware of them, you can use or ignore them to suit the demands of your subject. For instance, a brilliant patch of yellow oil-seed rape catching the sun in the middle distance could be the most vivid colour in your painting. So be it, but you should make use of the other guidelines to maintain the sense of distance.

TONE

Of the guidelines for creating an illusion of distance, perhaps the most significant and yet most difficult to appreciate is the one regarding tone. Tone – the lightness or darkness of a subject regardless of its colour – makes an enormous contribution to successful painting. In Lesson Three we saw how tone can be used to create the illusion of form, but it has even greater value when applied to the creation of pleasing compositions.

It is difficult to relate tone to the colour of objects. To help you to make these judgements, try this experiment. Make a five-tone scale on a strip of cartridge paper (as shown, right), then hold it up to the view outside your window and try to match each colour to one of the tones.

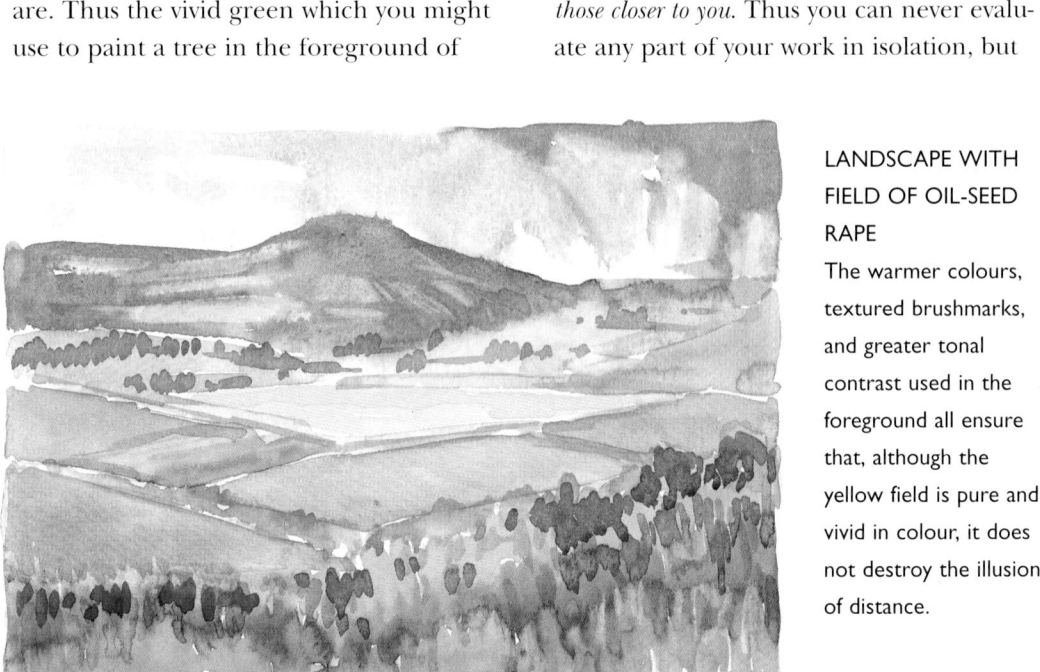

LANDSCAPE WITH FIELD OF OIL-SEED RAPE
The warmer colours, textured brushmarks, and greater tonal contrast used in the foreground all ensure that, although the yellow field is pure and vivid in colour, it does not destroy the illusion of distance.

FIVE-TONE SCALE
Leave the top square blank for white. With an HB pencil make hatched lines to represent two greys; with a 4B pencil make a darker grey and a black.

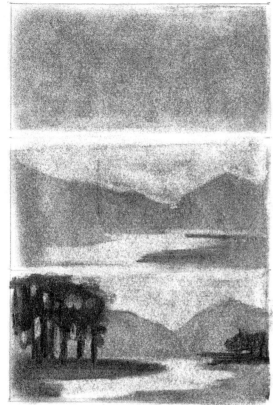

STEP 1
Rub the side of a piece of charcoal all over a small sheet of white cartridge paper and blend to a mid-toned grey.

STEP 2
Use a putty rubber to lift off charcoal in any area identified as being lighter than this mid-tone.

STEP 3
Use the charcoal to add the darkest tones.

MAKING A TONE STUDY

A tone study is a monochrome plan for a painting in which the illusion of space (distance) will be created solely through variation in tone. You should make a clear decision in all these exercises which are to be the distant areas, the middle ground and the foreground of your composition. The notion of a scene in three distinct planes is, of course, unrealistic since the natural landscape is nowhere near so neatly defined, but for these first attempts at creating the illusion of distance, it will serve our purposes admirably, highlighting as it does the effects of sharply contrasting tones. If you can work from life then so much the better, but even a black and white photograph will serve our purpose for the time being.

Using a stick of charcoal and a putty rubber, and working on white cartridge paper no larger than a sheet of writing paper, rub the side of the charcoal all over the paper and blend with your fingertips until a uniform mid-grey is achieved. Use a putty rubber to lift off those areas which are distant or require a lighter tone (the sky area and any water reflecting light, for example), to create large light and mid-toned masses. Next identify any areas that are darker than the mid-toned ground –

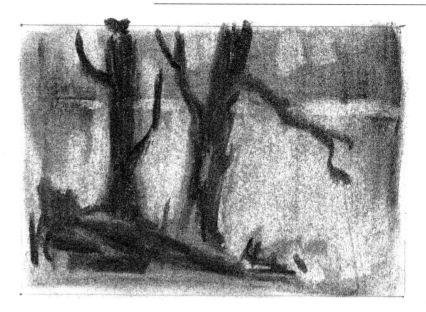

usually objects in the foreground (although you must, of course, use your common sense: a middle-distance tree will be darker in tone than foreground grass, and foreground grass will be darker than a foreground stream). Darken these areas with additional applications, blending with your fingertips if necessary.

When your study is complete, hold it at arm's length and try to judge how well you have created the illusion of space and distance. If these are lacking, make the background paler and less contrasted, and give the foreground more light/dark contrast. If all else fails, simply blend down again to that initial mid-tone and re-work.

Charcoal is an ideal medium for making compositional tone studies because it encourages a broad, undetailed approach to planning your compositions. Unsatisfactory efforts can be blended down and the process started again.

COMPOSITION

Good composition in terms of tone means making a pleasing arrangement of light and dark shapes. Be guided by your own instincts – you will find certain compositions more pleasing than others. Even if you plan to sell your work, you are your own most important critic.

For a simple landscape, an uneven division of land and sky is usually preferable to a mid-page horizon. By making the foreground the largest area you can add to the illusion of space. The best compositions are those which are balanced, but not in a boring, symmetrical way. One almost infallible way to ensure that the elements of your painting are well placed is to use the 'Golden Section', but don't forget that sometimes even *golden* rules can be broken.

Compositional studies can be made in any monochrome medium. When using pencils, you must still concentrate on identifying the main light, medium and dark *tones*, first drawing the outline shapes with an HB and then hatching the tones with a softer pencil (use the tone scale on page 56 to help you). Work on a small scale, no larger than a postcard, so that you will not be tempted to include unnecessary detail. Try also conté crayons – black, white and grey chalks – on grey sugar paper.

The Golden Section

Throughout the ages there have been many formulae for creating 'good' compositions. Some were based on geometric shapes such as a triangle or oval, others on typographical formats such as an 'S' or 'L'. One such formula first set out by Euclid over 2000 years ago is known as the Golden Section or Golden Mean. It concerns the division of a line or area into two unequal parts so that the proportion of the smaller to the larger is equal to that of the larger to the whole. In simple terms, this means a division of approximate proportions 3:5. It can be applied to the format of a work or to the proportion of land to sky in a landscape painting, or to the placing of an area of particular interest (a focal point). The four diagrams below show a rectangle divided both vertically and horizontally according to this formula, offering four possible 'ideal' areas of focus.

Left column Weak/faulty compositions. *Right column* Improved versions. *Top* An unequal division of land to sky according to the Golden Section makes a better composition than an equal division. *Centre* An asymmetrical arrangement is more interesting than perfect symmetry (on the right a third tree has been added, and the larger trees are at different distances from the viewer). *Bottom* The creation of a focal point. In the left-hand picture the eye is led out of the frame by a series of strong diagonals, but in the well-composed picture the arrangement of lines and shapes holds the viewer's eye within the frame.

PAINTING A LANDSCAPE

Before tackling the main task of this lesson – your first landscape painting – we must explore further the creation of tone, this time using watercolour rather than pencil or charcoal. The effort you make now to master the basics of watercolour work will be repaid many times over during your painting lifetime.

TONAL LANDSCAPE STUDY

Using an HB pencil on a small piece of watercolour paper (approximately 17.5 x 27.5cm/7 x 11in), lightly sketch a simple landscape – an imaginary one, a composition based on one of your charcoal studies, or use the example on the opposite page that has three trees in it, adding a wavy line to indicate a distant hill.

Make a strong grey mix from the primary colours, yellow, red and blue. Divide the mix into three separate wells. Keep one mix at full strength (dark grey), add one brushful of water to the second (mid-grey), and three brushfuls to the third (pale grey). Leave the sky unpainted, using the white of the paper to represent the lightest tone. Work from the top of the paper in the 'direct method'. Apply the palest mix to the most distant areas, mid-grey to the middle ground, and dark grey

to elements in the foreground (remember that the local tone of elements will alter details of this arrangement).

COLOUR LANDSCAPE

It is now time to begin colour landscape painting in earnest. For your initial attempts, I suggest that you copy a few of the illustrations in this chapter. In my view, incidentally, there is nothing wrong with copying if used as a means to an end – the end in this case being to practise your technique. Regular copying of other artists' work should be avoided, however, since all you are doing when you copy is to reproduce a scene as the artist has interpreted it, which will inhibit your development.

When making your copies, use paper no larger than about 17.5 x 27.5cm (7 x 11in) size so you do not need to lay large washes of colour (the subject of the next lesson). Use a No. 10 or 12 brush so that you are not tempted to put in a lot of fussy detail, and restrict yourself to just three primaries (one yellow, one red and one blue). Start with some blue in the sky area and perhaps lift out a few cloud shapes by dabbing with a piece of tissue. Keep it simple at this stage – we will learn about more sophisticated skies in the next lesson.

Carry on down the paper, painting next the distant hills in grey-blue, then the

middle-ground area using blue-greens, and finally the foreground with more yellowy greens. To avoid dark outlines you must either work quickly to allow a certain amount of bleeding of one colour into another or make use of paper dams.

Don't be too concerned about the faithful reproduction of colours and shapes. Treat the illustrations as a fund of ideas from which to create your own landscape. Accuracy will improve with practice; for now the important thing is that your work should convey the illusion of space and distance.

The next step is to paint a landscape from a photograph, preferably a black and white photograph, since you will not then be distracted by attempting to match the colours of your subject and will be free to concentrate on varying the tones. Once again, accuracy of detail is less important than the creation of space and distance. What appears on the paper will not be a faithful reproduction of the scene, but your interpretation of it in paint.

You can now return to the charcoal study you made earlier in the lesson and translate it into coloured paint. It is not easy to match coloured paint to monochrome studies. Try to imagine a black and white photograph of your colour study, or, once completed, you could take a black and white photocopy of it to judge your efforts.

The Direct Method

This term is used to describe the method of watercolour painting you have been using, whereby one patch or area of the work is painted at a time. Keeping details to a minimum, aim to achieve as much as possible in each area at your first attempt, with only limited superimposing. The white 'paper dams' necessary to keep one area of colour from bleeding into another, while not actually representing any part of the landscape, can have the effect of adding to the sense of light and air. However, too many gaps can look rather artificial and mannerist.

VILLAGE IN SUMMER

When painting your first landscape it is helpful to try to simplify it into three areas; a background, a middle ground and a foreground. This way of thinking will help you to create the illusion of distance, and will help you to control the tonality and colour temperature of your mixes.

Use a small piece of watercolour paper, about 17.5 x 27.5cm (7 x 11in), and two round brushes (a No. 10 or 12 and a No. 7 or 8). Use the smaller brush to paint the trees above the buildings where some clean, straight edges are required.

Once you have decided on your viewpoint, make a rough compositional study in pencil, dividing it into foreground, middle ground and distance. When you are working from Nature, make any changes or modifications that are necessary to improve the composition at this stage, moving your viewpoint if necessary.

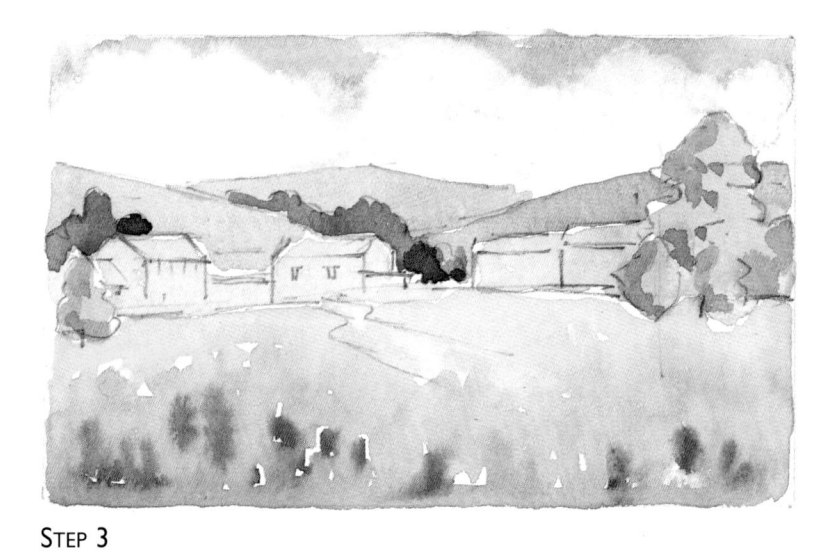

STEP 1

On watercolour paper, make a light HB pencil drawing of the subject. Using pale cool mixes, paint the sky and background hills.

Tip

When working on a fairly small scale, compositional tone studies on cartridge paper can be made at the same size as the actual painting. This makes it easy for you to copy the main outlines from the study onto the watercolour paper.

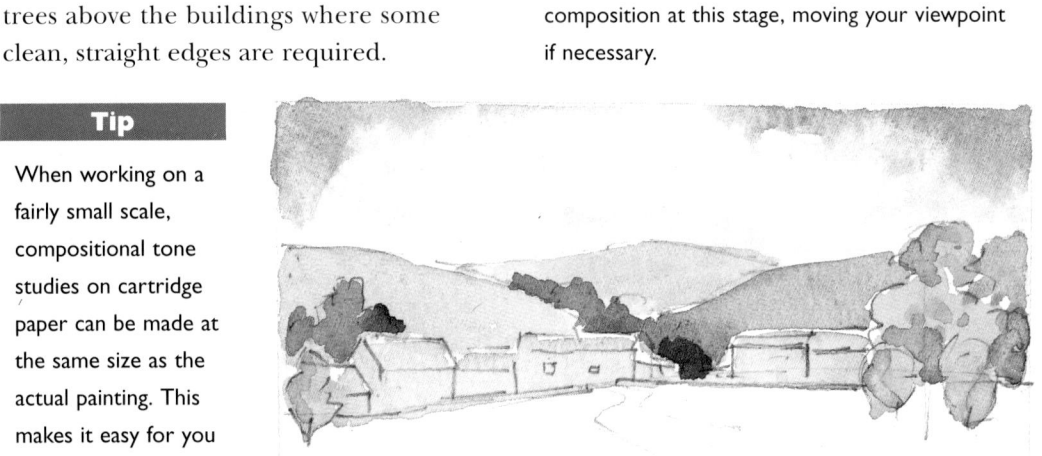

STEP 2

Now work on the middle ground, in places allowing the colours to run and blend, and in other areas keeping them separate by means of paper dams.

STEP 3

Treat the foreground (the meadow and the tree on the right) with warm, purer mixes of colour.

Palette

FRENCH ULTRAMARINE

WINSOR YELLOW

WINSOR GREEN

PERMANENT ROSE

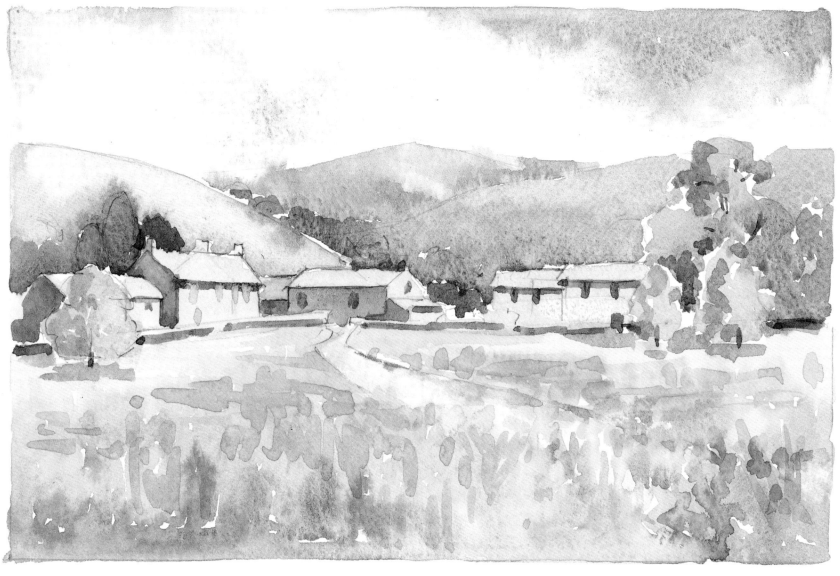

BURNT SIENNA

STEP **4** When the work is completely dry, superimpose foreground details such as texture and shadows on buildings.

FARM THROUGH THE TREES

In this second landscape the foreground trees break through the picture area, so when painting in the direct method, working from top to bottom, these areas must be avoided to prevent the background washes showing through.

Palette

COBALT

WINSOR YELLOW

RAW SIENNA

BURNT SIENNA

STEP 1

Make a light HB pencil drawing of the main outline shapes. Paint the background and distant trees first with pale colour mixes.

STEP 2

Work the middle ground, being careful to avoid the areas occupied by the trees, and preventing colours from running together by use of paper dams.

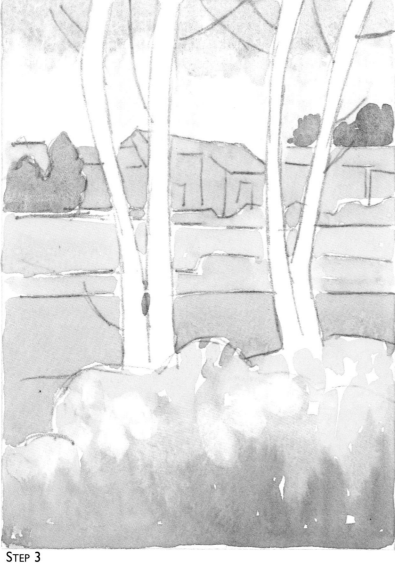

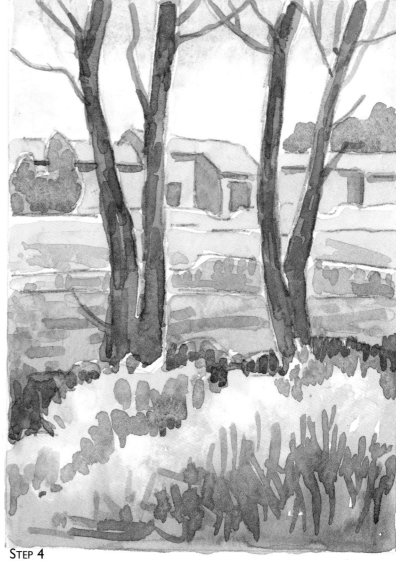

STEP 3

In the foreground, allow stronger, warmer colours to run together. Some areas can be lifted while wet to give patches of light.

STEP 4

Paint the tree trunks last. Leave the painting to dry before superimposing the shadow areas and some foreground texture.

PAINTING FROM LIFE

You are now ready to venture into the great outdoors and paint a scene from life. This may be easier said than done if you live in a large town or city, but few things are more enjoyable than painting in the open air on a fine warm day, and any time and trouble necessary to transport yourself into the countryside will be well worthwhile. Before you set out, you may find it helpful to re-read the section 'Working Outdoors' on pages 14–15.

One of the first problems you will encounter will be choosing a view to paint – not because views are scarce, but because there are so many of them. Unlike photographs, real-life views are not bordered by neat edges to show you where to begin and end, so when you find yourself perched on top of a hill with a 360-degree view all around you, a modicum of selection will be called for.

You will find a viewfinder invaluable in selecting the section of the landscape you wish to paint. You can make your own viewfinder (right), or use the viewfinder in your camera, but unless you plan to take some photographs anyway, the addition of a camera to your equipment can be an unnecessary burden.

Choose a viewpoint that lends itself to a

study in three distinct planes (foreground, middle distance and far distance) and use your viewfinder to isolate a section of it that appeals to you. Then set up your equipment and put what you have learned in this lesson into practice. Remember that it is quite all right to take liberties with your subject: if there is an ugly element contained in an otherwise beautiful scene, omit it; if a building is in the wrong place, move it; if you need a tree in the foreground to improve the composition, put one there. On the following pages I have analysed a series of scenes, selecting and emphasising particular elements in order to create a strong composition.

As always, the first priority is to produce an image that is beautiful and pleasing – accurate reproduction comes a distant second. Do your best to bring every work to some sort of conclusion. If, however, the paint has become really muddy and ugly through overworking, it might just be better to make a fresh start. Don't be discouraged if your early efforts are disappointing – remember the aims of this lesson and try again. Not every marathon runner finishes their first race.

A simple viewfinder can be made from a piece of card with a rectangular window cut into it.

I see many ingenious devices for helping landscape painters isolate and compose a landscape view. My own home-made version consists of transparent plastic (or acetate) sandwiched between two pieces of card. Three holes were cut in the pieces of card (using a craft knife and a metal rule) through which to scan the view. One hole is in the traditional proportion of 3:5, one is a more elongated format, and the third is square – an unusual format for painting landscapes but one which I like. This enables me to consider a whole range of possibilities when I hold it at different distances from my eye. Using a waterproof pen, I have drawn a cross on each of the three plastic windows. In the early stages of drawing this helps me to place features in the correct quadrant (or section) of the painting.

HAYFIELDS

My initial charcoal study *(above)* and the finished painting. The bright patchwork of colours attracted me to this landscape subject. The composition proved difficult because the strong diagonals in the middle ground tended to lead the eye out of the scene. I made the foreground flowers taller so that they intersected these lines, but feel that perhaps it is not quite resolved. Such subjects draw me to paint them over and over again, rearranging the shapes and colours.

This is an ideal subject for painting in the direct method. It is a patchwork of colours, painted literally one patch at a time, working from the top down, allowing some areas to run and bleed a little and keeping others distinctly separate.

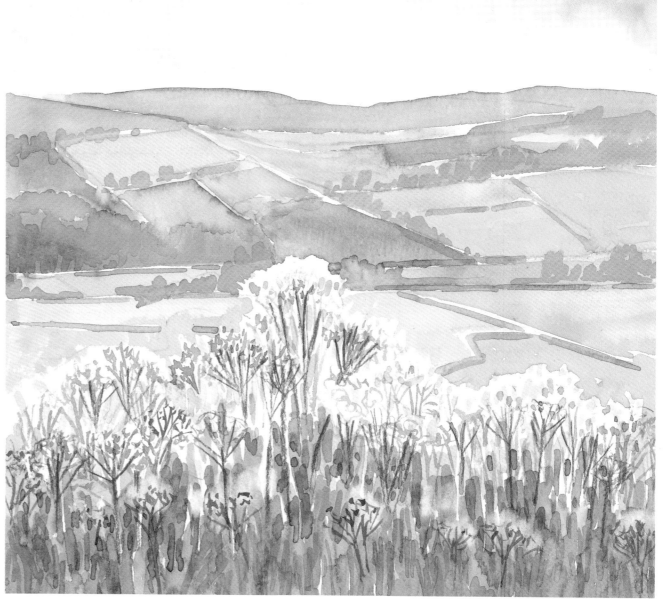

Above and left LAKELAND SCENE
The receding characteristics of cool colours are used here, although touches of blue in the foreground shadows lend cohesion to the work.

Below and opposite PORT APPIN
The building and island on the left help to balance the heavy right-hand side of the composition. The masts act as a counterbalance to the strong horizontal shoreline.

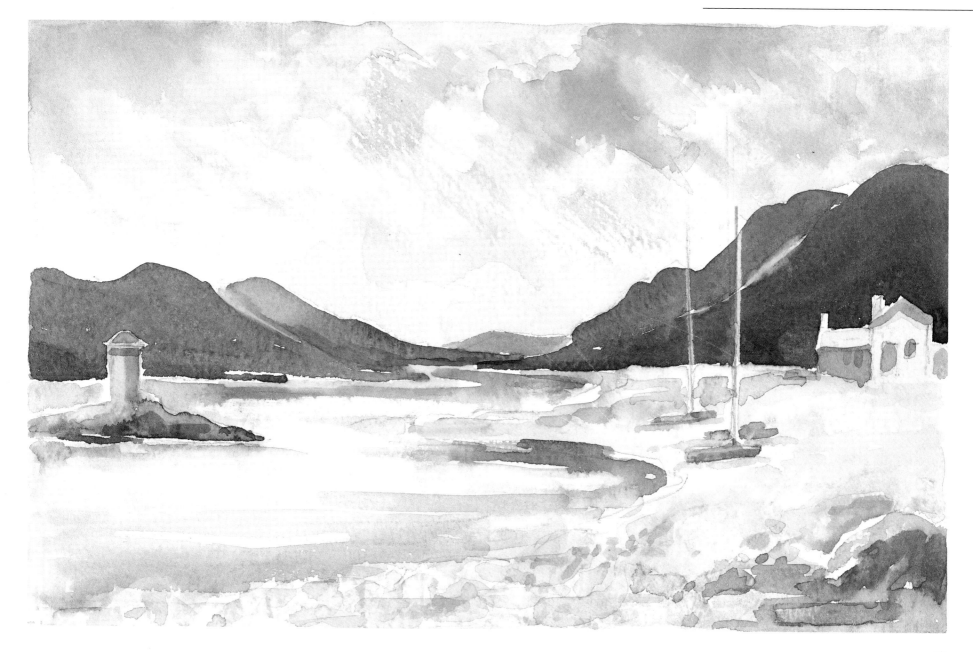

Washes and Skies

There are three basic approaches to watercolour painting: the direct method, whereby paint is applied to one area at a time; the traditional or layering method, whereby the work is built up in a series of superimposed layers of colour; and the wet-into-wet method, whereby colours are allowed to blend together. (A more detailed summary of these methods is given opposite.) We have already touched upon these approaches in earlier exercises and have used the direct method for all the step-by-step paintings detailed in the workbook so far.

Aims

- ■ To learn the techniques of laying washes of both uniform and gradated colour
- ■ To study the effects of superimposing one wash on top of another
- ■ To see how colour behaves when fed into a wet wash
- ■ To practise lifting colour off a wet wash in various ways
- ■ To learn how to lift colour off an area of already dry colour

Although many artists favour one or other of these methods over the other two, it is important to master all three, since in practice it is impossible to work exclusively in any one way.

These three methods all require some skill in an essential watercolour technique: the laying of a wash. The term 'wash' is sometimes used to mean a solution or mixture of pigment in water. More commonly, and specifically in this lesson, it is used to mean a solution of pigment in water applied to an area of paper.

Washes can be uniform in colour and/or tone, or they may increase or decrease in either as the wash proceeds down the paper. They can be superimposed upon when dry, or colour can be lifted off or added to them when wet. A wash might cover the paper completely, or could perhaps be used for a single area such as the sky in a landscape.

All things considered, washes are an indispensable part of watercolour painting, and this lesson is dedicated to showing you how to prepare and apply them in order to create a variety of different effects.

The Direct Method

This is the method you have used for your paintings in the previous lessons. The direct method involves painting a patch at a time, and it is usually easiest to work from the top downwards. The concept is simple and the process is relatively easy to control, but the main disadvantage is that it is sometimes difficult to get the patches to form a cohesive whole. Use of a limited palette can help. You can superimpose onto a directly painted picture, giving some areas a second or third layer of paint, both to correct parts that are too pale and to add details, but in its unaltered form the direct method is the watercolourist's equivalent of the oil painter's *alla prima* method, that is to say, getting it right more or less at the first attempt.

The Traditional or Layering Method

This method, exemplified by the English watercolourist, John Sell Cotman (1782–1842), involves laying a wash of pale colour evenly all over the paper, leaving holes or 'windows' for any objects which are to be kept white. When dry, another layer is added, again leaving any areas that are to remain the colour of the first layer. The process is repeated many times, the windows increasing in size and number with each successive layer. This method enables a gradual and controlled build-up of tones and produces works of great colour harmony, since each layer of colour is influenced by the ones beneath. Technically it involves learning to lay large areas of colour, and requires an understanding of how to build up the layers. It is a method best suited to thinkers and planners who like to feel in control!

Wet-into-Wet

We have already touched on this method briefly, and will explore it further in Lesson Nine. The paper is made damp all over and the colours are touched or flooded in, allowing for much bleeding and blending. The wet-into-wet method is an exciting way to paint, often producing chance effects and lovely impressionistic outcomes. The paint can sometimes behave unpredictably. The skill lies in being able to bring this loose, free beginning to a controlled conclusion, and so create an acceptable and recognisable image.

LAYING A FLAT WASH

The first exercise in this lesson is to lay a flat wash – a wash that is uniform in both colour and tone.

Take a piece of paper approximately 13 x 20cm (5 x 8in) in size and fix it onto your board. (At this size a piece of 300gsm/140lb paper is unlikely to need stretching.) Position the board at an angle of about 45 degrees. Prepare plenty of colour in your palette or saucer, and load a No. 12 brush fully. When working on a larger scale, use a 'mop', or wash brush.

Start at the top and paint the wash in a series of horizontal strokes, to create a uniform area of colour with no visible joins between the strokes. The angle of the board will encourage a reservoir, or bead of excess water, to collect at the bottom of each stroke (if no reservoir appears, load your brush more fully). It is this reservoir that helps you to achieve the invisible joining of each stroke by overlapping slightly so that the water in the reservoir blends successive strokes seamlessly.

If you are right-handed you will probably tend to make your strokes from left to right; if you are left-handed, from right to left. However, repeated strokes in the same direction may result in a build-up of water on one edge of the paper, and you will

need to correct this by making some strokes in the opposite direction.

The speed at which you lay a wash is important. If you work too slowly, this will allow the reservoir to sink into the paper, creating dark stripes. If you work too quickly, this will not allow time for the reservoir to form, and will result in a patchy, uneven wash down the paper.

Try to work to the very edges of the paper. The reservoir that collects at the bottom of the final stroke must be removed if it is not to cause a 'run-back' (a lighter area with a dark-fringed edge). Do not attempt to push this reservoir uphill with the brush, but simply touch it with a barely damp brush and watch it disappear as the brush absorbs it.

If there is any grease on your paper (often caused by fingermarks), it will be difficult to make the paint take. Moving the brush over the affected area, using a scrubbing motion, will probably cure the problem, after which proceed as before.

Once you have laid a wash on dry paper, lay a wash on dampened paper. You will probably find this easier than working on dry paper since the water in the paper will blur the edges of your strokes before the next is applied. You will find that you do not need to load your brush so heavily when working on damp paper.

With your board at an angle, load a large brush fully and make a brush stroke across the top of the paper, leaving a reservoir of excess water at the bottom to which your second stroke will be joined to create an even wash.

If you work at a regular and reasonable speed, the reservoir will ensure that the wash proceeds evenly down the paper with no visible joins or brush marks.

When you have finished applying the wash, allow it to dry off before moving the board to avoid unsettling the drying paint solution.

Tip

It is easier to dilute a wash mix by adding extra water than to strengthen it by adding extra pigment.

GRADATED AND VARIEGATED WASHES

Now experiment with tone by laying a gradated wash, one that changes gradually from light to dark. Dilute the mix every time you reload the brush to produce a wash that gradually becomes paler.

If you want the tone to darken as it descends, you could add more pigment rather than diluting the mix, but a simpler option is to work from dark to light and then turn the paper upside down.

A wash that changes from one colour to another is known as a variegated wash. The blue to pink wash shown here was achieved in two stages: first by laying a gradated blue wash, allowing it to dry *completely*; then by turning the board through 180 degrees and repeating the process using a pink wash. An alternative method is to transfer one colour mix into the other. Prepare a blue mix and a pink mix of medium-pale strength in two palette wells. Dip a brush into the blue and paint one stroke; without rinsing the brush, dip it quickly into the pink mix and transfer one brushful of it into the blue well and stir. Load the brush with this altered mix and paint the next stroke. Continue in this way, gradually transferring more pink into the blue well.

Single-colour wash gradated in tone by adding increasing amounts of water to the mix.

A blue to pink, or variegated, wash. A gradated blue wash was laid and left to dry. Then the paper was turned upside down and a gradated pink wash was superimposed.

Lifting from a wet wash by blotting with a tissue.

Lifting from a wet wash with sweeping strokes of a barely damp sponge.

LIFTING FROM WET WASHES

Areas of colour can be lifted out of a wash (when wet, or once dry) to create the effect of clouds.

The pictures on this page illustrate three methods of removing colour from wet washes: by blotting the wet wash with a piece of tissue, by rolling a dry brush across the surface, and by dabbing the surface with a sponge to absorb the liquid (or moisture). The amount you lift off and the effect you create will depend on how wet the wash is and how hard you press the brush, tissue or sponge. Experiment with different materials (kitchen towel is good,

Lifting from a wet wash by rolling a barely damp brush across the surface.

but can leave a textured imprint if pressed too hard) and also with different ways of handling them. Clouds are rarely pure white; their shapes are illuminated by the sun, and areas are thrown into shadow.

Cloud shadows can be added with grey on a lightly loaded brush while the sky is still wet, but in fact it is easier to let the sky dry completely, then re-wet with clean water and touch in the grey. This latter method also needs a lightly loaded brush but a slightly stronger colour mix. Three ways of creating cloud shadows are shown here, which involve lifting, feeding and superimposing washes.

Right Lay a cobalt blue gradated wash. Lift clouds while wet, using a tissue, and leave to dry. Superimpose some pale raw sienna in the centre of the cloud, giving a soft edge here and there with a damp brush .

Bottom right Lay a gradated cobalt blue wash and lift clouds while wet with an almost-dry sponge. Some pale raw sienna, and a mix of cobalt blue and burnt sienna, should be fed in while the wash is still damp, using a lightly loaded brush.

Right Lay a gradated cobalt blue wash and lift clouds using a barely damp brush. When all is dry, superimpose soft-edged clouds with a mix of cobalt blue and raw sienna.

LIFTING FROM A DRY WASH

Lifting colour from an already dry wash requires a repeated 'damp-and-dab-off' technique. To achieve this, damp the wash with a brush and immediately dab it *firmly* with tissue. Colour will be lifted off on the tissue. Failure to dab firmly will result in white patches with hard outlines – try it for yourself and see (the clouds on this page

were created using this technique). A sponge can also be used in this manner.

You will recall from Lesson One that certain pigments exhibit staining characteristics (see page 21). Once it has dried, no staining pigment can be completely removed by any of these methods, though most can be lightened to some degree. Once again, experimentation is the best way to learn.

Left A wash of French ultramarine with a little viridian was left to dry and cloud shapes then lifted with a damp bristle brush. The stiff brush lifts virtually all colour very quickly.

Far left A blue wash lifted with a hair or sable brush. The softness of the brush gives greater control over the amount of colour removed.

Left Violet wash (alizarin crimson and French ultramarine) lifted with a damp sponge. The staining quality of the crimson made it more resistant to lifting.

SKIES WITH LANDSCAPE

It is now time to incorporate the sky into a simple landscape. In these examples, colour composition plays an important role. The practice of using the same colours for both sky and land is a way of giving work cohesion. It ensures that the separate elements of sky, clouds and land have a pleasing unity.

Colour composition can be achieved by setting a strict limit on the number of pigments used, or by laying a base wash of a single colour to harmonise whatever colours are superimposed. This latter method is explored fully in the following lessons. Both methods have been used here.

The skies were painted first, bringing the washes well down, or even to the very bottom of the picture area. The clouds were fed into the wet washes or super-imposed when dry. The hills and trees were superimposed when the sky washes had dried using even stronger mixes of the same colours. The reflections in the early morning scene (right) were achieved by re-wetting the yellow base wash and feeding in the colour mixes used for the trees.

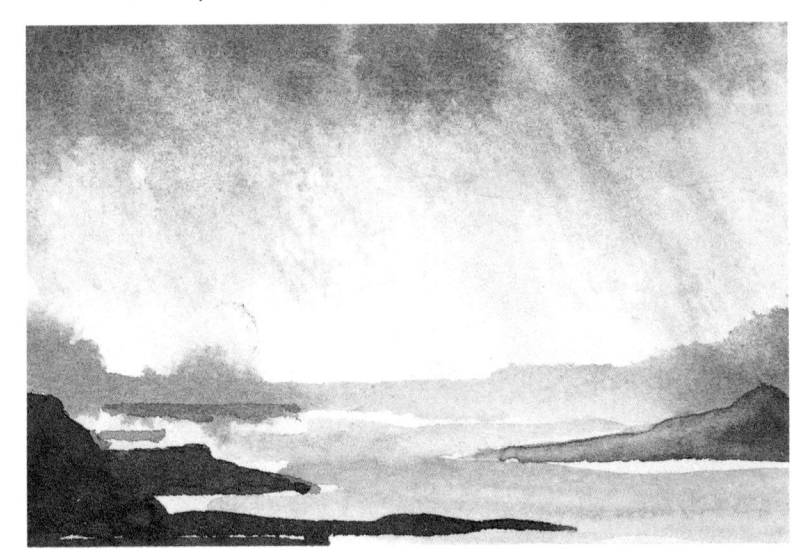

Early morning scene, using Winsor yellow, raw and burnt sienna and French ultramarine for sky, land and water.

Tip

Study the work of the English landscape artist, John Constable (1776–1837). He appreciated the importance of skies in his painting and made numerous drawings and watercolour sketches of them.

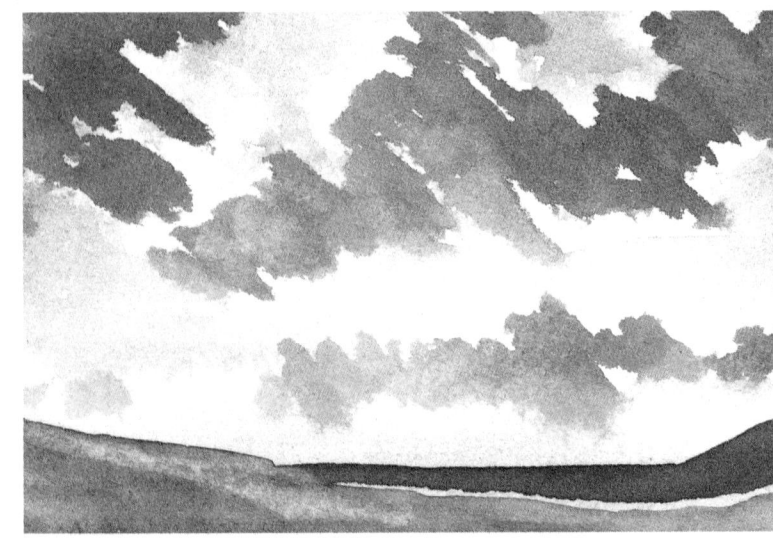

French ultramarine and burnt sienna were used for this landscape.

Stormy skies, using raw sienna, French ultramarine, alizarin crimson and viridian.

WINTER SKY

After the initial base wash of burnt sienna, the sky was built up by a series of washes painted mainly wet-onto-dry. Finally the darker shades of land and foreground shadow were superimposed using the same three colours – burnt sienna, French ultramarine and alizarin crimson.

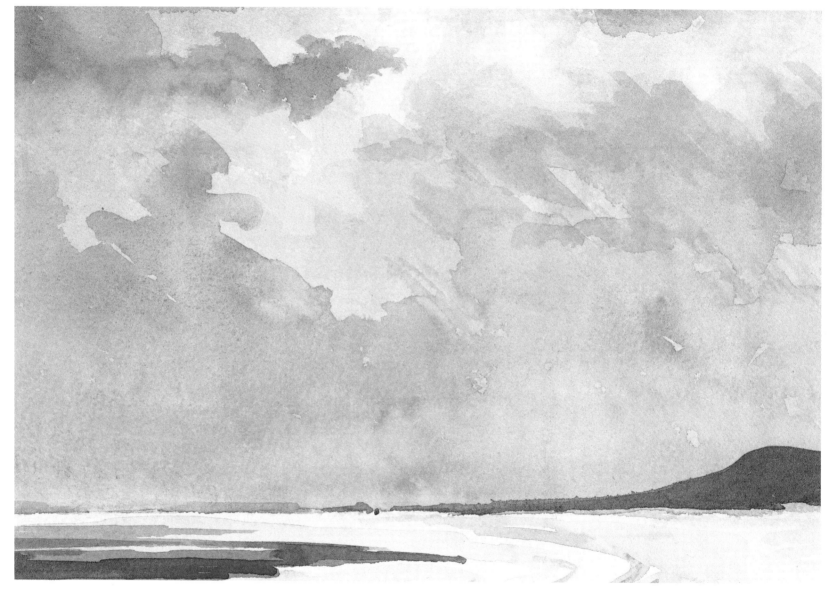

Tonal Layering

This lesson will give you the opportunity to continue to improve your wash-laying skills. It also introduces you to another basic approach to watercolour painting: the layering (or layer-on-layer) method, a traditional way of working with watercolour which involves superimposing successive washes over one another to build up the degree of tonality wanted in each area.

The method demands experience of how layers of paint build up the tones in paintings, as well as an understanding of the extent to which one colour affects others when superimposed in this way. First we shall concentrate on the building up of tones.

Aims

- To introduce the layering method of painting
- To create a gradual and controlled build-up of tones
- To practise creating distance via use of tone
- To reinforce understanding of the principles of good composition
- To improve wash techniques
- To learn how to mix neutral colours
- To experiment with tinted papers

Concentrating on the tonal aspect of the layering process will also give you more opportunity to study landscape composition and the illusion of depth and space.

Throughout this book I have stressed that the beauty of watercolour images is of far greater importance than the accurate representation of the subject, and mono-chrome work (using one basic colour mix) provides a perfect illustration of this tenet. Indeed, there is much to be said for many forms of limitation in art. Many experienced students readily acknowledge that they tend to put 'too much of every-thing' in their work, and wish they could reproduce the elegant simplicity which they see and admire in professional paintings. Using a limited palette is one step towards such a goal – you will have noticed that the palettes accompanying the illustrations in

VILLAGE HALL GARDEN

The base wash was pale burnt sienna. When completely dry, washes of a mix of burnt sienna and Winsor blue were superimposed in several layers and in varying strengths, each layer being left to dry thoroughly before the next was applied.

this book for the most part contain very few colours – and in this lesson we take this to the extreme, working in monochrome (meaning literally, one colour) and using clear tonal contrasts. First, we shall look at the greys and neutral colour mixes that are particularly well suited to this type of painting.

GREYS AND NEUTRAL COLOURS

A pure colour (for instance, green) mixed with its complementary colour (red) will become progressively less pure, until at some stage the colour becomes so impure – so neutralised – that it could be best described as grey-green, and eventually no longer green at all, but grey or black.

Truly neutral colours (neutral greys or black) have no colour bias; they are most readily produced by a balanced mix of the three primary colours, or a complementary pair (see examples, far right).

Relatively neutral colours, those with a slight colour bias, are produced in the same ways, but one of the constituent colours is allowed to predominate. It is important to familiarise yourself with the colour wheel (see page 35), and in particular with the pairs of complementary colours, in order that you can easily create or avoid neutral areas during superimposing.

Top Warm grey mix from French ultramarine and burnt sienna.
Above Cool grey mix from Winsor blue and burnt sienna.

Top Mix of yellow and violet complementaries (here Winsor yellow and a violet mix of French ultramarine with alizarin crimson).
Above Blue and orange (in this case French ultramarine and an orange mix of Winsor yellow with scarlet lake).

COLOUR MIXES FOR GREYS/NEUTRALS

Mix of green and red complementary colours (here, viridian and alizarin crimson).

A mix of three primaries (in this case scarlet lake, cadmium yellow pale and French ultramarine).

77

Neutrals can be mixed on the palette, or layered in washes to produce the mix on the paper. For example, a violet wash superimposed on a yellow wash will appear grey or grey-violet (see page 81); compare this to the mix of violet and yellow shown on page 77.

When mixing neutral colours, as always the aim is to achieve the desired colour with as few pigments as possible.

The chart of two-colour mixes on page 19 includes several greys, two of which are shown more fully on page 77 (top left). Others can be neutralised with a touch of a third pigment. If your struggle to get the required mix results in a muddy puddle of several different pigments, it is usually better to wipe it off and start again.

A SIMPLE LAYERED LANDSCAPE

Your first exercise in this lesson is to create an imagined rolling landscape in late evening light, similar to that shown on the opposite page.

You may find it helpful to draw two wavy guidelines across the paper to aid your composition. Even this simple act will require some thought because you will have to decide how wide to make each band and where the hills and valleys are to be placed.

The first step is to lay a base wash of raw sienna over the whole paper. Use a wash or mop brush if you are working at quarter-imperial size, a No. 12 brush if you are working at an eighth-imperial.

While this is drying, mix a strong dark grey. Use the pigments shown on the palette (right), or refer to the examples on the previous page, or on your own colour chart.

Divide your strong greyish mix between three wells of your palette, and dilute two of them to create a light and a mid grey. By using the same mix in three different strengths you can build up the tones in layers very quickly. It is possible to use the same dilute mix throughout, but this tends to result in a paler, rather flat image.

When the raw sienna base wash is completely dry, superimpose a wash of your palest grey mix from the horizon down to the bottom of the paper. When dry, repeat using the slightly stronger mix and working from the middle hill to the bottom. Finally, using the strongest mix, superimpose one more wash on the foreground, which will carry a total of four washes.

It is vital that at each stage you allow the wash to dry *completely*. Even the least hint of any dampness will cause the underwashes to be loosened and spoilt by subsequent ones.

Mix a grey from viridian and alizarin crimson with a small trace of raw sienna. Divide the mix between three wells of the palette. Use one mix at full strength (*bottom*), add one extra brushful of water to the second (*centre*), add two extra brushfuls to the third (*top*).

Palette

RAW SIENNA

VIRIDIAN

ALIZARIN CRIMSON

STEP 1

Lay a base wash of raw sienna and allow to dry.

STEP 2

Superimpose the palest wash of grey (viridian and alizarin crimson and just a touch of raw sienna), from the horizon to the bottom.

STEP 3

When dry, superimpose a slightly stronger mix of the same grey from the middle hill to the bottom.

STEP 4

When dry, superimpose your strongest mix of the same grey on the foreground only.

Palette

BURNT SIENNA

FRENCH ULTRAMARINE

'WINDOWS' IN THE LANDSCAPE

Develop your skills with washes, this time leaving a gap or 'window' in the foreground wash to represent a road or river winding through the landscape. Aim always to bring the washes down the paper evenly, painting round the windows (which you could first indicate with an HB pencil if it helps). This takes some practice. Keep the wash wet and moving down the paper like an advancing tide, working across the whole painting all the time. A second application of the two-colour mix can be made to bring out foreground detail.

Now progress onto more complicated shapes to paint around, such as the sailing boats in the regatta scene (page 81). Very small or complicated 'windows' can be preserved by the use of masking fluid (see page 81), which will allow you to wash over broad areas. Do not rely on it for the large shapes in these exercises, however, as learning to paint around 'windows' is an essential skill for watercolourists.

STEP 2

When dry, use a slightly stronger mix to create a hill in the middle distance and to strengthen the foreground. When this is dry, enhance the illusion of distance by superimposing the band of trees using the same mix of colour.

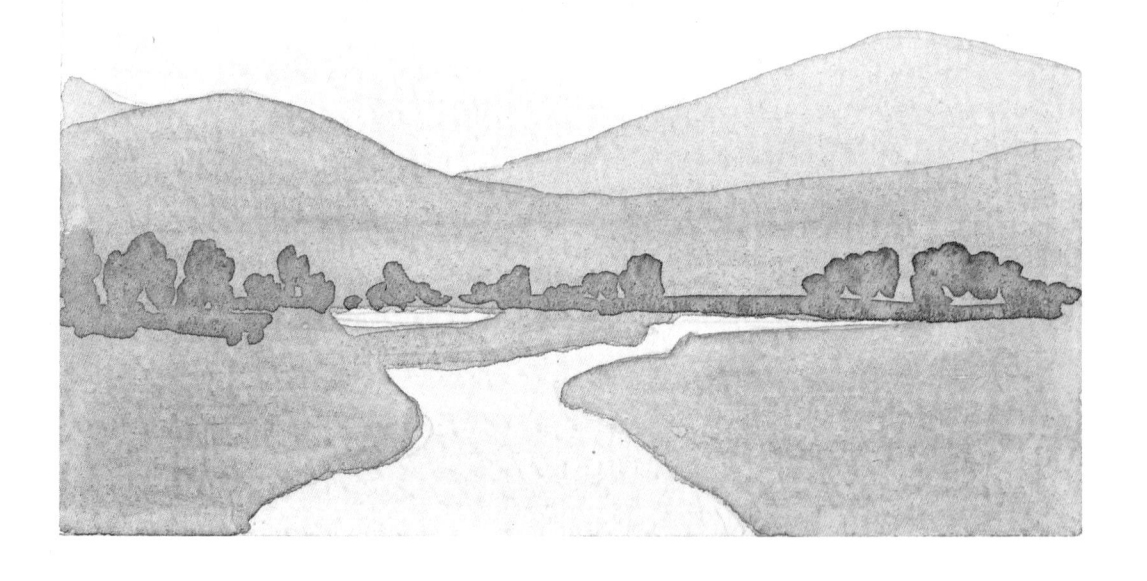

STEP 1

Lay a base wash of palest burnt sienna. Leave to dry. Superimpose a wash of mixed French ultramarine and burnt sienna over the whole land area, painting carefully around the windows in the foreground.

REGATTA

A more complex series of windows is dealt with in this composition. This painting also demonstrates how the transparent layers of colour affect one another on the paper, because additional washes do more than deepen the tones. The yellow base wash neutralises the later violet washes because yellow and violet are a complementary pair. (Compare this superimposed 'mix' with the actual yellow/violet mix on page 77.)

Layering requires careful planning and knowledge of colour characteristics.

(Compare this superimposed 'mix' with the actual yellow/violet mix on page 77.)

Masking Fluid

This rubber solution can be used to act as a resist against a wash. It is useful for small areas or details (it was used for the masts in the painting on page 67). Apply it with a fine brush or nibbed pen. When dry, apply a wash. The next day, rub off the dried fluid with your thumb.

(it was used for the masts in the painting on page 67).

Palette

WINSOR YELLOW

PERMANENT ROSE

WINSOR BLUE

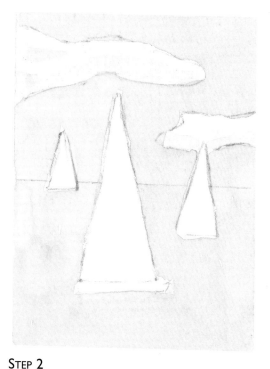

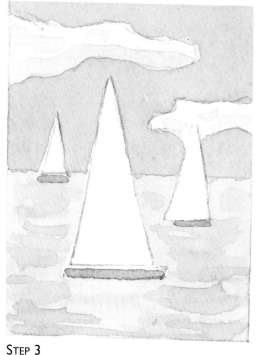

STEP 1

Make an HB drawing of two clouds, three sails, the boat's hull and the horizon. Lay a wash of palest Winsor yellow, bringing it down and around the two nearest sails. Leave to dry.

STEP 2

Lay a wash of palest permanent rose mixed with a little Winsor blue over all except the sails, allowing it to overlap the clouds a little. Leave to dry. You now have two tones plus the white of the paper.

STEP 3

Repeat the previous wash to the horizon line, adding just a few brush strokes to the water. When dry, superimpose the hulls of the boats with a mix of all three colours.

81

KETTLEWELL BRIDGE STUDY IN TONE

This picture was based on a charcoal study: and it would be wise for you to try at least one tonal painting based on a charcoal study made *in situ* before moving on to the next lesson and becoming involved with colour. It will demonstrate to you that the method works in 'real' painting situations, not just when copying or inventing subjects.

For this study I used three tones of a blue-violet mix, the palest being used in Steps 2 and 3, the mid-tone in Steps 4 and 5, and the darkest tone in the final step only.

Notice how the layer-on-layer method demands thinking in terms of wash areas, rather than painting individual elements as in the direct method. The flat washes gradually build up the tones and develop the illusion of depth. Brush marks are introduced only in the final stages. We will come to this composition again in the next lesson, where colour layers will be used.

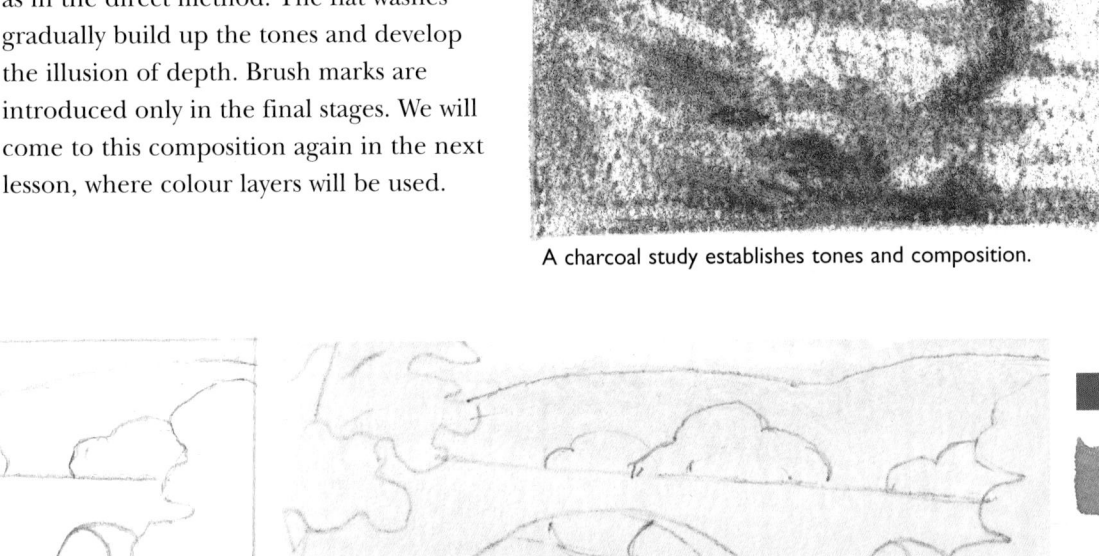

A charcoal study establishes tones and composition.

Palette

COBALT BLUE

SCARLET LAKE

STEP 1

As a preliminary measure, you will need to make a light pencil drawing of the main outlines, using an HB pencil.

STEP 2

Apply a pale base wash all over. Lift out some clouds and areas of river and pebble bank while wet, using a barely damp brush.

STEP 3

Make a second application of the same pale wash, omitting the sky, bridge, river and pebble bank.

STEP 4

Superimpose the mid-tone mix on trees, bridge arches and foreground.

STEP 5

Repeat the same mix on the same areas to build tonal strength while at the same time introducing some texture with brush marks.

STEP 6

Use the strongest mix on bridge arches, nearest trees and some foreground details. Dampen the foreground river area and feed in this strongest mix, allowing it to run and bleed.

Some pencil drawing is essential for subjects where precise edges are needed. This industrial canal scene, for instance, has quite a complicated series of 'windows' (see guidelines given on page 80) that must be defined.

It is important to know from the outset which areas, if any, are to be kept white. Having given everything else a pale base wash, next identify which areas are to receive no further washes and then give everything else a second layer, taking care to create even areas of wash.

Carry on working in this manner until you feel the required degree of tonality has been achieved.

CANAL AT EVENING
Areas of tone in the buildings and their reflections were established in a small preparatory study (*far left*).

To achieve a successful tonal effect it is important to keep the proportions of pigments consistent in the mixes. Burnt sienna and Winsor blue were used to mix these washes. Allow the blue to dominate for a cool effect, or the brown for a warmer look, but do not apply a random series of disparate washes.

Tinted Papers

Affordable tinted papers opened a whole new world to me. Costing no more than white paper, they offer the opportunity to experiment with colour harmony and colour contrast. For harmony use only warm colours on warm pale yellow and cream papers, and only cool colours on the cool pale grey-green, grey and blue papers. Reversing this procedure, that is cool on warm or warm on cool, produces works of considerable contrast.

In the examples shown here I worked on a warm oatmeal tinted paper. *Right* A layer-on-layer monochrome using violet (made from cobalt blue and permanent rose). The cream paper has a neutralising effect on the violet, lending it a somewhat grey tinge. *Below left* The same scene painted in the layered method using a range of warm colours – raw sienna, burnt sienna, aureolin and alizarin crimson. The colours harmonise with the warmth of the paper. *Below right* The scene painted in the direct manner, this time using a range of cool colours – Winsor blue, Winsor green, cobalt blue and a touch of Winsor lemon. The cool blue-greens contrast with the warm paper.

The violet wash is neutralised by the warm yellow tint of the paper.

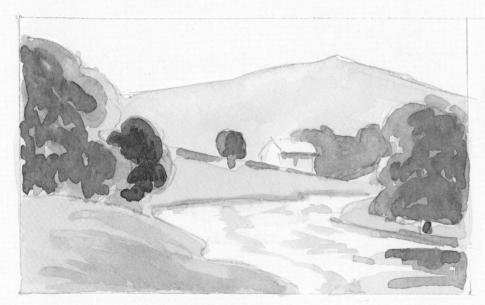

Warm colours harmonise with the warm paper.

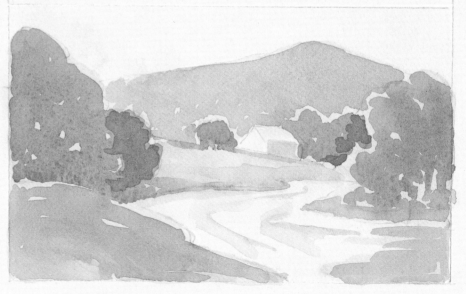

The cool colours contrast with the warm background.

LAKE AT SUNSET

This sunset painting is in limited colour rather than true monochrome, but follows the same principle and involves laying a variegated base wash of crimson, orange and yellow. By starting and ending with the crimson, you will achieve the effect of sky colours reflected in the water. When dry, superimpose the land mass in one or two layers. Then re-wet the sky to streak in a few wisps of cloud with a lightly loaded brush. Finally re-wet the lake to add reflections of the hills using the same mix as before. This exercise may seem relatively simple, but you will probably find yourself using reams of paper before producing an acceptable result. Conserve your materials and gain control by working small initially – no larger than the size of this page.

The more examples you copy, imitate or invent the more you will appreciate the advice to 'paint wash areas rather than objects' – an important lesson for all watercolourists and indispensable to those who are working in the layer method.

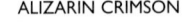

Palette

ALIZARIN CRIMSON

FRENCH ULTRAMARINE

CADMIUM YELLOW DEEP

STEP 1

First make a light HB pencil drawing of the land shapes. For the base wash (shown above) prepare three pale mixtures, one of the crimson, another of yellow and the third of the yellow and crimson mixed to make orange. Start at the top with a couple of strokes of crimson, then change to orange and then to yellow, then back to orange and finally to crimson. Don't be too concerned if this should dry a little streaky as skies and water are often like that in reality. If you feel that the result is too pale, simply wait for it to dry and apply a second layer.

STEP 2

When the base wash has dried, superimpose the land mass using a medium to strong mix of crimson and blue. When dry, apply a second layer of the same to the nearer land only.

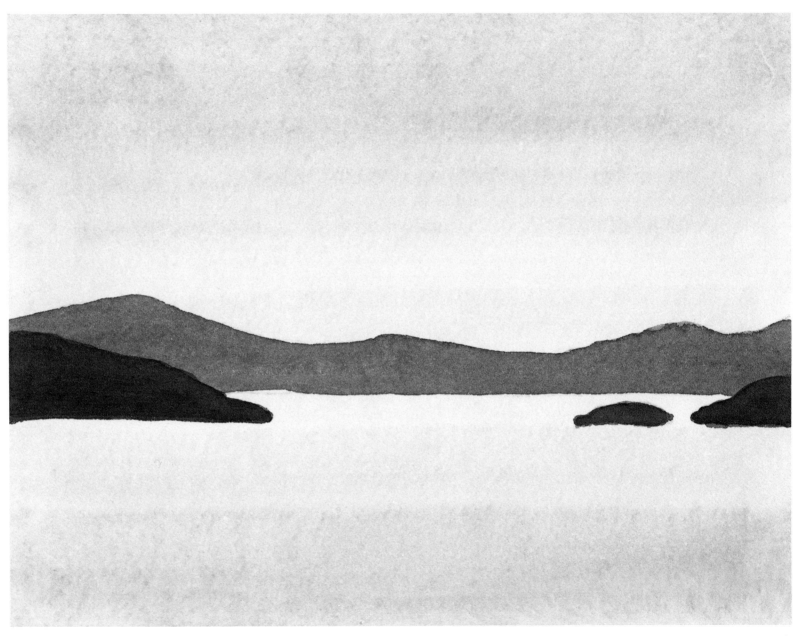

STEP 3

When dry, re-wet the sky area and streak in some clouds using the crimson and blue mix. Use a lightly loaded brush to prevent the colour from spreading too far.

Tip

One of the hardest things to acquire when painting layer-by-layer is the patience to let each layer dry completely before painting the next. Try making two identical paintings simultaneously, working on them alternately.

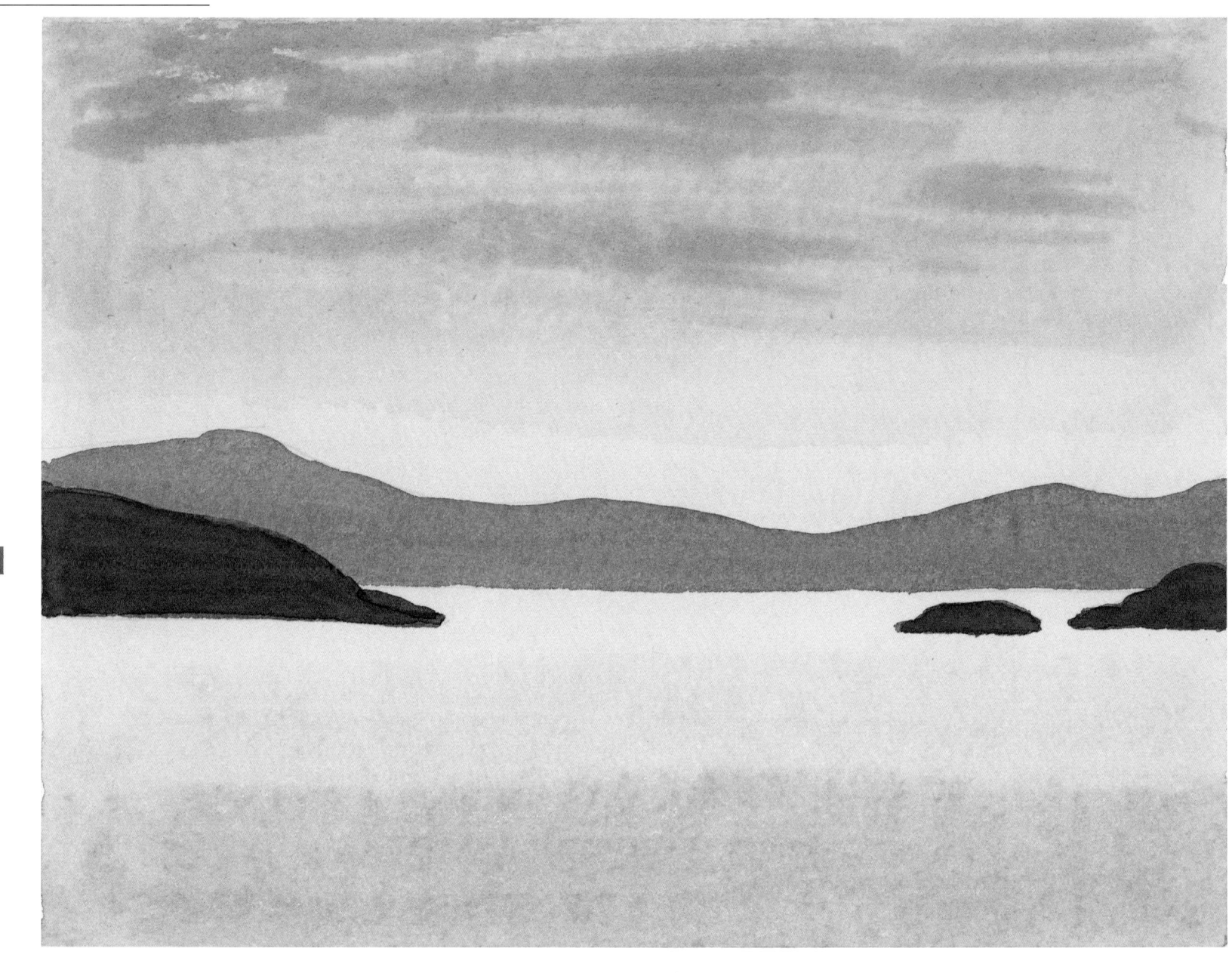

STEP 4

Use the same procedure as in Step 3 to add reflections to the water. Once you have finished this exercise you will appreciate that it could be repeated many times with ever-varying results. The factors governing the outcomes are the colours used, the strength of the mixes, and the strength and quantity of the colours fed in during the later stages.

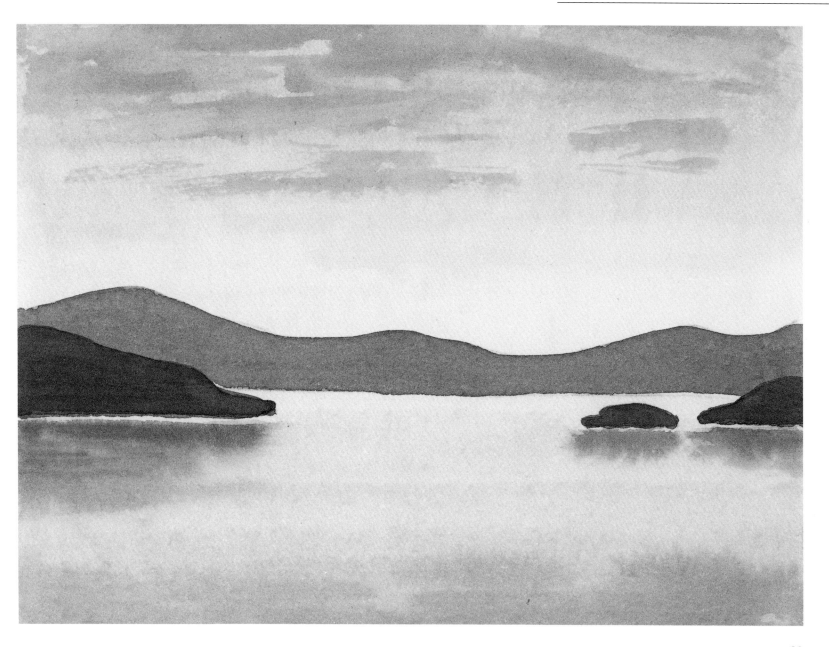

Colour Layering

A large portion of this lesson consists of copying my versions of two paintings by John Sell Cotman, not because I want you to turn out imitation Cotmans, but because you can learn from the experience what will and what will not work when building layer on layer of colour.

The layering method produces works of great colour harmony because every wash of transparent colour is affected by every preceding one. Because the cool colours (ie, those containing an element of blue) are stronger and darker in tone than the warm ones, we must paint the pale warm washes first, gradually introducing the darker, cooler ones as the work progresses. Just as we did when working monochromatically in Lesson Seven, we must leave windows in

Aims

- To discover a logical sequence of colours for layer painting
- To gain more experience of laying washes and building layers
- To learn from both copying and working 'on site'

the later layers in order to preserve areas of earlier washes.

SUPERIMPOSING COLOUR

As an experiment, try painting a green field and then superimposing some pink flowers on it. It cannot be done: the pink is affected by the green underneath and turns a murky grey. If, on the other hand, you lay a pale wash of pink and when it has dried superimpose a wash of green, leaving several flower-shaped windows, you will produce a green meadow with a sprinkling of pale pink flowers.

Now experiment with overlaying different colours as I have done opposite. There is no right or wrong way of using colours to be learnt from this exercise, but there is a need to experience how one colour will affect or be affected by another. It is always difficult to predict the effect of any given mix on a previous layer or layers. Keep a piece of scrap paper nearby to use as a testing area for your various layers before applying them to your study. Remember, the first wash must be dry.

A wash of medium green was allowed to dry then pink flowers were superimposed. The green shows through the transparent pink, making the flowers a muddy colour.

A wash of pink was allowed to dry before superimposing the pure bright green, leaving several pink flower-shaped windows. The green has been modified to an olive shade by the pink. A deeper pink will be added to the flowers later to give them form and detail.

Three bands of cool colour (two blues and a green), were laid horizontally and allowed to dry. Vertical brush strokes of warm colours were then superimposed. Take care to dilute every colour to the same extent to maintain the relative tonal values of the pigments. The greater the dilution, the greater the influence of the underlying colour.

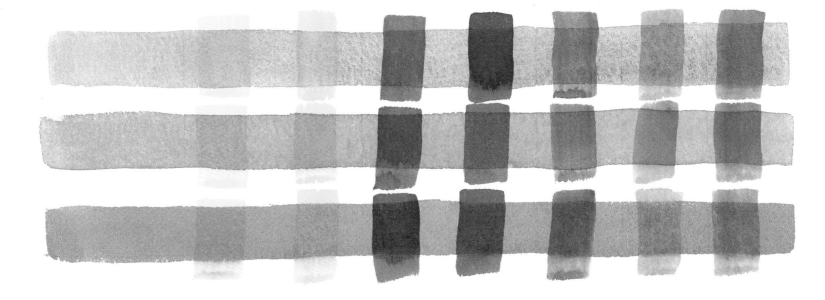

Tip

Always allow the first colour to dry completely, and use a lightly loaded brush for the next layer. The accidental overloading of the brush when superimposing onto the vertical bands of scarlet lake and magenta (see right) has loosened the colour and caused some 'runback' and fuzzy edges.

It can be seen that the darker colours (the blues, or those with a blue content) have the greatest influence whether laid underneath or superimposed. Here, vertical bands of warm colours were laid first and allowed to dry. The horizontal brush strokes of blue and green were then superimposed.

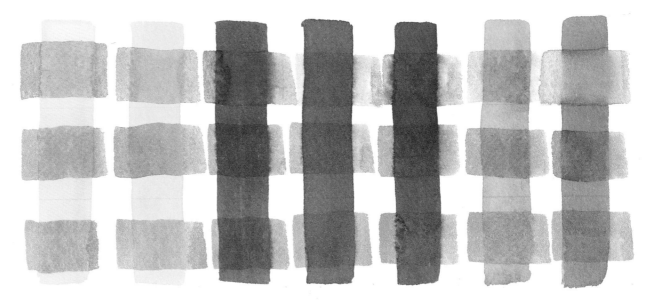

Learning from Copying/ Learning from Life

Copying can be a useful aid to learning but it is not without its dangers. In the struggle for a convincing representation we may be tempted to copy another painter's interpretation, but although this may result in a degree of success at the time, as the sole means to progress, it is a cul-de-sac.

In former times artists' apprentices learned their craft, and the 'right' way to paint, by imitating their masters. Today there is no right or wrong way to paint, and we are encouraged to experiment and to celebrate our individuality from the very beginning. Perhaps the pendulum has swung too far. Some teachers are apparently so anxious to avoid being prescriptive that students have no option but to resort to trial-and-error learning, and this can make it a frustratingly slow and sometimes confidence-bruising affair.

My own method of teaching incorporates the best of both worlds. By copying the work of different watercolourists you will learn a wide range of techniques and approaches. At the same time, through constant practice on real-life subjects, you will eventually discover the styles and methods of working that suit you best.

I made this copy of John Sell Cotman's *Greta Bridge* (1803) from a printed reproduction, which I hope is reasonably faithful to the colours of the original. I painted in flat washes of raw sienna, burnt sienna and Winsor blue, allowing each layer to dry completely before superimposing the next. The process is not unlike building up a picture by cutting and layering tinted acetate sheets or transparent tissue paper. I was surprised how few brush marks were needed, and all of them towards the end (for pebbles and rock strata, for example).

TRANSPARENCY AND OPACITY

Some teachers advise limiting the number of layers in order to reduce opacity, but I have never found this to be a problem, especially when using truly transparent colours. The chart on page 21 lists those artists' quality colours that exhibit opacity, and these must obviously be used with care when layering.

The greatest risk of opacity is in the very darkest areas (which may receive up to five or six layers), but these are usually quite small. The well-known English water-colourist Rowland Hilder (1905–93) was a great exponent of layering. He would often use many layers of colour, one over another, without any apparent loss of transparency and in the most sophisticated ways with outstandingly beautiful results.

COPY OF COTMAN'S 'MARL PIT'

Cotman's *Marl Pit* provides good practice in controlling the build-up of a picture through succesive layers of colour. I have tried to make my step-by-step interpretation as much like the original as possible. The proportions of the original are 34 x 39cm (13½ x 15½in), and you should rule a rectangle of this size on a piece of paper to serve as a frame. Next draw the main outlines of the clifftop, trees and diagonal shadows using an HB pencil. I took the liberty of simplifying the goats in Cotman's painting and turning them into rocks, which will serve our purposes just as well.

The picture can be tackled in two halves – the sky and the land – beginning with the sky. The land is a series of warm layers: first yellow, then an impure orange, then brown and finally dark brown.

Although the colours are impure ochres and browns rather than pure yellows and reds, the sequence of the layers is similar to the sequence in the colour wheel (see page 35), starting with yellow, then orange-red, and finally mixes that include some blues. As I gradually built up the darkest darks, the washes covered smaller areas and the 'windows' became increasingly larger. The hardest part, as usual, was having the patience to let each layer dry completely.

Palette

FRENCH ULTRAMARINE

WINSOR BLUE

RAW SIENNA

LIGHT RED

Light red, which is used in the later washes, is a slightly opaque colour which I normally avoid when working in many layers, but in this instance the opacity of the paint lends solidity to the cliff face and, by contrast, the sky seems lighter and more airy.

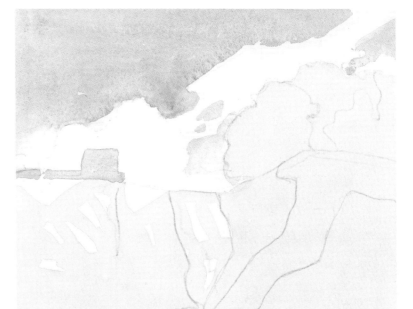

STEP 1

Make an outline pencil drawing, and then apply a pale wash of Winsor blue to the sky area, leaving out the large white cloud. When dry, apply a second blue wash, this time French ultramarine, leaving out all the clouds. While this is drying, apply a wash of pale raw sienna to the whole land area. When this is dry, superimpose a second layer of the same colour, leaving out a few small areas on the left near the horizon.

Tip

When copying outlines from another painting or drawing, it is useful to turn both your paper and the illustration from which you are working upside down. This helps you to see the main shapes more accurately without worrying about what they represent.

STEP 2

Next lay a wash of light red over the land area, leaving some windows of raw sienna in the sunlit area of the cliff. This can be blotted with crumpled kitchen paper while damp to give some texture. Apply another wash of light red, again leaving some random windows.

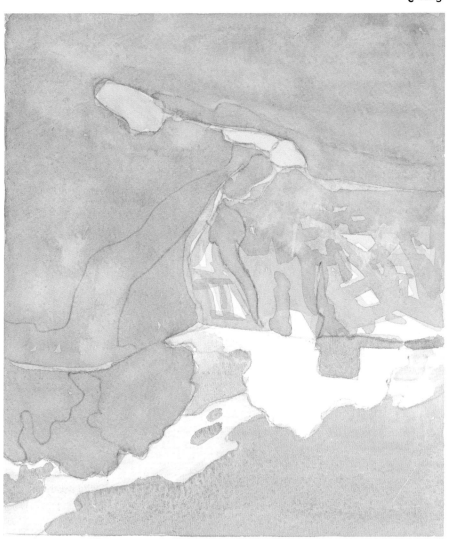

STEP 3

A clear distinction between the sunlit and shadowed areas can be made by applying two washes of light red with a little Winsor blue added, a window in the rough shape of a diagonal cross being left during the second wash.

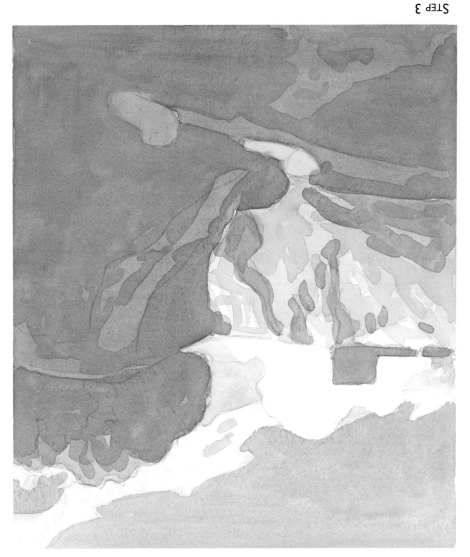

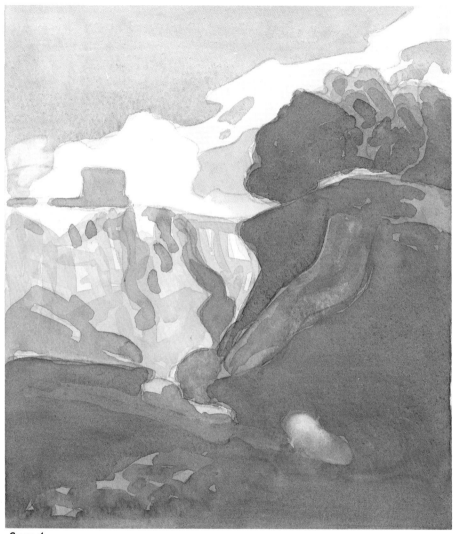

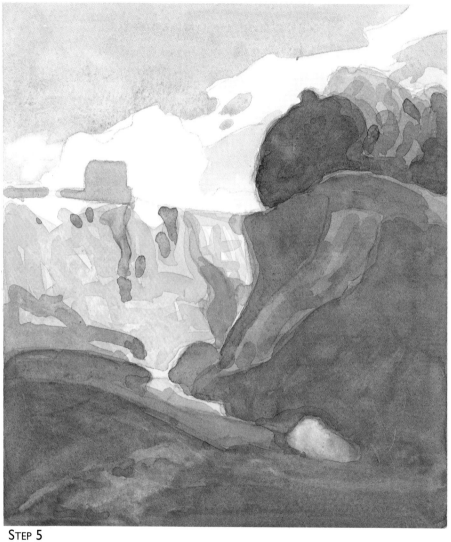

STEP 4

Strengthen the shadow area with a wash of light red and Winsor blue with a little alizarin crimson. Compare this step with the previous one to see where windows are left.

STEP 5

Finally, apply two washes of Winsor blue to establish the darkest darks. The final wash is virtually all windows, with only tiny areas receiving a second application of colour.

KETTLEWELL BRIDGE IN COLOUR

By repeating the bridge scene on page 82 in Lesson Seven, you will build up confidence in working with layered washes in both monochrome and colour. The river-and-bridge motif can be found just about anywhere, and I hope that, once you have copied mine, you will be able to go out and find something similar to draw *in situ* and to paint at home.

A photograph is not enough reference on its own for painting landscapes at home or in the studio. Some drawings, a charcoal study and some colour notes (see page 98) made on the spot would be ideal. If you only have a photograph, make a charcoal study of it before painting, as a way of ensuring effective use of tone for both composition and sense of distance.

Again, pale and warm washes were painted first with increasingly cooler and darker washes superimposed. I have kept the notes to describe each step deliberately brief so that you can put into practice what you have learned rather than slavishly following directions. Remember to leave each layer to dry before applying the subsequent layer.

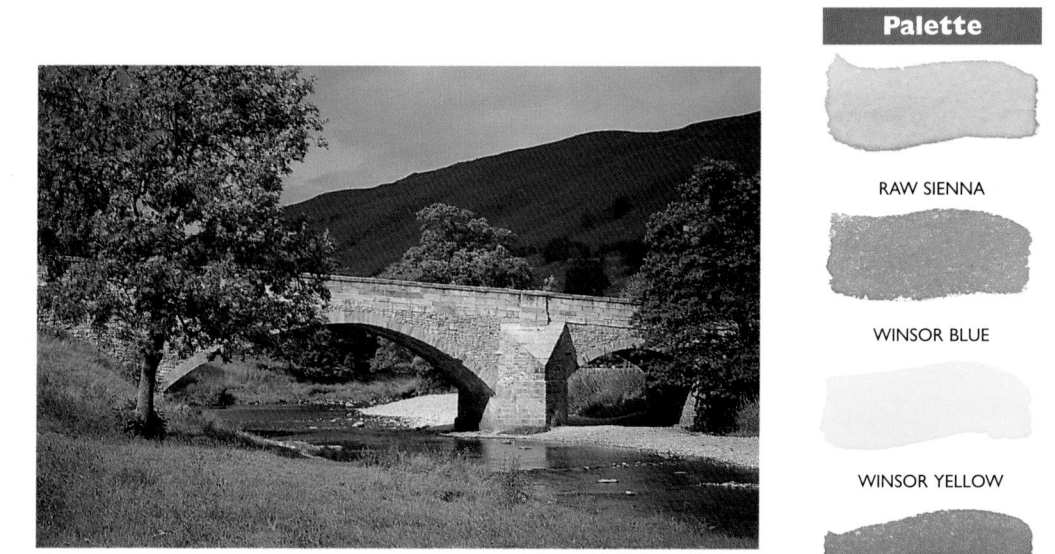

Use this photograph together with the tonal study on page 82 for reference.

Palette

RAW SIENNA

WINSOR BLUE

WINSOR YELLOW

BURNT SIENNA

STEP 1

Make a light pencil drawing and then apply a pale raw sienna base wash. Lift some colour in the river area while it is still wet.

STEP 2

Apply a pale wash of Winsor blue to the sky. Dampen the river area with clean water and feed in stronger blue using a lightly loaded brush.

STEP 3

Apply a layer of pale yellow-green mixed from raw sienna, Winsor yellow and a touch of Winsor blue to the hill, grass and foliage areas.

STEP 4

To the trees, apply the same mix with a little extra blue added.

STEP 5

Add more blue to the mix and strengthen the tonality of the trees, introducing brushmarks to indicate the texture of the leaves.

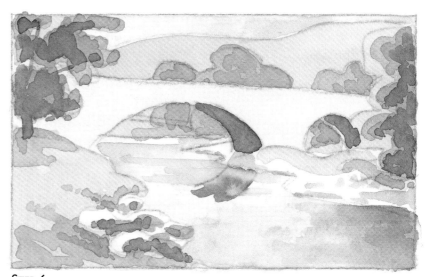

STEP 6

Use a mix of Winsor blue with burnt sienna for the dark details. Re-wet the river area and touch in a little of this mix for the reflections.

Making Colour Notes

You will find it helpful when making preliminary studies in pencil or charcoal to note down the colours of the scene. If the scene then changes in any way (light quality, weather conditions, objects being moved, and so on), or if you wish to paint in the studio, you will not then need to work solely from memory. Colour notes can be made in the following ways:

distant hills blue-violet

sky pink, fading to lemon yellow

near hill as above but stronger

trees very dark blue-violet (almost black)

lake faithfully reflects above colours

shore brownish red-violet, dark

1 An annotated line drawing.

2 Blobs of paint dotted on paper to evoke the mood of the moment.

3 Use coloured pencils to record colour or evoke the mood. They are a clean and handy medium to use, and you can 'mix' colours by superimposing one over another. Water-soluble coloured pencils can also be blended using a damp brush. Water-soluble crayons have a more chunky form, enabling studies to be made on a larger scale.

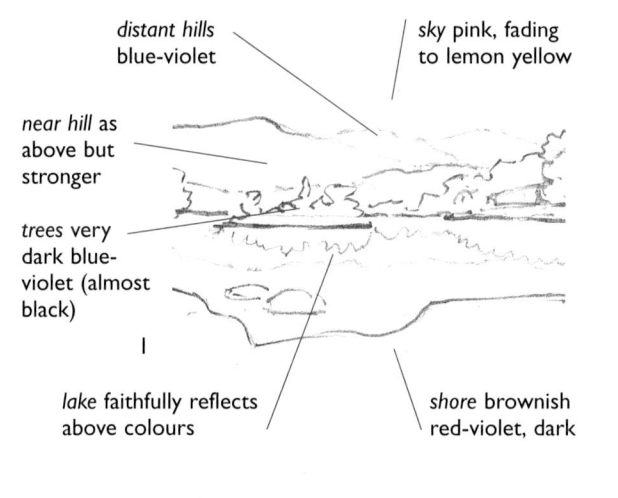

2

3

WORKING FROM REFERENCE MATERIAL

All painters discover through experience their own preferred way of working. One artist may only be able to paint landscapes while actually standing at an easel 'in the field'; another may prefer to paint in the studio, having collected reference material on the spot. Both would argue that their approach gives them the freedom to be creative. In time, you will find your own way of working.

The process of making drawings, colour notes and tone studies on site and painting the subject at home can be a useful one to adopt. By removing yourself from the subject, you will be giving yourself greater objectivity allowing you to be selective about your subject, to simplify things, to plan your washes, and to be more creative.

Photographic reference is useful back-up material, but this should not be your only reference. Colour slides give more accurate colour reproduction than prints.

Colour Notes

Dull, slightly overcast.
Soft misty blues.
Green in the middle ground.
Warm base wash of palest raw sienna to be preserved for priory and river-bank. River – dark browns and greens except where reflecting the grey-blue sky. Foreground pale, more yellow than green.

Palette

FRENCH ULTRAMARINE

RAW SIENNA

WINSOR YELLOW

HOOKER'S GREEN

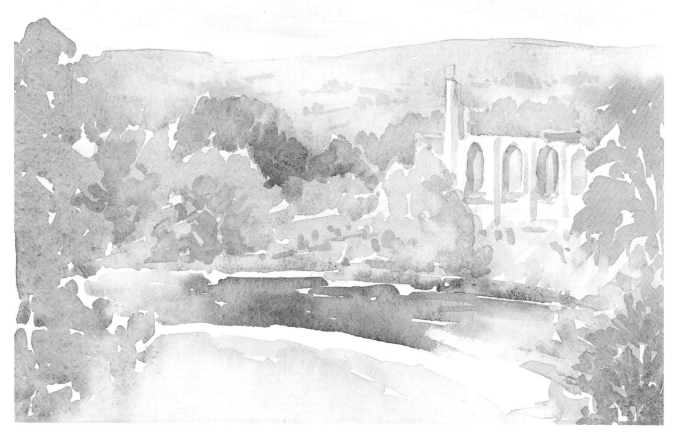

BOLTON PRIORY

The reference I gathered together for this painting included a colour slide, a quick line drawing, a tonal study in pen and ink, and the colour notes (*above*) written in my sketchbook. I selected a palette of French ultramarine, raw sienna, Winsor yellow and Hooker's green.

Working in the studio from the studies, I was able to simplify a mass of information. The warm base wash helped to unify the colours and was deliberately left as small gaps glimpsed in among subsequent layers of paint.

Wet-into-Wet

The preceding eight lessons have equipped you with nearly all the knowledge you need for a lifetime of watercolour painting. The missing piece of the jigsaw is a thorough understanding of working wet-into-wet. I have left this lesson until the end because it is at the same time the most difficult and the most exciting – an opportunity for creative fun with paint.

Working wet-into-wet could not be more different from the layer-on-layer method of Lesson Eight. Whereas layering demands detailed planning and vast reserves of patience, wet-into-wet is spontaneous, immediate and often quite unpredictable.

The stress I have placed throughout on creating beautiful images rather than necessarily recognisable ones is nowhere better

Aims

- To introduce working wet-into-wet on a larger scale
- To allow you to be creative with colour
- To encourage open-mindedness in the ways you work

applied than when working wet-into-wet. The method is ideally suited to producing impressionistic, even abstract results.

You have already experienced working wet-into-wet on a small scale when you painted the flowers and fruit of Lessons Two and Three, and also when painting trees on damp paper in Lesson Four. For full-blown wet-into-wet work, however, you must make the whole of the paper wet before you start by brushing or sponging it with clear water. Because so much water is applied to the paper, you are likely to encounter cockling problems unless you use heavier papers or the paper has been stretched (see page 13). Watercolour paint is then applied to the wet paper (hence, wet-into-wet). The results will be soft-edged and lacking in definition.

Even working quickly, you are unlikely to complete a painting before the paper starts to dry off. When it does, let it dry completely. The whole or part of it can be re-wetted and the work continued. If you feel that a wet-into-wet study needs some sharper definition, simply wait for it to dry out completely and then superimpose detail

This wet-into-wet abstract sheet was created in three stages. The paper was brushed all over with clear water and the colours were then touched in using a brush lightly loaded with Winsor yellow (*top*), then permanent rose (*centre*), and finally cobalt blue (*bottom*). Had the paper started to dry off during the process, I would have waited for it to dry completely and then re-wet it before continuing to touch in the colours.

wet-onto-dry. Although we have not yet tackled a whole painting on a wet surface in this book, you are already familiar with the techniques involved, such as letting colours bleed and blend together, layering, and superimposing texture and detail.

EXPERIMENTS WITH WASHES

It is possible only to point you in the general direction of what is required with wet-into-wet. Your results will certainly be quite different from mine; indeed, I doubt if I could reproduce my own examples with any accuracy, such is the wonderful unpredictability of the technique.

Early experiments are best begun with no preconceived image in your mind. First, wet a sheet of paper thoroughly with clean water using a mop brush or sponge. Touch in some random colours allowing them to run and blend. You will find some control is possible when using a lightly loaded brush, and that the mixes need to be somewhat stronger than usual if they are not almost to disappear on drying. The illustrations on this and the opposite page show examples of such experimentation.

Next, as illustrated on this page, make several abstract multi-coloured sheets aiming each time for results with only minimal tonal contrast.

Tip

Remember that papers of 300gsm (140lb) or lighter are likely to cockle unless they have been stretched.

The aim at this stage is to keep the sheets image free. Using mainly warm colours, wet the paper and touch in the colours. Alternatively, paint a pale wash and feed in other colours while the base wash is wet. Aim for a multi-coloured effect but with only minimal tonal contrast.

You may feel that such experimentation is a waste of time, but this is not the case. Such abstract and seemingly worthless beginnings can often be put to good use, so be sure not to discard any as 'failures'. Some can be developed with subsequent layers of wet-into-wet and wet-onto-dry paint, while others can be used as coloured grounds on which to work the charcoal studies described in Lesson Five – an interesting and effective way of combining colour and tone.

WET-INTO-WET BASE WASH

I sometimes encourage students to be more adventurous by taking some of their multi-coloured experimental sheets out-doors and using them as base washes for paintings. The idea is to find any subject that appeals and to do the absolute mini-mum additional work to produce an identifiable image. The results are invari-ably works of much greater freedom and exciting colour than the student is normal-ly able to produce. This churchyard scene is an example of this method of working.

Unless your work is to be completely abstract, you will no doubt wish to add detail to some degree. When the time comes to develop a little definition, you must abandon wet-into-wet and work on

Palette

WINSOR YELLOW

CADMIUM YELLOW

PERMANENT ROSE

WINSOR BLUE

COUNTRY CHURCHYARD
This is a good example of what can be done with an abstract sheet taken outdoors in search of any image that appeals. The multi-coloured base wash was prepared as an abstract in the studio using wet-into-wet tech-niques. Later work was added outdoors *in situ* wet-onto-dry.

STEP 1
Lay a multi-coloured base wash, allowing separate mixes of the two yellows and permanent rose to run and bleed together. Use wax candle resist for preserving white patches.

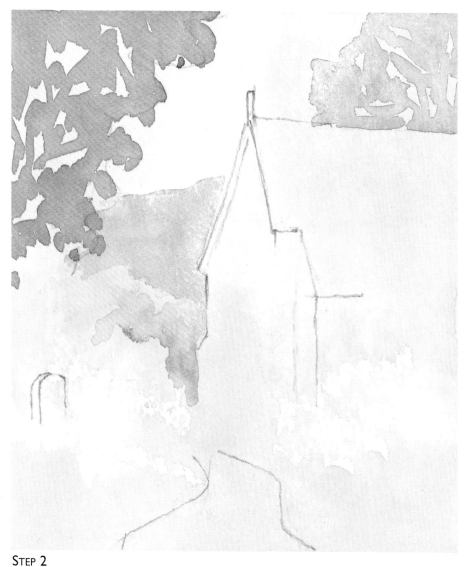

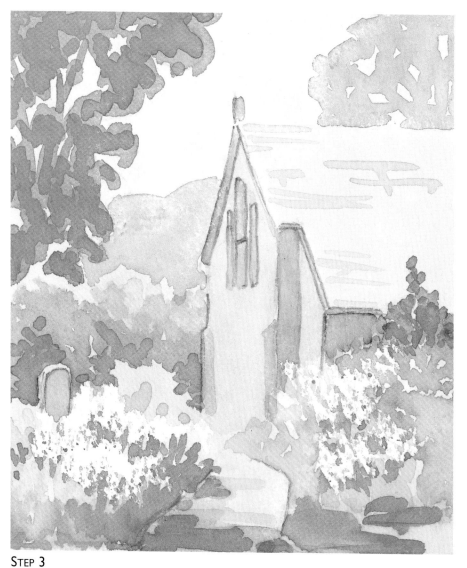

STEP 2

Make an outline drawing of the subject. In this case, the church roof was delineated by painting the negative shape created by the hill and tree (see page 106).

STEP 3

You can give colour harmony to the finished image by keeping additional painting to a minimum and leaving much of the base wash visible.

dry paper. Because the tonal contrasts that are created by working wet-into-wet are so weak, use fairly well-diluted mixes for these finishing touches so that they do not stand out too sharply from the rest.

There is an ever-present temptation to tidy up and delineate details. Resist it, for the great appeal of the wet-into-wet method is the soft, impressionistic effects it produces. Such impressions are fragile and easily overwhelmed by an excess of detail.

EXPERIMENTS WITH TEXTURE

Wet-into-wet lends itself to experiments of all kinds. Try some of the ideas suggested on these two pages for creating random textures and interesting marks. Then throw all of your preconceptions and inhibitions to the wind and experiment with anything and everything.

Texture can be created in many ways. Colour can be splattered onto damp areas using a bristle brush or old toothbrush (although if the area is too wet the splattered paint bleeds away and simply disappears), while spraying water onto semi-dry areas of colour creates a sort of mottled effect. Yet another kind of texture can be created by scattering salt over wet colour and leaving it to dry completely before brushing off. Painting with a sponge

Spraying water onto an almost dry wash from about 30cm (12in) away using a household spray.

Scattering salt onto wet paint. Leave on until the paint is dry, then brush off. Fine and coarse salts produce different effects.

Spattering colour from a toothbrush onto dry paper using two shades of green.

Spattering colour from a toothbrush onto damp paper using two shades of green.

is a way of adding some definition that is not too pronounced or hard-edged.

Masking fluid has already been encountered on page 67, where it was used to paint the fine lines of the masts, and its use for preserving small areas is discussed on page 81. Masking fluid can also be used in an experimental way as a resist to give textures and effects that would otherwise be difficult to achieve. As shown on this page, masking fluid can be applied with various implements. Use an old brush, as masking fluid will quickly ruin it, even if you wash off the rubber solution in soapy water after use. Interesting effects can be created by applying masking fluid at different intervals through the painting, thus preserving small areas of earlier washes that have had subsequent washes superimposed over them.

Another useful watercolour resist is wax. Try candles or wax crayons. Everyday materials such as clingfilm, bubble wrap, kitchen towel and coarse-weave fabric can all be pressed into the wet paint to leave a textured impression.

Make it a part of your wet-into-wet experiments to try working with the board flat on the table. Also try tilting the board this way and that to encourage colours to flow into a particular area.

This is the time, too, to try working on the grand scale, which could mean using a full-imperial sheet of paper, your largest

Masking fluid applied with a dip pen (*top left*), a matchstick (*top right*), a brush (*bottom left*) and a toothbrush, giving a spattering effect (*bottom right*).

Masking with a wax candle. Draw shapes with the candle and then apply a wash. When dry, the sheen of the wax can be removed by covering with blotting paper and applying a warm iron.

Texturing with clingfilm. Apply a wash. Press crumpled clingfilm into it while wet. Leave in place until dry, then peel off.

Texturing with bubble wrap. Lay a wash, and then press and lift off the plastic wrap repeatedly until the paint starts to dry.

brushes and mops, and several saucers for your wash mixes (as well as plenty of kitchen towel for blotting off the painting and mopping up the table).

WET-INTO-WET FLOWER SHAPES

Now try to create washes that give a vague impression of flowers in a garden or a hedgerow. These could be based on imagination or on photographs. Experiment by flicking paint from an old toothbrush and blotting off some random shapes for white flower heads. Once the paper starts to dry, leave it to dry completely before re-wetting and building more layers. At this stage it is better to think in terms of creating pleasing colour compositions rather than recognisable flowers.

When you are happy with the colours, add a degree of definition by painting negative shapes, that is by painting distant foliage and garden features around the pale flower shapes, as described on page 90 when we created pink flowers in a meadow. The house in this flower-garden painting was created as a negative shape by working the blue sky around it.

Working in this way reinforces what we have learned about painting warm and pale objects first and darker, cooler objects last.

FLOWER GARDEN
Worked wet-into-wet, the illustrations show how I worked, but your results may differ owing to the unpredictability of the method.

Palette

COBALT BLUE

PERMANENT ROSE

WINSOR YELLOW

STEP 1
First lay a warm multi-coloured wash, adding texture with some lifting and spattering. If you are lucky, something resembling a clump of flowers will appear.

106

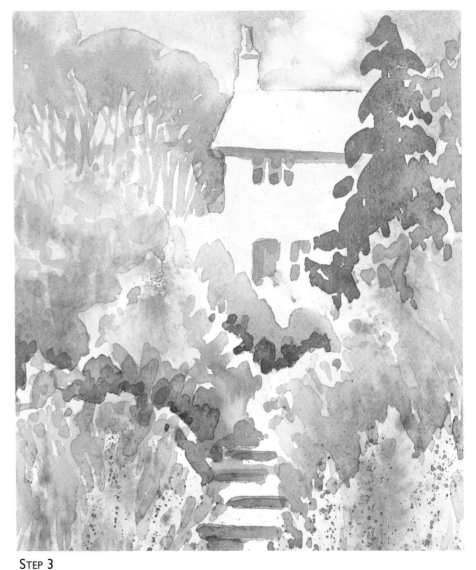

STEP 2

Use the cool blues and greens of the sky and dark conifer to create the outline of a house as a negative shape.

STEP 3

Re-wetting the paper when necessary, develop the image further, adding details and definition in the later stages by painting wet-onto-dry.

A DIRECT COMPARISON

In order to appreciate the unique soft-edged effects of the wet-into-wet method, paint the flower garden again, this time in the direct method working on dry paper. You will quickly see that the two methods produce sharply contrasting results. This will also remind you to keep an open mind about your approach to painting a subject.

In my experience, students who are prepared to be innovative and experimental will make faster progress than those who get into the rut of always working in the same way.

In Lesson Five we learned that the easiest way to paint in the direct method was from the top down. Now we shall experiment by turning that advice on its head, working from the bottom up and painting the nearest things first and the background last. (It does make some sense in the flower-garden image I have chosen for this experiment to paint the flower heads first, as they will form the most important part of the composition.) Follow the step-by-step instructions on pages 108–9. Once the flowers and their supporting stems and foliage are in place, complete the work by painting both positively and negatively to fill in the more distant foliage, trees and garden features.

FLOWER GARDEN
Painted in the direct method.

STEP 1
Compose the flower heads, allowing them to grow up into the top half of the paper. Then add their supporting stems and foliage.

SCARLET LAKE

PERMANENT ROSE

ALIZARIN CRIMSON

QUINACRIDONE MAGENTA

CADMIUM YELLOW PALE

COBALT BLUE

HOOKER'S GREEN

STEP 2
Add flower centres. The more distant foliage is added with pale dabs of blue-green between the existing leaves and stems.

STEP 3
For a building or other specific shape in the background, some light pencil drawing may be helpful. Remember to keep colours cooler and less vivid, and to use less tonal contrast in the background.

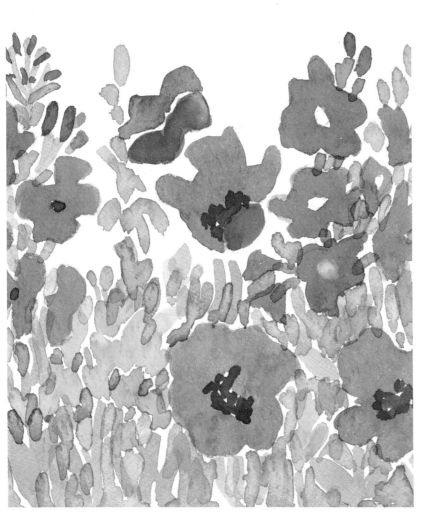

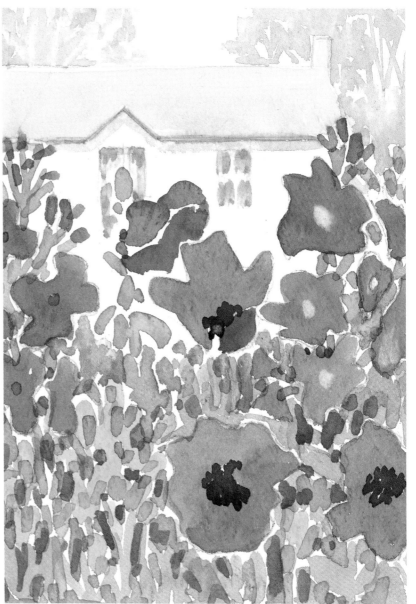

LESSON NINE

COMBINING PAINTING METHODS

Although we have dealt separately in this book with the three main methods of watercolour painting – direct, layer-on-layer and wet-into-wet – it is unlikely that any but the simplest studies will be completed using one method alone. The layer-on-layer process, for instance, may begin with a wet-into-wet base wash. In the direct method, some wet-into-wet techniques are almost invariably used and details are superimposed at the end. I have chosen the works on these pages to illustrate the effects that can be achieved by combining two or more methods. Many would say that the methods they use in their work cannot be categorised. For the beginner, though, I feel that identifying processes, methods and techniques makes them more easily understood.

Each of us has our favourite way or ways of working and perhaps you are now beginning to recognise yours. It is also true that some subjects lend themselves more readily to direct painting, while others suggest the slower building-up of layers, and yet others seem to cry out for a largely wet-into-wet approach. A full understanding of every method and the gaining of technical control through constant practice combine to give you a huge range of creative choices.

TOWNHEAD BRIDGE
Method mainly wet-into-wet.
This work started with a soft-focus, multi-coloured base wash with colours fed in and allowed to bleed and run. Details and definition were superimposed wet-on-dry towards the end.

NETTLEHOLE RIDGE

Method mainly layer-on-layer.

This was painted largely from memory and the colours were applied both wet-on-wet and wet-on-dry in many layers. The aim was for a fairly limited tonal range and a minimum of detail to give a sense of space and air. The composition has no focal point, but I have explored the texture of the foreground by repeated layers of washes. The first layer of the foreground was pale lemon, then warm yellow, and a range of greens. Some blue-green brush marks were added before the last wash was completely dry to give slight run-backs here and there.

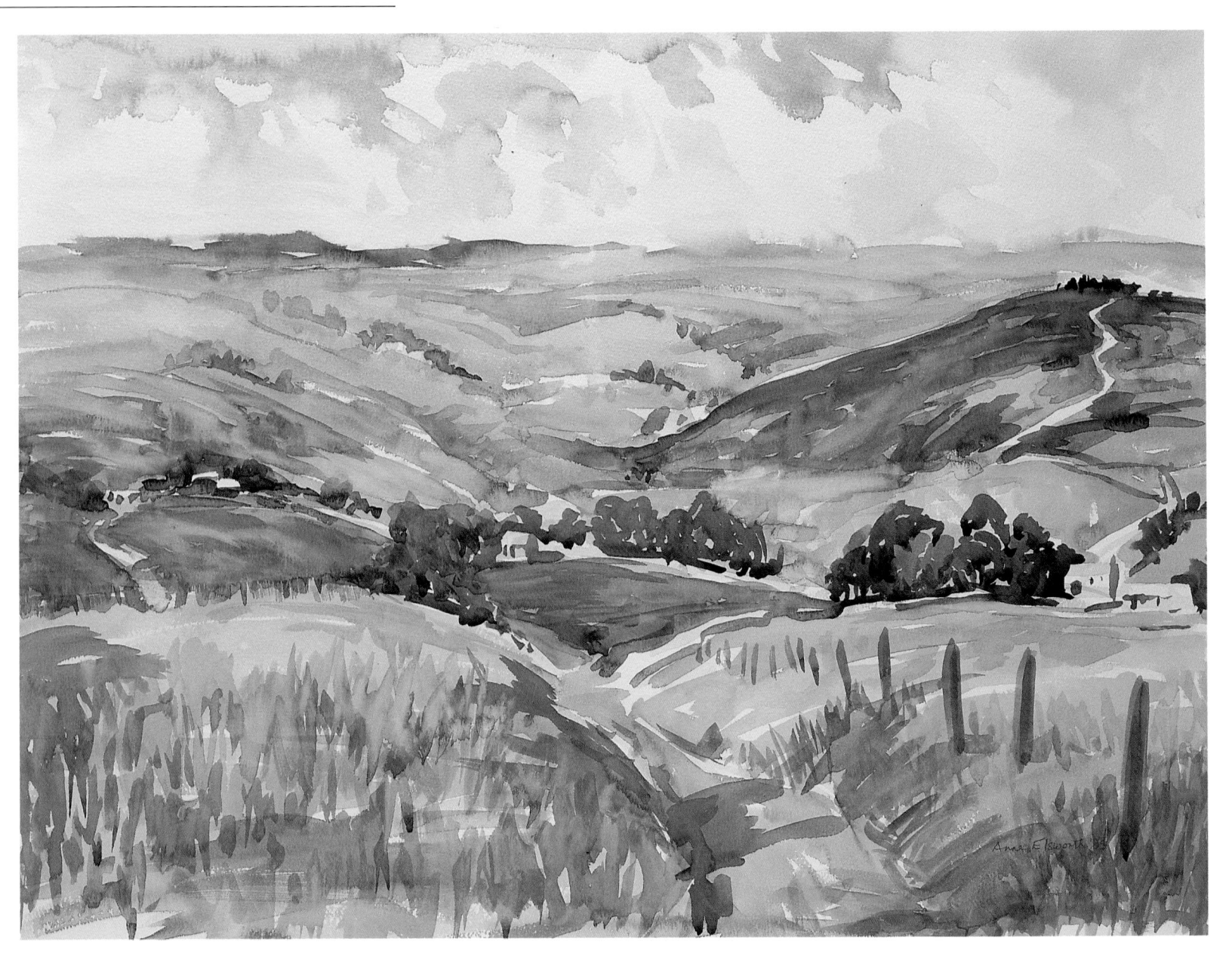

TOWARDS WEETS TOP

Method mainly direct. This was painted at considerable speed on the spot 'at one go', working largely from the top downwards. Colours were allowed to run and blend in most areas. A limited amount of superimposing was necessary at the end, notably for the dark trees on the right.

THROUGH THE WINDOW

Method combination.

This was painted a patch at a time; that is, first one pane and then another, sometimes working wet-into-wet and sometimes superimposing. This work could be seen as six small paintings held together by a window frame! It is advisable to work across and down the paper in the usual way to ensure that, for example, the hill is the same colour and tonality in both panes.

To avoid accidentally painting what you hope to preserve as white window frame, you could protect it with masking fluid. When this is removed any shadows on the frame can be added. Some measuring and ruling are useful in the preliminary stages of a composition such as this.

Straight Lines

There are occasions when measuring and ruling are useful in the preliminary stages of a composition. In the painting on this page, for instance, it ensures that the verticals and horizontals are true, and that the frame is properly proportioned. There are no problems of perspective here because of the face-on view. Ruled guidelines do not mean that you have to paint scrupulously straight lines; they do not suit a fairly free way of working.

If the proportions and widths are suitable, masking tape is a useful aid when painting straight lines, although it should only be used as a guide because paint will seep underneath it if brushed across. Masking tape that is very sticky might damage the surface of the paper when removed. Avoid this by dabbing a length of tape on your clothing before using it. The fluff picked up is enough to make the tape a little less adhesive.

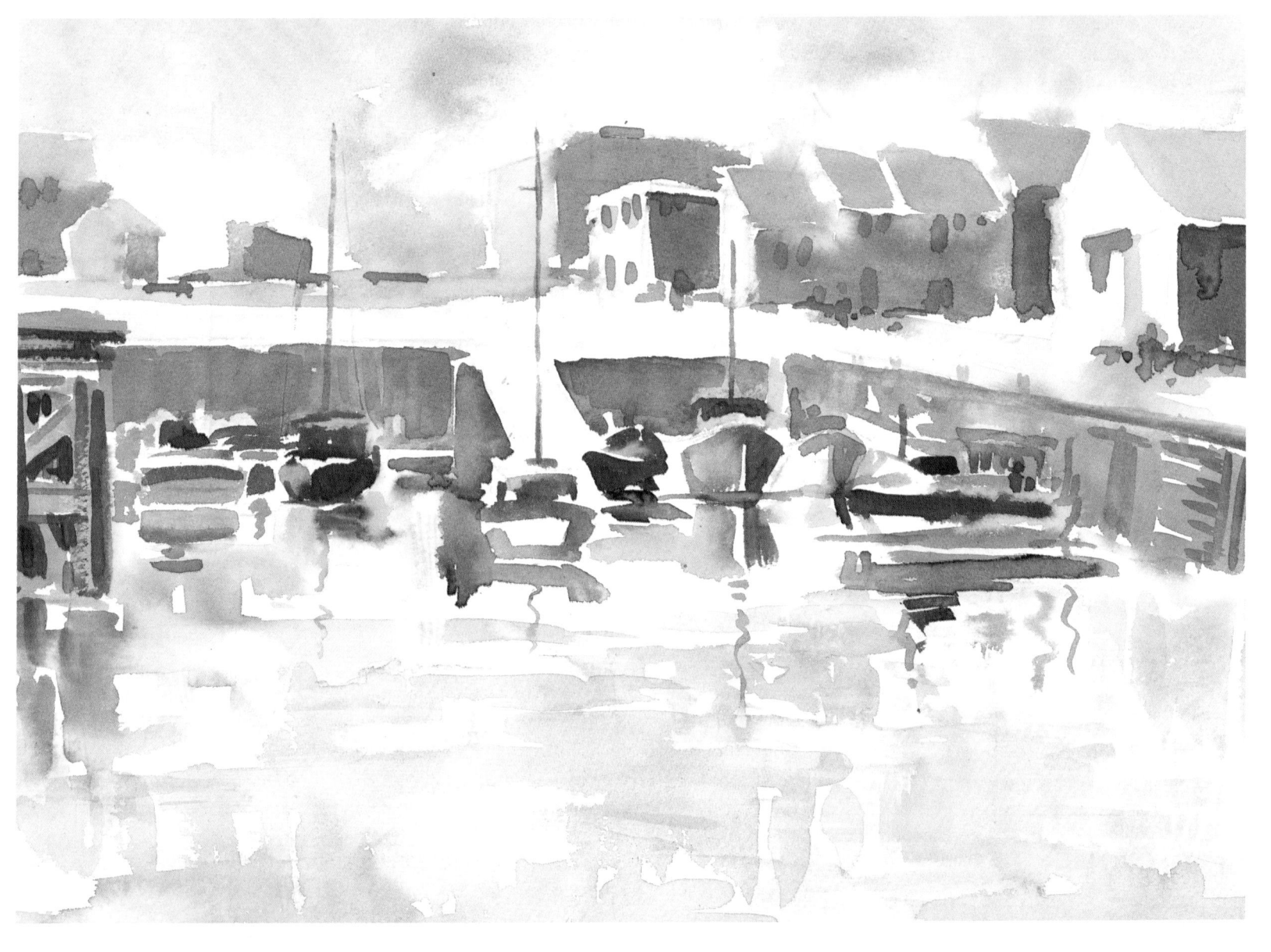

HARBOUR
MORNING
Method combination.
A perfect blend of
wet-into-wet and
direct painting. The
buildings are rendered
softly, wet-into-wet,
while the water
sparkles with light,
using the white of
the paper and
energetic brush
strokes of colour.

Finishing Touches

Our journey through the methods and techniques of watercolour has been a long one, and by now you should be confident to tackle almost any still life or landscape using the full range of techniques available. My aim throughout has been to lead you through the techniques and processes of painting in watercolour, and to encourage you to learn by experience. There are no short cuts, but your results will improve with practice.

In some ways, however, your journey has only just begun. Competence in handling any medium is not an end in itself but only the means to an end. I encounter many students who have achieved considerable expertise in applying paint and yet remain frustrated with their results. A frequent failing is to have paid insufficient attention to

such picture-making skills as composition, creation of the three-dimensional illusion, or effective use of colour. We have touched on these matters, and the importance of regular drawing practice, and I urge you to devote as much time as you can to studying these skills.

Another frequent failing is an inability to interpret convincingly the various elements of a study. Watercolour is an ideal medium for conveying an impression, and it may be better to portray minor elements of a scene with a few brush strokes than to attempt an accurate, detailed representation. Such advice about simplifying the subject, or painting more expressively in a free and spirited way is easy to give, but far harder to put into practice. The more specific the subject, the greater the difficulty. It is fairly easy to take a few liberties with the shapes of trees and hills and hope to get away with it, but people, animals and man-made constructions present a far greater challenge. Nevertheless, the acquisition of such interpretative skills is vital if your work is to progress. In this lesson we shall concentrate on improving your observational skills so

that you can extract the salient details from any subject, and use those details to provide a simplified but instantly recognisable interpretation. Observation, translation into paint, techniques and processes are all inextricably interwoven, but observation is the place to start.

Features such as figures, animals, buildings and boats, when included in a landscape, can serve a variety of purposes, aside from the obvious ones of adding realism and interest to your work. Strategically placed, they can be a useful aid to composition, and also serve as a reference to the scale of the other parts of the painting. The way a figure is dressed can emphasise the weather conditions you are trying to convey. Badly drawn or poorly interpreted, however, such features can spoil an otherwise pleasing work, so it is well worth spending some time learning how best to interpret them. Remember that the more colourful and detailed you make your figures, the more they will attract our attention, standing out from their surroundings like sore thumbs rather than blending into the composition.

Aims

- To learn how to interpret in paint some of the more difficult elements of landscape
- To practise achieving a more simplified, impressionistic interpretation of landscape through speed painting

FIGURES

Simplify figures to the bare essentials.
Begin by painting some pin figures as a
way of studying overall poses. Look at
the angles of head, body and limbs.
Bodyweight is often carried on one leg –
the other being used for balance – and this
can result in a tilting of both the shoulders
and the hips.

The next step is to flesh out your figures
into silhouettes. Here you must observe
not only the body's angles, but whether the
figure is bulky or slim, stooped or straight.
Pin figures and silhouette shape studies
can be made in either pen, pencil or
monochromatic paint.

As we have already encountered, what
you *know* is likely to obscure what you
actually *see*. For instance, we know that
everyone has hands, feet and a neck, but
these are simply not visible at a distance
and so should not be recorded. The colour
of flesh we *know* to be pinkish (it can be
mixed with red and yellow with just a touch
of blue), but it is often *seen* as – and thus
looks more realistic when painted as – a
brown or grey.

Working wet-into-wet will help prevent
the effect of figures that appear to leap
out from the page, as this method gives
less definition.

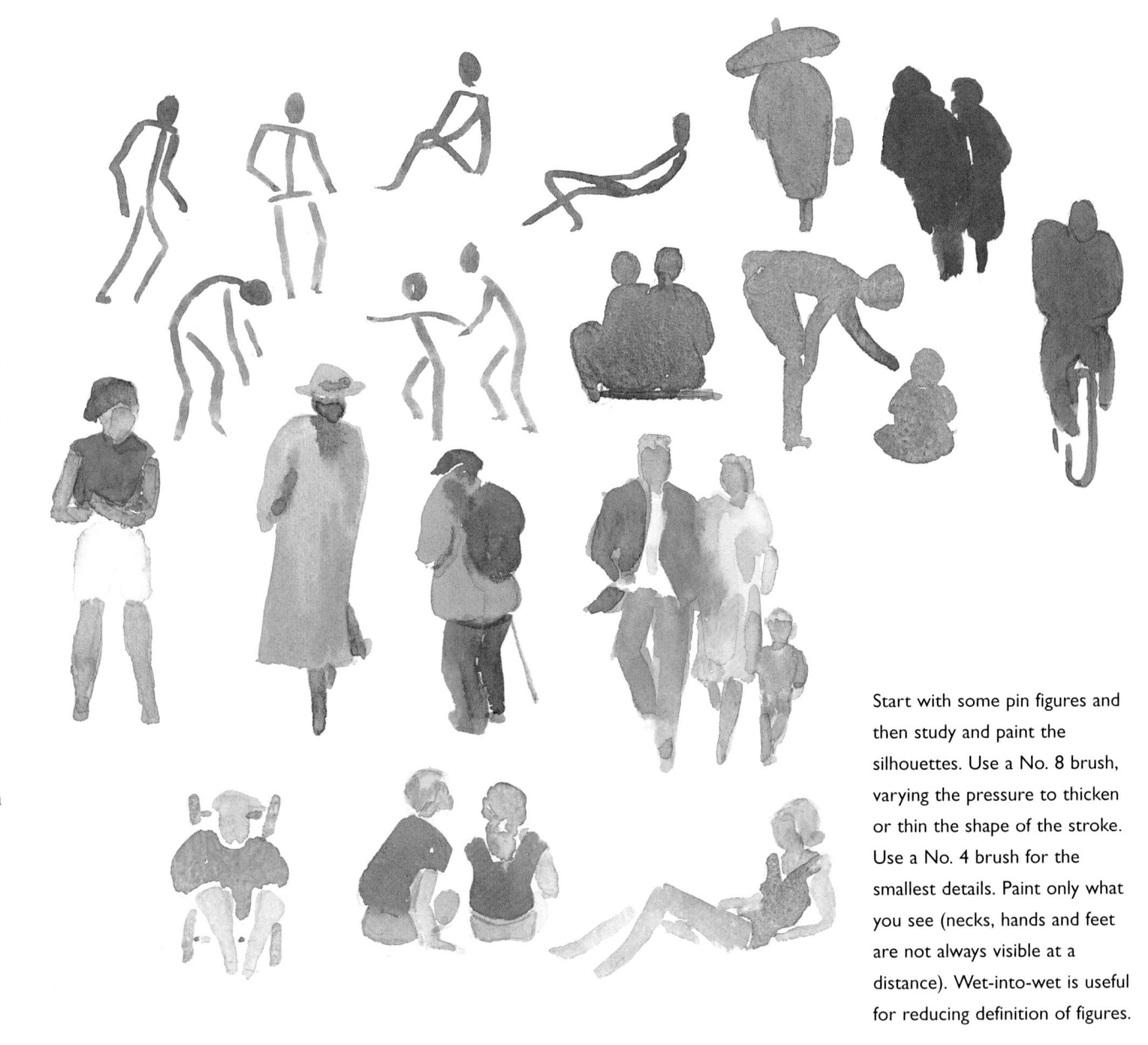

Start with some pin figures and
then study and paint the
silhouettes. Use a No. 8 brush,
varying the pressure to thicken
or thin the shape of the stroke.
Use a No. 4 brush for the
smallest details. Paint only what
you see (necks, hands and feet
are not always visible at a
distance). Wet-into-wet is useful
for reducing definition of figures.

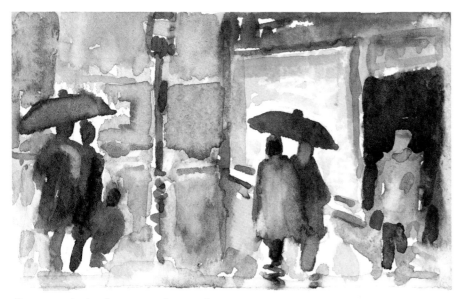

Figures emphasise the wet weather conditions.

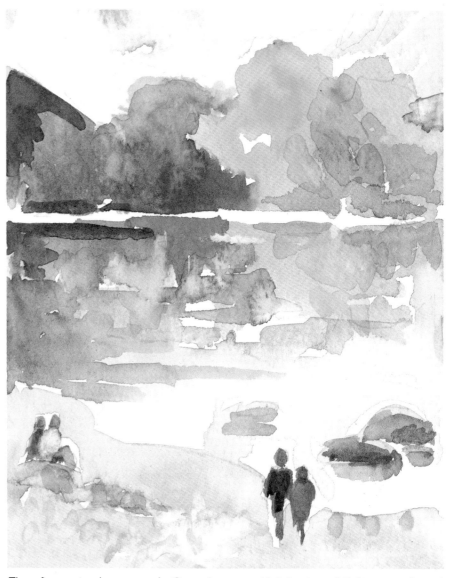

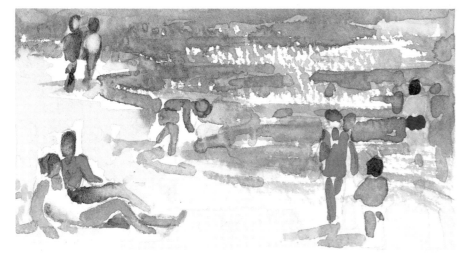

Sea and sand were painted first and then the figure shapes were lifted using a damp-and-dab-dry technique. Touches of colour were then superimposed.

These figures give the scene scale. Cover them up and it is hard to tell if this is a small pond or large lake.

Moving figures usually traverse the scene too quickly for you to capture them with paint in their entirety. When a figure reaches a point in the landscape where it will benefit the composition, I simply record the top of the head and position of the feet with a couple of dots in order to get the scale correct relative to the surroundings. (This saves me from making such fundamental errors as figures which are too tall to pass through doorways!) The figure itself can be put in later. It is sometimes easier to add figures at the end by lifting paint off in the correct silhouette and then adding touches of colour.

ANIMALS

Animal and figure studies collected in a sketchbook are an essential resource for landscape painting, whether you are working indoors or out. Farmers do not always keep stock just where you would like them to, but the inclusion of animals is legitimate use of artistic licence. One professional painter told me that many of his customers liked to feel they had the view to themselves and did not like to see human figures in a landscape, but animals were always acceptable.

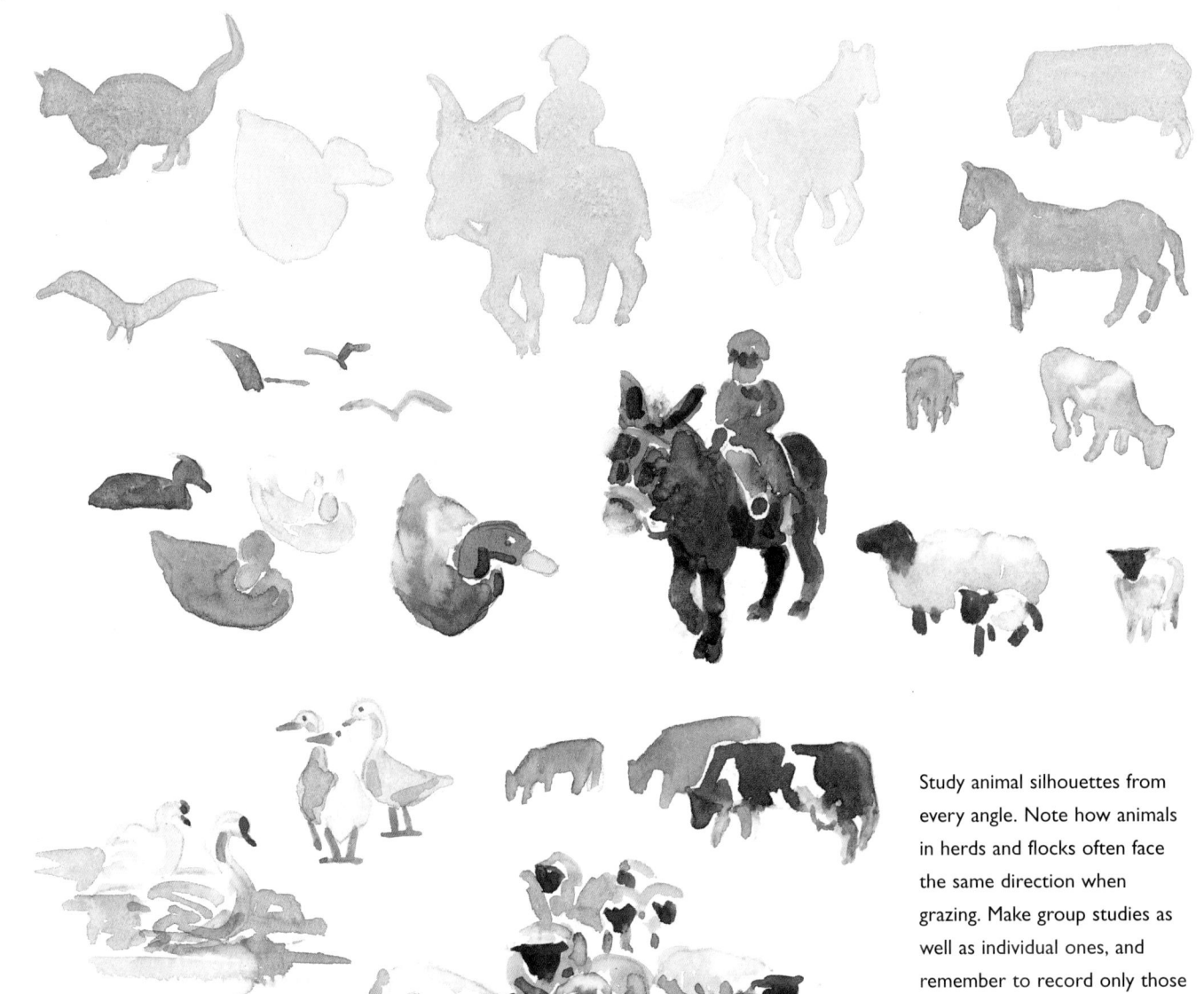

Study animal silhouettes from every angle. Note how animals in herds and flocks often face the same direction when grazing. Make group studies as well as individual ones, and remember to record only those details you can actually see.

Right and far right
The addition of cattle to empty fields gives the foreground interest – a legitimate use of artistic licence.

Below Birds were included to improve the composition, leading the eye in a curve across the straight lines.

Below right The shepherd and his flock lend scale and interest to an otherwise featureless landscape.

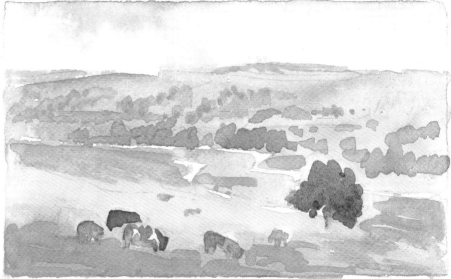

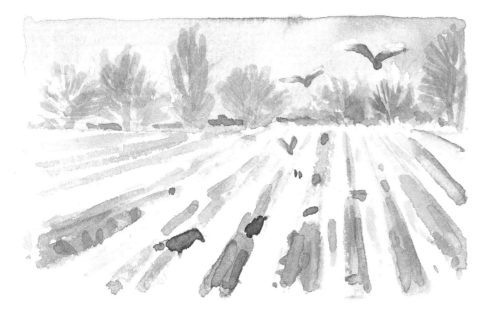

BOATS AND WATER

Boats can pose quite daunting problems when making preliminary drawings, being a complicated mix of both straight and curved lines, but marine and inland waterway subjects look strange and lifeless without them.

Before making studies in your sketchbook using both drawing and paint, try to get a feel for the subject by tracing and copying both photographs and painted examples. When working from life, look first at the overall dimensions: length of hull relative to height of mast, angle of hull and angle of mast, and so on. Detailed superstructure and intricate rigging are only observable in close-up, but do not try to fudge the arrangement of sails; sailors will spot your 'invented' rigging.

More often than not, the craft you paint will be floating and, consequently, reflected in the water below them. Objects and their reflections should be painted at the same time so that the colours match exactly.

Sweeping brush marks and dry brush strokes are effective in suggesting the movement and sparkle of water. Brilliant light reflecting from water can best be simulated by making the surrounding darks darker, because it is the contrast between light and dark that is important.

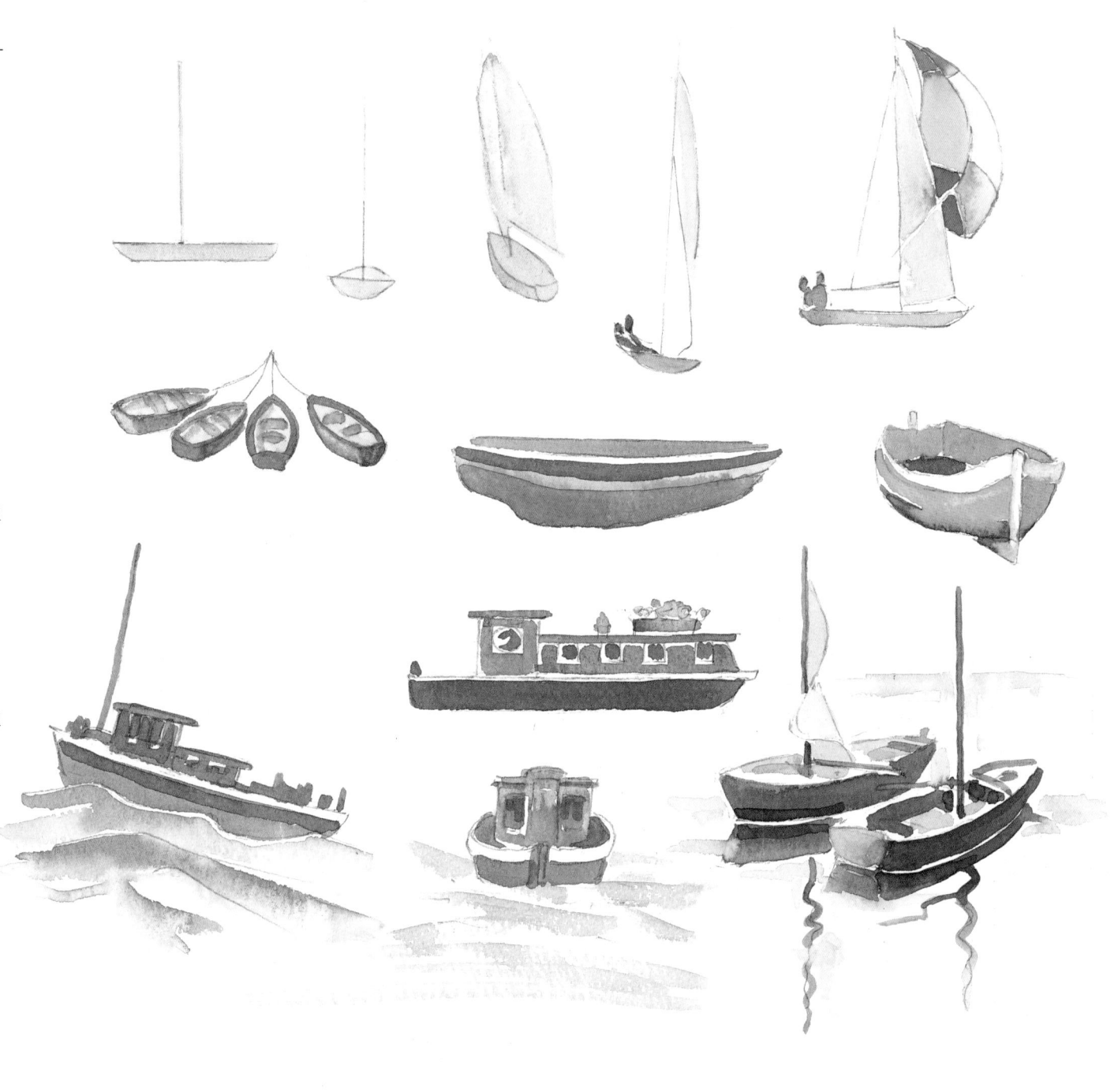

The jumble of craft and moorings in a harbour simplified into a few lines and brush strokes.

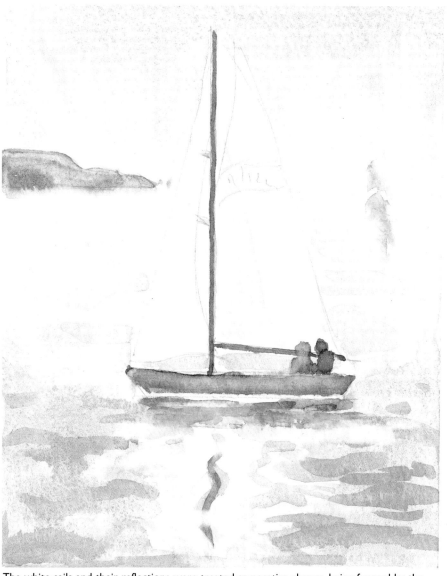

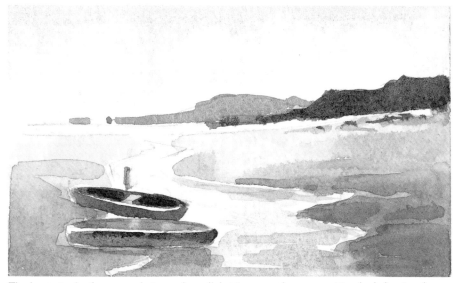

The boats in the foreground give scale and also improve the composition by balancing the headland on the right.

The white sails and their reflections were treated as negative shapes, being formed by the sky and water around them.

121

BUILDINGS

Perspective is a man-made convention for depicting three-dimensional objects, and its detailed study is only necessary if you wish to paint architectural subjects. When you are using bridges, barns or farm buildings as minor features in the landscape, careful observation is all you need. Once again, it is important to paint what you can *see* rather than the individual bricks, tiles, carvings, window frames or other ornamentation you know might be present.

Building materials – grey stone, red tiles, whitewashed walls, brown wood – are all altered by weathering, and our perception of them is affected by distance and light. At a distance, red brick and white wall may both be seen as different shades of grey. A dark slate roof will appear dazzlingly white if sunshine follows shower. By choosing colour mixes compatible with the rest of the painting you can ensure that the buildings do not demand more than their fair share of attention.

Look closely at the way others have interpreted buildings in landscape. Make studies in your sketchbook, paying attention to the overall shape, the angle of gable ends, degree of slope on ridge tiles, the relative positions of the various sections of the building, and so on. When working in the

Top right Use a pencil held out at arm's length in a vertical or horizontal position (indicated by the red line) to judge angles and relative positions.

Right Observe the overall shapes (the silhouettes) of buildings.

When you are painting with layered washes, you can describe buildings by painting the landscape around them. Trees and simplified details can be superimposed wet-on-dry.

A 13mm (½in) flat brush was used to create random roof shapes, then the door and windows were added with the same brush used on its side.

direct method, try a square-ended brush and see how few brush marks you can use to create a meaningful impression. When working in the layer method, paint around negative shapes, leaving a building-shaped space to which a suggestion of detail can be added later. Try wet-into-wet techniques to soften the outlines of distant buildings.

Right Wet-into-wet techniques produce a soft-edged effect and keep the cottage from leaping off the page.

Below left When the subject contains an imposing building or ruin, it is still important to choose an attractive viewpoint if the outcome is to be a pleasing painting.

Below right To ensure buildings do not attract too much attention use colours compatible with the rest of the work.

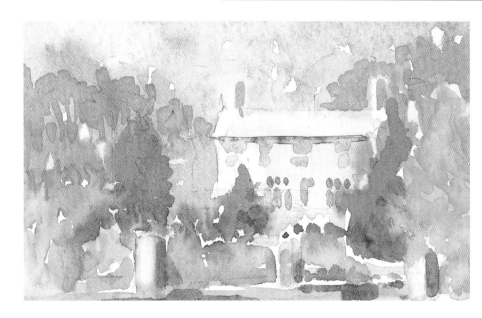

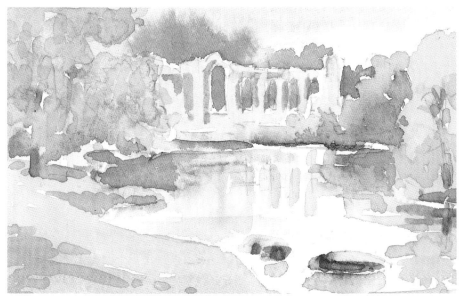

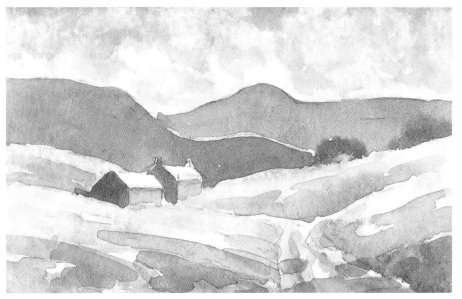

SPEED PAINTING

Speed painting – completing a painting like the one illustrated here in less than ten minutes – is a means to learning simplification and developing your ability to make an impressionistic interpretation. This picture, and the pictures on page 126, were all painted in just a few minutes, using the field box mentioned on page 10. The painting of the bridge opposite was made using my regular tubes and palettes and took about 15–20 minutes. The exact equipment used is immaterial, but speed is of the essence.

Not everyone aspires to impressionism, of course; some wish to use watercolours for precise botanical studies and others to create purely decorative paintings. However, I have yet to meet the student who did not at one time or another bemoan their failure to simplify. When viewing a typical subject with its multitude of detail and myriad changes of colour, it is difficult to decide just what to include and what to omit. A little speed painting can work wonders. To begin with, it is best to work from larger photographs (newspapers and magazines are a good source). Choose a subject which you feel has a good composition and holds your interest. Black and white photos will leave you free to use colour for its own sake or to express a mood rather than mixing to match.

Before starting to paint, take as long as you like to work out how you are going to tackle the job. Will it be best to work in the direct manner, making use of paper dams, to avoid having to wait for washes to dry? The answer is not always clear-cut. If, for example, the subject is something on the lines of the *Lake at Sunset* on page 89, it may be quicker to spend two minutes laying a variegated wash, seven minutes waiting for it to dry and one minute superimposing the shape of the hills. That would certainly amount to a ten-minute painting with time to spare for a catnap.

Experiment with some colour mixes before you begin and try some 'fresh air' drawing, too. This is like practising a golf swing; simply indicate with your finger where you will draw the main shapes once you begin. For the actual drawing on paper, I often use a brush and almost clean water – these enable me to draw in a more expressive way than do other materials.

Work quite small to start with, perhaps not much bigger than a postcard, working up eventually to an eighth or even quarter-imperial size. Allow 15 minutes for your first efforts and ruthlessly reduce the time to 10 or even 5 as you gain confidence. Choose a brush that really seems too big for the job, only reverting to a smaller one when you absolutely must (small brush

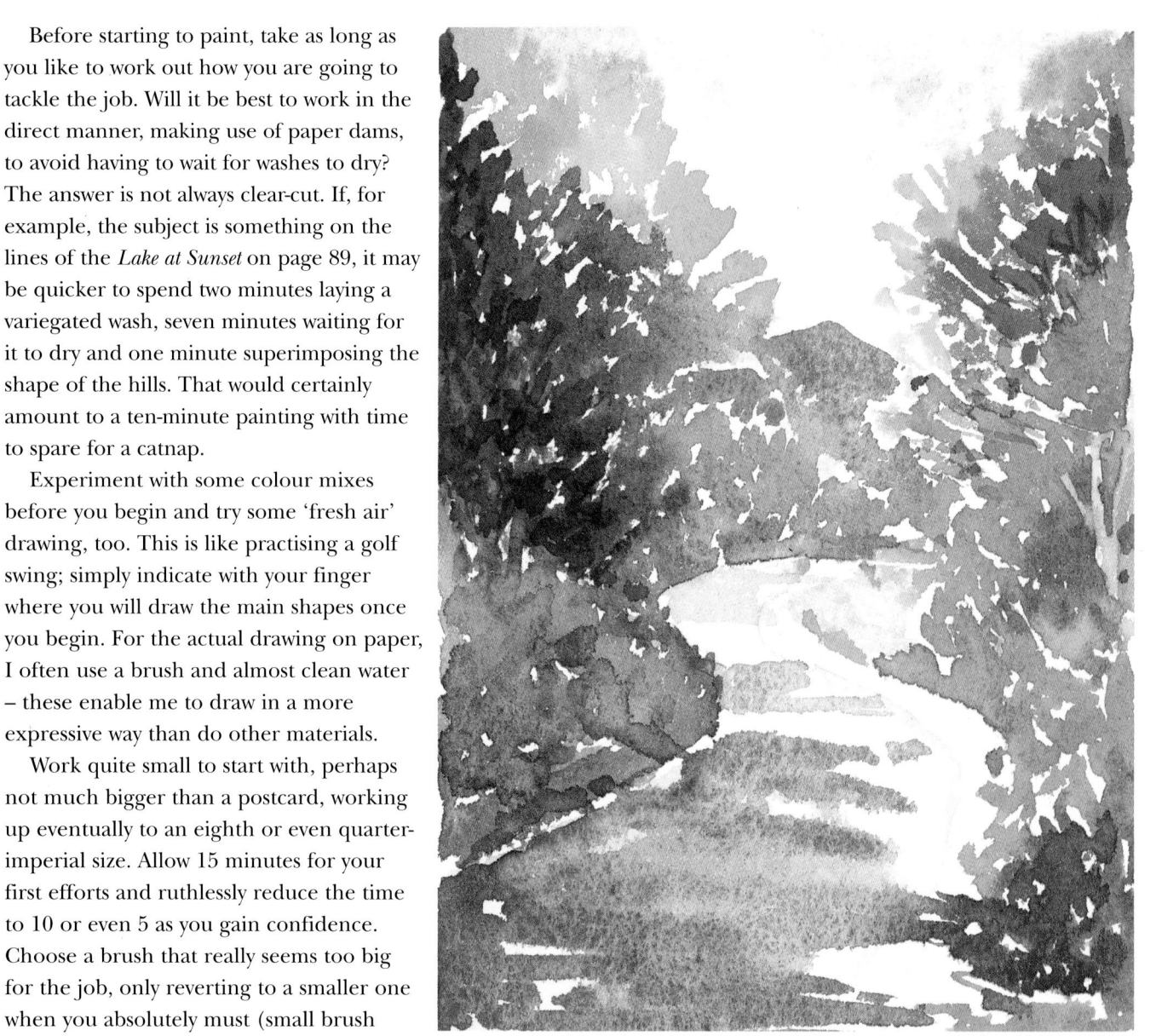

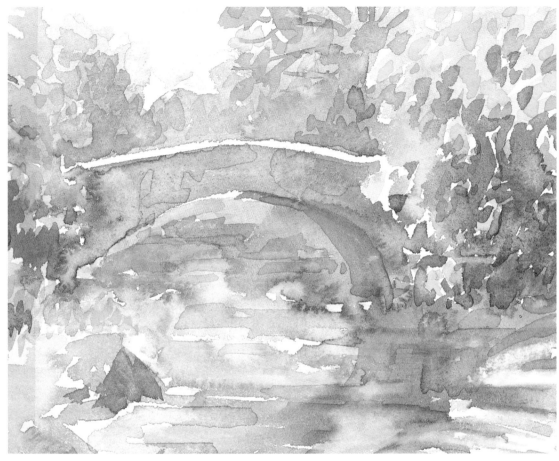

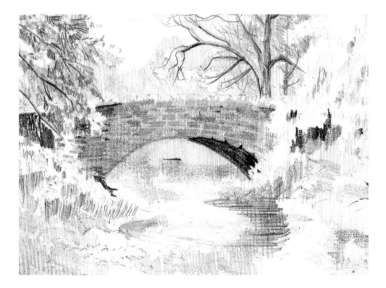

Left KANCAMAGUS HIGHWAY

This painting, and the two on page 126, were all painted in a matter of minutes.

Above BRIDGE AND LABURNAM TREE.

This painting took about 15 to 20 minutes. The aim of speed painting is to enforce a simplified or impressionistic interpretation, and it is fun just to have a go. However, if your early efforts are disappointing, spend some time making a line and tone study first, as I have done here. Time spent on careful studies enables a loose, free approach which still has veracity. The large paper dam at the upper edge of the bridge represents light catching the parapet, while at the same time preventing background colours from bleeding into the bridge area.

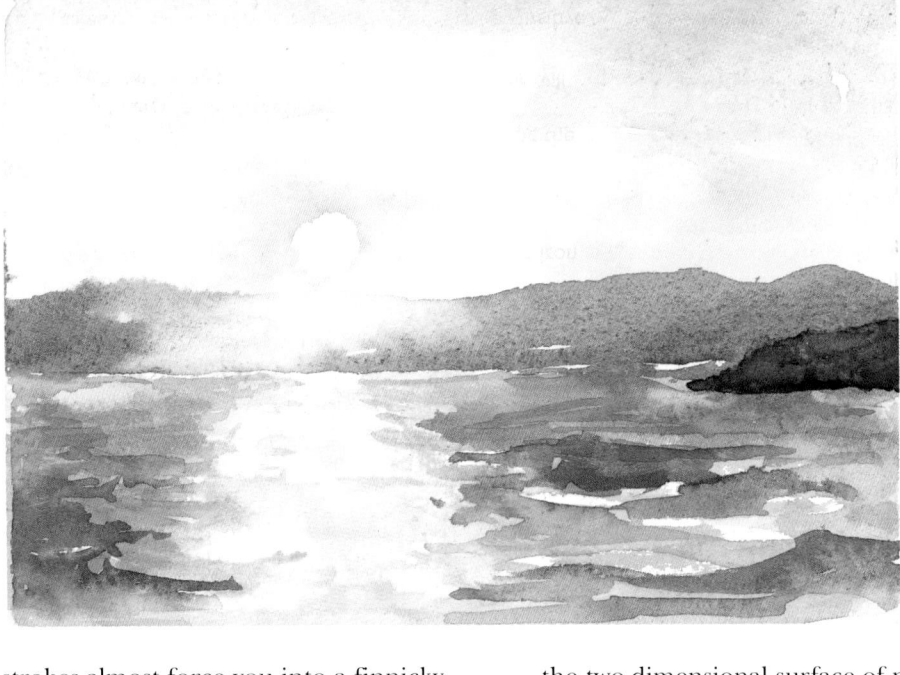

strokes almost force you into a finnicky treatment).

The next step is to work from *coloured* photographs, making a charcoal study before you start painting.

Speed painting *in situ* is the final stage. Half close your eyes and record only the main essentials, or stare for perhaps a minute, then turn your back and paint the remembered impression. This is more difficult than working from photographs, of course, because you have to interpret a three-dimensional world onto

the two-dimensional surface of paper, using paint, but by now I hope a certain reckless *joie de vivre* will have entered your soul and you will be really enjoying yourself.

Enjoyment and the urge to create something unique and beautiful is surely the motivation for learning to paint. The patience and perseverance that you have employed in making your own watercolour workbook will, I hope, reap a rich reward in enjoyment and creativity, and lay a firm foundation for the remainder of your painting lifetime.

Left RETURN TO ROCKPORT
Painted from memory.
Right SUNSET ON THE ST LAWRENCE
Painted *in situ.*

Speed painting is a most useful skill for the holiday-maker – an invaluable way of compiling a visual diary or of illustrating a written one. It is also essential for scenes such as these, in which the transitory effects of sunset or a passing storm allow no time for closely observed studies. Work fast and not too large and hope for the best – you may be pleasantly surprised.

GLOSSARY

aerial perspective effect of atmospheric haze causing distant landscape to appear blueish.

base wash preliminary wash of colour applied to a painting.

bleeding the tendency of any two wet areas of paint to run and blend together when allowed to touch. Also, the tendency of colour(s) to diffuse when applied to wet paper or wash area.

body colour opaque water-soluble paint (eg, gouache); transparent colour mixes with addition of white pigment; white pigment superimposed on otherwise transparent work.

colour saturation the purity and intensity of a colour.

colour wheel a system of organising colours.

colour wheel method my own term, coined to denote the method of creating an illusion of form by using the inherent tonal value of colour, without loss of colour saturation.

complementary colours strictly two colours which when mixed produce black; generally taken to mean any two colours opposite each other on a colour wheel (eg, yellow and violet, red and green, blue and orange).

cool colours broadly, blues and those with some blue content.

direct method process of painting one area of a work at a time, most commonly working from the top downwards.

dry-brush technique of dragging a lightly loaded brush across dry paper.

earth colours like tertiary mixes in appearance, but manufactured from natural earth deposits or synthetic iron oxides.

feeding technique of adding extra colour or water to an existing wet area of wash or to wet or damp paper.

ferrule the metal part of a brush, binding (or covering the binding of) hairs to the handle.

fugitive those pigments which when exposed to light will fade to some degree. Pigments are rated from very permanent, permanent or moderately permanent to fugitive. (Avoid fugitive colours.)

full strength in watercolour, the pigment used with minimum dilution but always liquid in consistency.

gradation the gradual passing from one shade or tone to another by imperceptible degrees (see wash).

granulation the tendency in some colours for small particles of pigment to separate and settle into hollows in the texture of the paper.

hue synonym for colour. Also, recently used by manufacturers to denote those colours produced using different constituents from those originally used (commonly in moderately priced ranges).

impure colours tertiary mixes and earth colours. In nature most commonly found in landscape.

layering, or layer-on-layer method by which the colours and tones of a painting are built up in successive layers or washes.

lifting off removal of part of a wash to correct, or create an effect.

local colour the inherent or objective colour of objects or surfaces as seen unaffected by reflected colour, nearby colours or lighting effects.

monochrome work executed in tints and shades of one colour (commonly greys).

negative shape the shapes around and between objects.

neutral colours the result of tertiary mixes (ie, three primaries); also a comparative judgement between colours. Any colour can be rendered more neutral/less pure by addition of its complementary.

opacity extent to which a colour or mix of colours will obscure the paper.

opaque pigment or wash likely to obscure the paper to a greater or lesser degree (ie, not entirely transparent).

palette surface on which to lay out and mix paints. Also, an artist's chosen range of pigments.

paper dams my own term, coined to denote narrow gaps of dry white paper used to prevent colours from bleeding together when wet.

pigment colouring matter.

primary colour pure yellows, reds and blues.

pure colours primary and secondary colours. May be at full strength (saturation) or tinted (paler).

reservoir my own term for the bead of excess water or wash that collects at the base of any wet brush mark or wash area when paper is at an angle.

secondary colour pure oranges, violets and greens. May be mixed from primaries or bought ready-made.

staining those pigments which in solution resist attempts to lift or wash off completely. Some will wash off while still wet, but all will leave some residual colour on the paper once dry.

superimposing the laying of one wash on top of another.

tertiary colours mixture of three primaries (or of two complementary colours).

tint a colour made paler by the addition of extra water or white pigment. (NB most watercolourists avoid white pigment and therefore opacity.)

tonal mass the overall tone or value of the larger areas, irrespective of minor changes within that area.

tonal scale an ordered range of tones from light to dark.

tone/tonal value the lightness and darkness of things (including pigments) irrespective of their colour.

transparency the extent to which the paper can be seen through the paint, and therefore the extent to which light is reflected by the paper.

true colours a primary or secondary colour perceived as having neither warm nor cool bias.

warm colours broadly, yellows and reds and those with some red content.

wash a solution of pigment in water; also a wash applied to paper on an area larger than a single brush stroke. Flat: applied uniformly. Gradated: changes imperceptibly from dark to light. Variegated: changes gradually from one colour to another (using two or more colours).

wet-into-wet process of painting on damp paper. Also adding extra colour to a wash before it dries.

wet-onto-dry superimposing additional wash or brush marks onto a previously painted dry area.

INDEX

040-823-01